# EVERESTING

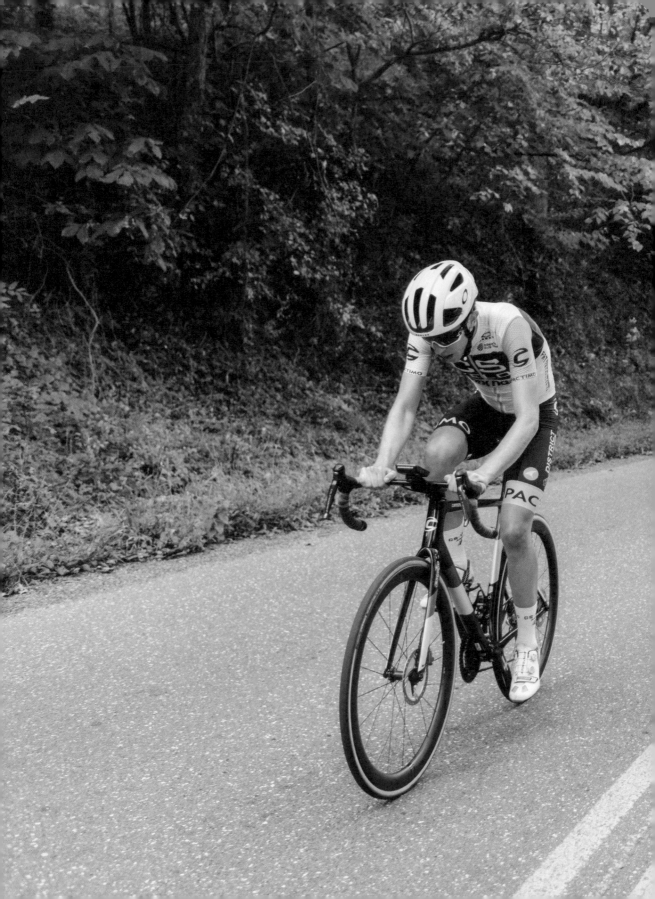

# EVERESTING

## THE CHALLENGE FOR CYCLISTS:
## CONQUER EVEREST ANYWHERE IN THE WORLD

—

## MATT DE NEEF

*Hardie Grant*

BOOKS

# CONTENTS

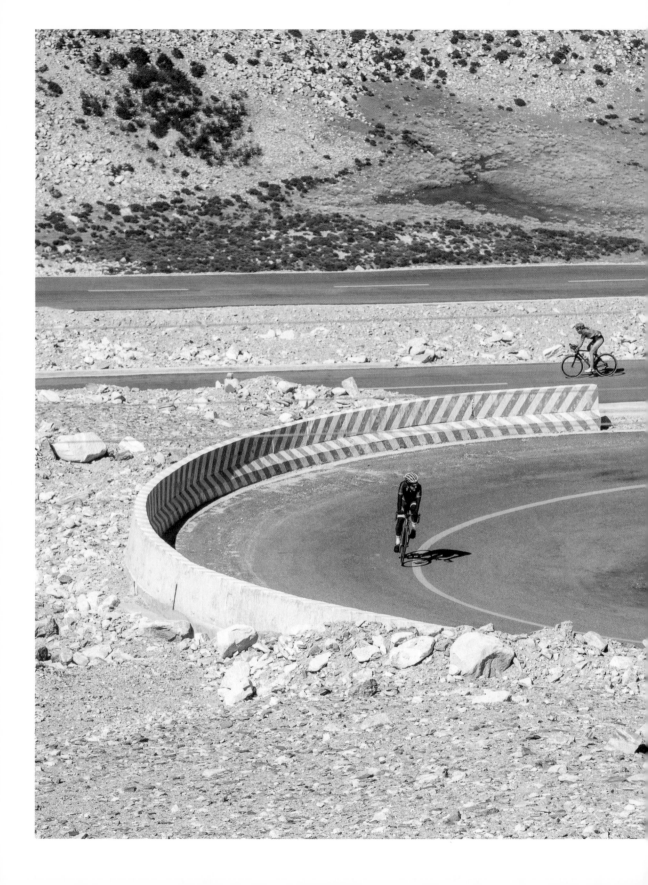

Everesting

# PROLOGUE

**Picture this.** You're standing over your bike, moments away from starting to ride. It's almost 1 am, pitch dark, and you're completely on your own. A quiet, lonely road snakes its way unseen up the mountain in front of you, dense bush closing in on both sides. You know it will take roughly 90 minutes of riding to get to the top.

But you aren't just about to climb this mountain once – that would be challenging enough. No, you're about to ride it over and over again, up and down, for most of the next 24 hours. In that time you'll be pushed to your absolute limit, physically and mentally, as you try to endure fatigue like you've never felt and pain in places you didn't know it was possible to feel pain.

Just the thought of it is enough to make even the most hardened athlete wince. And yet, this is a challenge cyclists have completed more than 10,000 times worldwide.

All have ridden 'repeats' of a single hill or mountain – up and down, over and over – in one continuous ride, until they've amassed 8848.86 metres (29,032 feet) of elevation gain, equivalent to the height of Earth's highest peak, Mt Everest.

For some, an Everesting can take as long as 30 hours and involve more than 500 kilometres (310 miles) of riding, half of it uphill. For many, it's the hardest physical challenge they'll ever face.

It's difficult to overstate the enormity of the challenge. One of the world's toughest recreational cycling events, a French ride called La Marmotte, covers 174 kilometres (108 miles) with 5180 metres (16,990 feet) of climbing – little more than half the height of Mt Everest. A particularly mountainous stage of the Tour de France, the world's most prestigious bike race, might span 200 kilometres (124 miles) with 5000 metres (16,400 feet) of climbing – also considerably less than an Everesting.

Because Everesting is a challenge defined as much by its failures as its successes, for every story of someone reaching the mythical 8848 metres, there's at least another of someone falling short. For those that do reach the height of Everest, the only prize is a place in Everesting's online Hall of Fame, the official record of those who have completed this monstrous challenge.

There have been successful Everestings on road bikes, on mountain bikes, on fixed-gear bikes without brakes, and on unicycles. Everestings have been completed on foot, on skis and even via the internet. They have been completed in more than 100 countries around the world and on every continent except Antarctica. 🚲

**Left**
All you need to complete an Everesting is a hill you can climb over and over.

**9**

# PART ONE
# EVERESTING

# HOW IT BEGAN

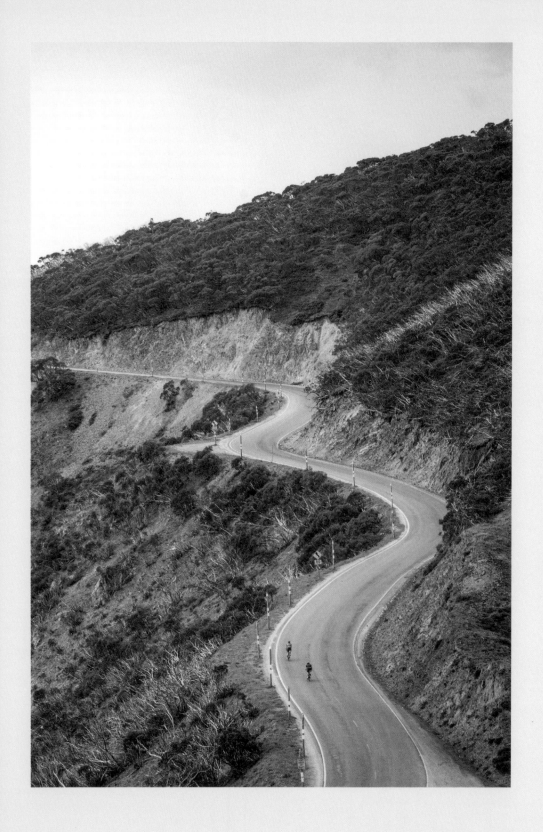

Everesting

**N**one of Everesting's vast potential could have been known to recreational rider and Everesting founder Andy van Bergen when he clipped into his pedals at the foot of Mt Buller in the early hours of 28 February 2014. Over the next 22 hours, through darkness and daylight, through sunshine and rain, the then 34-year-old would ride lap after brutal lap of the 17-kilometre (10.5-mile) climb to the popular ski resort in the High Country of Victoria, Australia.

With that ride, he didn't just become one of the first in the world to complete an Everesting; he helped usher in a phenomenon that, in the years that followed, would take the cycling world by storm.

Andy and I have been friends since 2012. We've ridden together countless times – often uphill – we've run dozens of cycling events together and we've been colleagues at the CyclingTips online magazine since 2013. In 2014 I watched with interest as Andy launched Everesting to the world, and in the years since, I've keenly followed and reported on the challenge's growth.

But in 2020, as Everesting's popularity grew beyond all expectation, it was clear this challenge deserved to be documented in a more comprehensive way.

Andy remembers the start of the Everesting well. The unwelcome tap on the shoulder from his dad, Tony, waking him before midnight, after just 2 hours of sleep. Dozing in the car as Tony drove the serpentine road down the mountain. Feeling like he'd 'been hit by a bus' as he got himself ready to ride. Bidding Tony farewell just after 12.30 am, and setting off up the mountain for the first time, into the inky black.

He also remembers how quickly the self-doubt crept in. 'When I got started, that first kilometre or two … you're just thinking "What in God's name am I doing? This is so stupid. It's pitch black." I'm by myself, I'm in the bush and my legs already hurt because I'm not warmed up and I'm tired as anything – so tired – and I've got Mt Everest ahead of me to climb."'

From Andy's handlebars, a small, low-powered commuter light provided just enough illumination to see the road immediately before him but little else. 'Because the light's in front of you there's no peripheral vision,' Andy recalls. 'So you are really enveloped in darkness. Coupled with that, you're hearing animals scurrying through the bush and bushes moving.'

At around 2 am, after an hour and a half of riding, Andy reached the Mt Buller village for the first time. One lap down, seven to go. Or so he thought.

'I got to the top of the first lap and checked my Garmin [GPS cycling computer] and realised that my elevation calculations had been probably a little bit optimistic,' Andy says. 'In all my planning and mental preparation I had eight Bullers in mind. At the top of the first lap I realised instantly that I was going to be doing nine laps.

'I had this feeling creeping up and I knew that this had the ability to overpower me. And so I squashed that thought straight away and just said, "This is what we're gonna do. We're going to get to the bottom. This first one? That was a bonus one. It doesn't count. We're starting from the bottom."'

Back at the bottom of the hill, 2 hours after setting off, Andy said a quick hello to his dad who'd been sleeping in the car. It was a brief but welcome moment of human contact amid the crushing solitude of those pitch-dark opening laps.

Through the early hours of the morning, Andy ploughed on, his tiny light cutting a narrow swathe through the black of night. On his second ascent he turned to audiobooks to distract himself from the loneliness, and from the knowledge that he'd have to complete an extra lap beyond the ridiculous challenge he'd already been facing.

While Andy was riding alone in Victoria's north-east, he wasn't the only one attempting to climb the equivalent of Mt Everest that weekend. He'd convinced dozens of other riders to join him, each tackling their own climb at the same time.

On Mt Hotham, 65 kilometres (40 miles) to the north-east, Josh Goodall was having his own battle with the darkness.

The climb from Harrietville to Mt Hotham spans a seemingly interminable 30 kilometres (18.6 miles) and, at its peak, is the highest sealed road in Australia. More than that, it's one of the country's most challenging climbs – completing a single ascent is a noteworthy achievement. That day, Josh needed to complete six laps to conquer his own personal Everest.

The final third of the Mt Hotham climb pokes its head above the tree line, offering an exposed, barren vista. It can be a lonely, inhospitable place even on a warm summer day; in the small hours of the morning, at the start of a full-day cycling marathon, it's something else entirely.

**Left**
Embarking on an
Everesting often
means having to
ride in darkness.

'During the climbs and the descents I saw not a soul, heard not a peep from any creature, no vehicles passing, no lights but the Audax-grade laser torches strapped to my cockpit, no shred of wind,' Josh told me. 'My universe was the gravelly tarmac disappearing about 5 metres in front of me, my own breath, and a weird occasional creak from my bottom bracket that I really thought I'd finally eliminated the previous week.'

It took Josh more than 24 hours – 19.5 of those on the bike – to conquer Mt Hotham six times, riding from early morning, through the day, and back into darkness at the other end.

Some 40 kilometres (25 miles) to the north-west, Sarah Hammond was creating her own slice of history. With eight laps of the 18-kilometre (11-mile) climb on Mt Buffalo, she would become the first-known woman to complete an Everesting.

Like Josh, Sarah completed her entire ride in solitude. 'The last couple of laps were surreal; it was mechanical in my legs, but my head was totally disconnected,' she wrote afterwards. 'Fighting off sleep, the lines on the road were blurred. I was crying and talking rubbish out loud. I had resorted to counting every metre of elevation, hysterically wanting it to be over.'

Some 200 kilometres (124 miles) to the south-west, in the heart of Melbourne, Mike Melling-Williams was engaged in a similar fight. Where Andy, Josh and Sarah had less than 10 ascents of their respective mountains to complete an Everesting, Mike's challenge looked significantly different. He'd opted to Everest on Anderson Street, next to the Royal Botanic Gardens. The street has an ascent of just 25 metres (82 feet); he would need to climb it 356 times.

He started his first climb at 4 am on the Saturday morning, with 'bike, lights, a few bottles of water and a burning desire'. He wouldn't finish for a full 24 hours, almost 22 of which he spent in the saddle, covering a gruelling 423 kilometres (263 miles).

'People went to a soccer game at AAMI Park [a nearby stadium] and then on the way back saw me still upping and downing,' he recalls. 'I remember a young kid saying to his folks, "That guy is still riding."'

On that weekend in late February 2014, all of these riders, and several dozen more besides, were linked by a shared goal. They might have been separated by hundreds, if not thousands, of kilometres, riding their own climb, many of them in complete isolation, but all were trying to scale their own Everest.

All were doing so voluntarily, as part of Andy's Everesting challenge, one that, at that time, only the strongest and most dedicated were invited to tackle, let alone able to complete.

---

### THE HEIGHT OF EVEREST

Remarkably, it wasn't until December 2020 that China and Nepal first agreed on the height of Mt Everest. Since a survey in the mid-1950s, Nepal had listed the summit as 8848 metres (29,029 feet) above sea level – the most widely accepted mark – while China had the summit at 8844.43 metres (29,017 feet), arguing that the mountain's snow cap shouldn't be counted.

In 2019 and 2020 the two nations remeasured the summit and agreed on a new height of 8848.86 metres (29,032 feet) at the snow cap – 86 centimetres (2.8 feet) higher than the previously accepted mark.

For Everesters the change has little impact; the vast majority of riders climb a little higher than Everest as it is, in order to give themselves a buffer in the case of a GPS error or if they miscalculated the number of laps required.

It's best to understand Everesting as the culmination of half a decade of masochistic cycling challenges, one-upmanship and testing the limits of one's own ability.

Back in 2008 Andy and a small group of fellow riders tackled Victoria's 7 Peaks Ride, a tourism initiative designed to draw cyclists to the state's High Country over the warmer months, to cycle up seven of the region's mountains. That challenge got Andy thinking – while most attempted the 7 Peaks over several months, why not do it quicker? In November 2009 he and a small group of friends attempted to complete all seven climbs as quickly as they could.

Driving between climbs, they managed the feat in just under 50 gruelling hours. A year later, in 2010, they revisited the challenge, slashing 15 hours off their previous effort.

But 7 Peaks was just an appetiser for Andy and co. In 2011 they upped the ante again, with a ride that would inspire the name of their tight-knit, hill-loving collective.

Peaks Challenge Falls Creek (previously 3 Peaks Challenge) is one of Australia's toughest recreational cycling events, a punishing 235-kilometre (146-mile) ride featuring 4300 metres (14,100 feet) of climbing across three tough alpine climbs in the High Country. For many, it's the hardest ride they'll ever do. For Andy, it was inspiration.

After riding the loop, Andy wanted a way to make it harder, to *really* challenge himself and his retinue. Why not do the ride twice, in opposite directions, on consecutive days? 'We plotted it out on paper and it ended up being 9100 metres (29,850 feet) [of climbing] and 480 kilometres (298 miles) or something,' he recalls. 'And I've just got this thing where I have to round [it up]. So we decided to include [Mt] Buffalo as well. That would make it 10,000 vertical metres (32,800 feet), 500 kilometres (310 miles). We decided to do it over 36 hours so we'd have a sleep in the middle.'

He dubbed the ride 'Hells 500', a nod to both the difficulty of the event and its length.

In March 2011 a group of four riders – including Andy and his uncle, John Van Seters – made the 4-hour drive from Melbourne to the High Country and completed their audacious ride. They made quite the splash. 'In the [following] weeks and months we'd join different group rides around the place and people would say, "This is Andy and John, you know, those Hells 500 guys,"' Andy remembers. 'It wasn't until that moment that it was like, "Oh, that's who we are. We are Hells 500." That's where the name came [from] and it stuck.'

The outrageous rides continued in the years that followed. In February 2012 a nine-strong Hells 500 contingent tackled a ride Andy dubbed 'Three Long Five High', a 300-kilometre (186-mile) one-day epic with 5000 metres (16,400 feet) of elevation gain. It took the group 13 hours to complete that challenge, summitting four large alpine ascents in the process. Andy recalls a moment late on the final climb as one of his worst-ever experiences on a bike. 'I was seriously contemplating having an accident so I could respectfully pull out,' he says.

And yet, despite the difficulty of that ride, Andy wasn't done concocting obscenely tough rides to test his and his friends' limits.

A little over a year later, in April 2013, the Hells 500 crew expanded again with a ride dubbed 'Crux'. Held in the hilly Dandenong Ranges, 40 kilometres (25 miles) east of Melbourne, the ride comprised three laps of The Crucifix, a tough but popular climbing route that in itself contains four climbs of varying difficulty. The total challenge: 12 ascents, 215 kilometres (134 miles) of riding and 5600 metres (18,370 feet) of climbing in a ride that took 10.5 hours.

Among the 13 riders taking on the challenge that day: your humble narrator. For years I'd watched with admiration as

**Above**
The riders of a fledgling Hells 500 during Three Long Five High in 2012.

Andy and friends had tackled increasingly obscene challenges. With Crux, I had the chance to experience the madness firsthand. It was every bit as hard as I was expecting.

In early 2014, a year after Crux, Everesting was born.

Unlike the Hells 500 'epics' that preceded it, the group's 2014 adventure didn't require all participants to gather in one location – it didn't require Andy to organise a physical event. All of this meant the number of participants could expand significantly, which was relevant because, from as early as the 2011 epic, an increasing number of riders had been keen to take part.

Indeed, by the time 2014 rolled around, more than 100 people had expressed an interest in joining the next Hells 500 ride.

'I'm talking about people wanting to fly over from the US or from the UK, which was kind of mind-blowing as well,' Andy says. 'But then the responsibility … it turned it from being a challenge for us into running an event. I didn't want it to be an event or anything like that. I knew that whatever the [2014] challenge was going to be, it had to be something that would have a framework, but people would be able to do it wherever they were.'

As he brainstormed ideas for the 2014 epic, Andy remembered a story he'd read a year or so earlier – the incredible tale of another Melbourne-based cyclist George Mallory, who'd completed a series of breathtaking rides on nearby Mt Donna Buang.

How it began

Before making a name for himself in cycling, George did the same in rock climbing. Born in South Africa in 1959, he discovered the sport in high school and went on to become a trailblazing and well-respected member of the local climbing community. He had pedigree when it came to climbing – his grandfather, also named George Mallory, was a pioneering explorer and mountaineer who played a pivotal role in Great Britain's earliest expeditions to Mt Everest in the 1920s. Tragically, in 1924, on his third expedition to Everest, Mallory and his climbing partner Andrew Irvine went missing while making a push for the summit.

Exactly what happened to the pair on the upper slopes of Everest remains one of mountaineering's most enduring mysteries. Mallory's body wasn't found until 1999 and Irvine's is yet to be recovered. It's still not clear whether the pair perished while climbing or while descending, perhaps having reached the summit.

Some 70 years after Mallory's untimely passing on Mt Everest, his grandson had his own Everest in mind.

In his rock-climbing days in South Africa, George Mallory II had tackled the challenge of stringing together multiple ascents for considerable elevation gain. The crowning achievement in this quest came in March 1989 with 'The Big Push', a feat several years in the making and one that saw George and his climbing partner Kevin Smith scale a phenomenal 1500 metres (4920 feet) across five climbing routes in one 24-hour period.

George soon moved to Melbourne and turned his attention to cycling. Before long he was doing on the bike what he'd done on the rock walls of South Africa: stringing multiple climbs together in one big day.

**Left**
George Mallory played a formative role in the phenomenon we now know as Everesting.

In late 1992, he began what would become a 2-year project to accumulate as much climbing as he could in one effort, by riding up and down the 17-kilometre (10.5-mile) road on Mt Donna Buang, 65 kilometres (40 miles) east of Melbourne. Through 1993 and into early 1994, George worked his way up from two laps of the picturesque, rainforested climb to four, and then to six laps. With more than 6000 metres (19,685 feet) of elevation gain, that six-lap ride had more climbing than even the most mountainous days of the Tour de France. George started to think that climbing the height of Everest in a single ride was possible.

It was around that time, in February 1994, that George was invited to be part of the American Mt Everest Expedition, a mission that would retrace his grandfather's footsteps from 70 years earlier. But it was George's goal of riding the equivalent height of Mt Everest on Mt Donna Buang that took on much greater resonance.

In March 1994 he climbed a monstrous seven laps (7500 metres/24,600 feet) before knee pain and 'profound exhaustion' overwhelmed him. Seven months later, George returned to the mountain and continued where he'd left off. With eight laps in one day in October 1994, George had more or less climbed the height of Everest. But still he wasn't done.

In November 1994, aged 34, George returned and completed a staggering 10 ascents of Mt Donna Buang. In just under 23 hours he rode 340 kilometres (211 miles) and climbed more than 10,000 metres (32,800 feet) – well over the equivalent height of Mt Everest. He tried for 11 laps the following month but was forced to cut his effort short, thanks to an untimely bout of diarrhoea (he still managed eight laps).

## EVERESTING VS EVEREST

So how does Everesting compare to climbing Mt Everest itself? For George Mallory, the 10-lap ride he did on Mt Donna Buang in 1994 was probably harder.

'When I climbed Mt Everest, there are 3 big days to get to the summit,' George tells me. 'And when I was doing those days, I would benchmark them against riding the 10 laps of Donna Buang. Each of the 3 days, including summit day, which is the biggest, are equivalent to about five or six laps of Donna Buang (5000–6000 vertical metres/16,400–19,685 feet). Now, of course, when you're at altitude and you've got a little tent and whatnot, your opportunity to recover is not the same as when you're at home in Melbourne. I wouldn't like to go and ride six laps of Donna Buang 3 days in succession. So you can't easily compare the two. However, I do recall saying to many people when I got back from Everest, "Well, just calm down; it's not that hard. There are things I've done that are harder than climbing Mt Everest." By which I meant the 10 laps of Donna Buang.

'I really struggled with the 10 laps. It took everything I had. Everest, by comparison, didn't really seem that hard. I'm going to stick with my assertion that 10 laps of Donna Buang on a 10-kilogram (22-pound) bike, without support, is probably harder than climbing Mt Everest in good conditions with oxygen [and] Sherpa support, in what I call tourist style.'

George's attempts to climb Everest on Mt Donna Buang served as invaluable training for the real thing. In May 1995 he reached the summit of Mt Everest proper, as part of the 3-month-long American Mt Everest Expedition. He and his companions made their ascent from the north, following the same route George's grandfather had taken 71 years earlier.

In May 2012, more than 17 years after George's exploits on Mt Donna Buang and Everest, the tale of his incredible cycling project was published on CyclingTips.com. Like so many who read the article, I shook my head with incredulity as I absorbed George's gripping account, staggered at the magnitude of what he'd achieved. It seemed unfathomable that any cyclist would be able to spend most of 24 hours slogging up and down the same hill, much less a rider who was relatively new to the sport. It seemed as if he'd achieved something no one else would ever dare attempt, such was the audacity and difficulty of the challenge.

George couldn't have known it at the time, but his Everest ride on Mt Donna Buang, and the article describing it, would become pivotal in the formation of what we now know as Everesting.

For Andy, the idea of following in George Mallory's tyre tracks ticked a lot of boxes: it took the annual Hells 500 challenge to a new level, riders could do it wherever they wanted, and it had a wow factor that would continue to build the group's reputation.

In late 2013, those who had expressed an interest in the next Hells epic, plus participants from previous rides, received an email from Andy teasing the upcoming challenge. Those who were interested – and who had completed a 'qualifying ride' with more than 5000 metres (16,400 feet) of climbing – were told about Everesting, asked to pick a hill, and sworn to secrecy about the challenge.

A few months later, on the last weekend in February 2014, 65 committed individuals ventured out to tackle their own Mt Everest.

One of them was Brendan Edwards. He'd chosen the popular climb of Perrins Creek Road in the Dandenong Ranges and everything had started well. But it didn't stay that way.

What began as a few too many bathroom breaks turned into something much more debilitating. After 13 hours spent riding up and down the scenic but challenging 2.5-kilometre (1.5-mile) ascent, Brendan returned to his car, ready to make plans for a dinner break. '[I] got off the bike and experienced a massive dizzy spell, blacked out and fell against the car,' he wrote. 'For a few seconds my body completely shut down and I had gone numb. I couldn't move for a couple of minutes, and I knew I was in trouble. Just a minute ago I felt so comfortable to finish the ride. Now I was right royally screwed.'

By this point in the ride, Brendan had drunk more than 6 litres (1.6 gallons) of liquid, but with several bathroom breaks an hour, dehydration had caught up to him. At dinner, he could barely stomach anything. And yet, at 6.30 pm, 14.5 hours after his ride began, he got back on his bike and continued. The bulk of the ride – up to 6000 metres of climbing – was done, but Brendan was in trouble and he knew it.

By 10 pm, 18 hours after starting, he took stock of his progress. He'd climbed a massive 7450 metres (24,440 feet) but still had 1400 metres (4600 feet) to go – another seven laps of a climb he'd been tackling since 4 am. He quickly realised that, at his current pace, he would be on the mountain for another 5 brutal hours. His Everesting attempt was over.

Roughly 30 kilometres (19 miles) to the north-east, on Myers Creek Road near the leafy tourist town of Healesville, Cyril Dixon was facing his own physical battle. He was

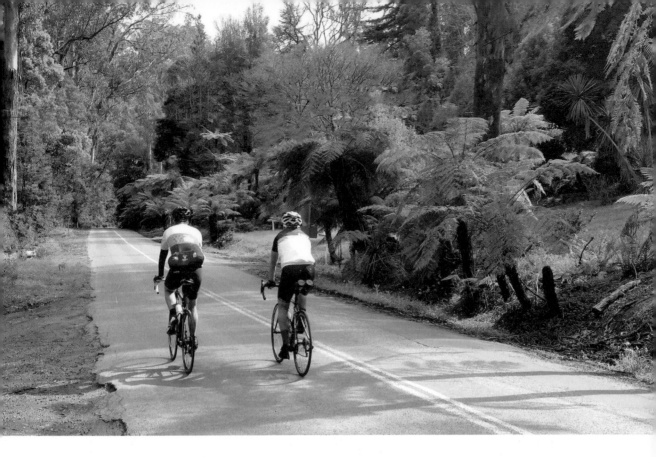

moving along nicely, and after 18.5 hours on the hill, and 17 of the 19 laps he'd need to Everest the 8.4-kilometre (5.2-mile) climb, he'd covered 289 kilometres (180 miles) and 8000 metres (26,250 feet) of climbing. But then, with just two laps to go, things took a turn for the worse.

'As we descended before starting the last set of two, I felt my heart trip into atrial fibrillation (AF),' Cyril wrote on Strava later. His heart had kicked itself into an irregular rhythm. 'I was in AF and there was nothing I could do about it. There is no riding up hills while I'm in AF – just impossible.' Cyril's ride was over, too.

Another 50 kilometres (31 miles) to the north-east, on the lower slopes of the Reefton Spur in the Yarra Valley, Paul Dalgarno was watching as his projected finishing time

ballooned out. He'd started his ride at 1.30 am to avoid finishing in the dark, but he hadn't factored in enough time for breaks. 'By 8 pm, I still had five laps to do, and less than an hour and a half in my front light's battery pack,' he wrote later. 'Descending the spur without lights would have been impossible … so I resolved to do the ascents with no front light, to save juice, then plug it back in again at the top for the descents.'

Thankfully, at around 10.30 pm, Paul's parents-in-law came to the rescue, shepherding him through a final, torturous lap. 'With my light about to go, they followed me down on the last Reefton descent and then followed me, driving their car and mine, at a snail's pace, lights blazing, while I did the final ascent.'

**Above**
Sunrise over
Mt Buller helped
Andy's spirits rise
during his first
Everesting.

When the sun started to rise on Saturday 1 March 2014, Andy was nearing the top of his third ascent of Mt Buller, his Everesting almost one third complete. He'd been riding for almost 6 hours, and climbed almost 3000 metres (9840 feet). Daylight delivered a much-needed boost – no longer was he riding in the lonely dark. Now he could actually see more than 2 metres ahead of him.

Breakfast at the top of lap 4 further improved his mood. Everything was going to plan. But as the kilometres ticked by, so Andy's fatigue increased. He'd been expecting things to get tough beyond 7000 metres (22,960 feet), but in the end the hardest part of the ride came sooner, on laps 5 and 6 of his nine-lap marathon.

The fatigue was near overwhelming, he was hurting in places he'd never hurt before during a ride – his toes and the arches of his feet – and there was still so much climbing to go.

It's little surprise the difficulty came when it did – Andy was fast approaching uncharted territory. He'd done some incredibly hard rides in his time, but never had he done so much climbing in one day. Not only that, but he'd recently become a father for the first time, heavily reducing the time he had available to train.

Just as Andy was at his lowest ebb, partway through lap 6, things took an unexpected turn for the better. As he mashed away on the pedals, a car with a bike on the roof pulled alongside him, its driver yelling to Andy through the passenger window. 'He was like, "How's the Everesting going?"' Andy recalls. 'And I just remember being like "Hang on, what? How do you know about this?"'

The man in the car, Chris Archer, had driven more than 3 hours up from Melbourne specially to ride alongside Andy, to support him through the tough final laps up the mountain. The pair barely knew each other.

Chris's presence would be a great boon. 'He probably saved me,' Andy recalls. 'Not probably – he definitely saved me. The next two laps were particularly dark and slow. And he just distracted me and [we] got to chat away, which was really lovely.' Chris would tell Andy stories to distract him from the pain, or just ride in silence, offering the simple support of another nearby rider – whatever the situation dictated. 'I think if I had to do those following two laps by myself, that would have been bad. I would've been a shell of man,' Andy tells me with a laugh.

With Chris by his side, Andy climbed Buller for a seventh time, the pair then enjoying a particularly fast descent as a reward. But then, as they neared the summit of Buller for the eighth and penultimate time at around 7 pm, the ride took another turn. 'We didn't need a [rain] radar – we could see a big wall of a storm,' Andy remembers.

The rain had started to fall before they'd descended out of the Mt Buller village. 'It just absolutely unleashed,' Andy recalls. 'The temperature dropped by 10 degrees. I started shaking and I was shivering uncontrollably. I was so buckled – everything hurt at this point; my fingertips hurt even. And so I'm trying to control [the bike] and it's getting dark … and there's thunder and lightning and [it's] pouring with rain …'

By the time Andy and Chris reached the bottom, the worst of the weather had passed. Better still, they would have more company for the final lap: Andy's wife, Tammy, and her sister Bree had decided to ride the final lap as well. For both it would be their first mountain climb in some time. For Tammy, it would be her first bike ride since giving birth to their daughter Mila 8 months earlier – far from an easy reintroduction to the sport.

For Andy though, all that remained in his Everesting was one final ascent to the Mt Buller village. Despite the fatigue and the all-encompassing pain, the proximity of the finish line and the company helped him through. 'I had the companionship of Tam and Bree as well as Chris and the idea that all I needed to do was to get to the top,' he says. 'All that fatigue and everything – I was sore, of course, but it's gone because all you have to do is get to the top one more time. The pace was obviously a little bit cruisier as well, which was really lovely. It was the coolest thing because I had done a lot of riding with Bree and Tam previously, but it was like a year before that Tam had stopped riding. So to get to ride with her again was super, super special.'

Andy and Chris left Tammy and Bree to their own devices a couple of kilometres from the top and pressed on through the village. Andy's GPS unit ticked over to show 8848 metres (29,029 feet) of elevation gain just a few hundred metres from the finish. He pulled over, took a quick photo of his device's screen, and pushed on.

At 10.40 pm, Andy unclipped from his pedals for the final time. He'd been on the mountain for 22 hours, 18.5 of which he'd spent riding up and down the same 17-kilometre (10.5-mile) stretch of road. He'd ridden a total of nine laps – one more than he'd been planning, he'd weathered unimaginable fatigue and an almighty storm, and all on just 2 hours of sleep, with far less training than he would have liked.

Looking back now, Andy recalls that the greatest feeling of satisfaction came in the days after the ride; actually finishing the ride was more of a relief than anything. 'I think it was a little bit of an anticlimax,' he says. 'I would have celebrated with Chris in that moment, and he was pumped for me and I was pretty pumped about it as well. There would've been some hugs with Mum and Dad. Then Bree and Tam got up there a few minutes later and celebrated as well. But as far as these things go, it's always quite anticlimactic. It's certainly no disappointment because it's done and you know you'll get a chance to reflect on it later. The next day when you wake up and you're sore in that really wonderful sort of sore way, that's when it's cool. You're like, "Holy shit, I just did that. That's cool."'

In climbing the height of Mt Everest by bike, Andy became one of the very first in the world to achieve the feat. As he ticked off lap after lap on Mt Buller that day, he had no idea how others attempting the same mission that weekend were faring, nor how the challenge he'd started would be perceived by others.

He certainly had no idea that he'd kicked off a sporting phenomenon that would sweep the globe in the years to come, attracting amateur and professional riders alike, and capturing the imagination of so many more. 🚲

**Right**
Irish rider
Ronan Mc Laughlin
has broken the
Everesting speed
record twice.

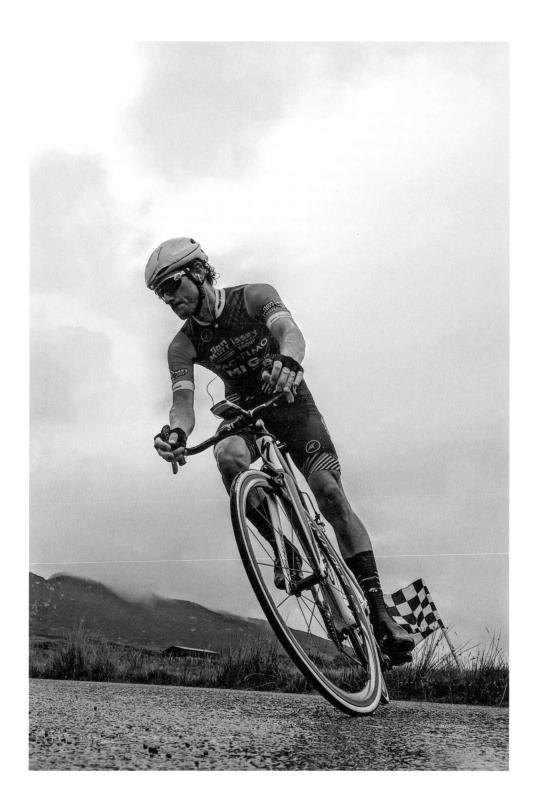

How it began

# PART ONE
# EVERESTING

**02**

# THE RISE

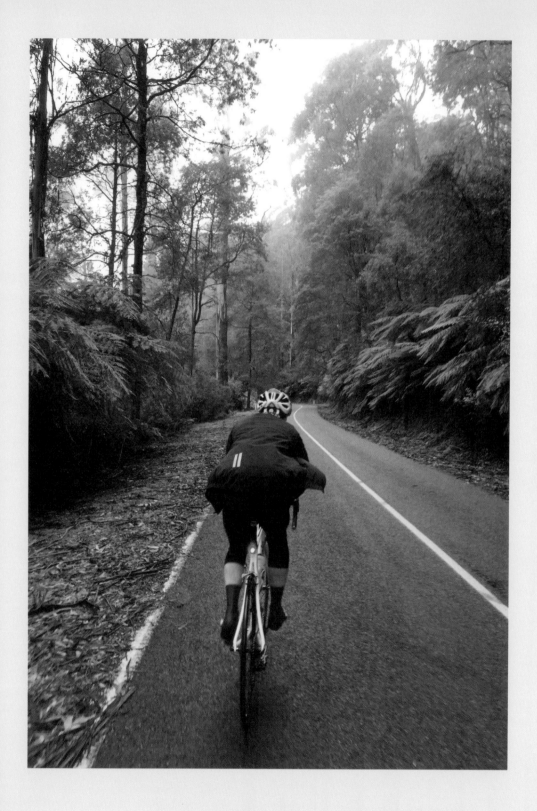

Everesting

**O**n the final weekend in February 2014, as 65 riders tackled the seemingly impossible challenge of completing an Everesting, many more of us watched on from afar. We watched as riders posted updates to social media, charting their progress, and we watched as dozens of riders completed the challenge, uploading their ride details to social fitness website Strava.

To those who'd been following along, Everesting was the talk of the town.

For many of those observers, a seed had been planted. George Mallory's incredible 'Mt Everest in a Day' had been a source of wonder and amazement when it hit the web in 2012. But when 33 riders completed an Everesting in one weekend alone, it was clear this challenge was very much possible.

It had a sense of the 4-minute mile about it. That feat, once seemingly out of reach, suddenly seemed achievable when British middle-distance runner Roger Bannister ran a mile in 3:59:04 on 6 May 1954 at the Iffley Road Track in Oxford, England. With that mark finally broken, it paved the way for others to do the same. So it was with Everesting – once dozens had completed the challenge, others started to wonder whether they could too.

As Andy tracked the growth of Everesting from early 2014, he noticed its spread in geographical clusters. When one person did an Everesting in a given area, others would invariably follow. He saw spikes in Australia, the UK, Japan, South Africa and the US, each community growing as more people caught the Everesting bug.

But as much as Everesting has grown in local clusters, the spread isn't constrained by geography. 'Every time someone completes an Everesting, all their Strava followers see it, comment on it and like it,' Andy explains. 'Of course, there's the Facebook, Instagram and Twitter post and they might write a blog or do a video. So there's this is incredible network effect – one person does it, and then maybe three people are interested and it just keeps going on and on like that.'

### JVS'S FIRST EVERESTING

George Mallory wasn't the only person to climb the height of Mt Everest before Everesting was launched. So too did John Van Seters, uncle of Everesting founder Andy van Bergen, in September 2013.

A few weeks before his Everesting, as part of a challenge on Strava, John had done a 16-hour, 350-kilometre (217-mile) ride on the popular '1 in 20' climb east of Melbourne, racking up 7200 metres (23,620 feet) of ascent. Naturally, he was keen to up the ante. Inspired by George's 1994 effort, John went and spent 20 hours riding up and down the 1 in 20, covering 430 kilometres (267 miles) and accumulating 9110 metres (29,888 feet) over 30 laps of Melbourne's most iconic climb.

While social media helped spread the word of Everesting among cyclists the world over, more traditional media coverage helped share it more broadly. Cycling media outlets were onto it early. Australian-based website CyclingTips, where Andy and I have both worked since 2013, covered Everesting in the days after the initial weekend back in 2014, with Andy offering a firsthand perspective on the enormity of the challenge. British website road.cc also offered early coverage, reporting on two cyclists who had Everested the Box Hill climb south of London in August 2014.

The mainstream media started to catch on, helping spread the word beyond enfranchised cyclists. Melbourne's *The Age* newspaper was the first to provide dedicated coverage of the challenge with a feature article in May 2014. 'Every generation needs one,' wrote reporter Campbell Mattinson. 'An ultimate, amateur, physical goal. A marathon, an ironman triathlon, a swim across the English Channel. Now comes "everesting", the test of an amateur cyclist's endurance.' Australia's national broadcaster, the ABC, picked up the scent in June with coverage of Adrian Ellul's Everesting north of Mackay, in north-east Queensland. Slowly but surely, international media outlets began to take notice.

In the US, NBC provided coverage in June 2015. VICE joined the party in the same month, and in August 2015, British paper *The Telegraph* entered the fray. The more people that read about Everesting, the more people decided to take it on themselves. Slowly but steadily, Everesting grew around the world.

Some 33 people had completed an Everesting in that weekend in February 2014; after a month that number had gone up to 50. Within 9 months, 280 rides could be found in the official Everesting Hall of Fame, and by March 2015, that number had surged to more than 400.

And then indoor cycling helped take Everesting to another level again.

In September 2014 a fledgling tech company called Zwift burst onto the cycling scene, attracting coverage from the sport's biggest media outlets. The company's multiplayer online cycling app would prove transformative for the indoor cycling market and for cycling as a whole.

For most riders, training indoors on a stationary trainer was a laborious and mind-numbing activity – one reserved for only the wettest and coldest days. Zwift promised to change that. By riding their bikes on an indoor trainer connected to a computer, tablet or mobile, cyclists could ride virtually in the Zwift universe with others from around the world. The rider's real-world exertions were converted to in-game progress for their virtual avatar.

From the outset, the game's virtual world, Watopia, offered a range of route options, from pan-flat waterside jaunts to hillier routes with climbing for those who wanted it. A rider's 'smart trainer' would represent in-game gradients with a change of resistance – as their avatar started climbing a hill, it would get harder to pedal in real life.

### THE RULES OF EVERESTING

- An Everesting involves climbing the height of Mt Everest – 8848.86 metres (29,032 feet).
- The effort must be completed by doing 'repeats' of the same hill.
- The athlete must descend the way they climbed (unless it's unsafe or illegal to do so, such as in the case of a one-way road or path).
- The effort must be completed in one activity – rests are allowed, but sleep is not.
- The effort must be uploaded to Strava for official verification.

In early 2015 Zwift introduced a simple feature that would prove crucial in the growth of Everesting – the ability to do an in-game U-turn, sending the rider's avatar back the way it came.

Frank Garcia, an intrepid rider from Arizona, USA, soon contacted Andy about the U-turn function. The ability to turn around, he explained, meant it was now possible to ride a virtual Everesting. An individual could simply ride up a given hill in Watopia, hit the U-turn button at the top, descend, then do another U-turn at the bottom and ride back up. Repeat the process enough times and a rider could reach the virtual height of Everest.

Andy admits he was resistant to the idea to begin with, saying it 'didn't feel like it was quite in line' with the difficulty of a 'real',

## RGT ENTERS THE FRAY

In November 2020, Hells 500 added a second online training platform to its list of approved apps for vEveresting. A vEveresting can now be completed via Zwift or RGT Cycling, another 'virtual reality cycling simulator'.

outdoor Everesting. But after giving it some thought, he soon came around to the idea. 'I thought if I don't do this, then Zwift is gonna do it or some other group is gonna do this and organise it and it's going to kind of take away from what Everesting is,' he tells me. 'If it was gonna happen, I wanted to make sure we had some ownership over it as well.

**Right**
Thousands have now completed a vEveresting via the Zwift platform.

## EVERESTING VS vEVERESTING: WHICH IS EASIER?

It's one of the most frequently asked questions in the Official Everesting Discussion Group on Facebook. The consensus, from those who've tackled both, is that a vEveresting is easier, for several reasons. 'It's not easy, but it's definitely easier,' wrote Ross Fripp in the Facebook group. 'You can totally dismount on the descents, you have a toilet nearby, you don't need to worry about the wind or temperatures. You don't have to worry about traffic, turning around is simply the press of a button, you don't need to unclip or, in my case, worry about a roundabout or traffic lights! You only need to look at the average times of virtual ones to see they generally take hours less time. Not taking anything away from a virtual … But no way is it as hard as an outdoors one.'

Some suggest that a vEveresting doesn't quite feel the same either. 'I've just completed a vEveresting, and I'm not going to lie to myself: I don't feel like I've done a real Everesting,' wrote Renzo Corsini Pino in the same Facebook group. 'Same here!' replied Mirko Schmidt. 'Having a 10-minute break sitting down in a bathrobe every descent [doesn't feel] that epic.'

What does Everesting founder Andy say? 'I've done four and a half of them now,' he says of vEverestings. 'I can tell you they stack up. I've done easier outdoor Everestings. I don't care what anyone else says. They're tough. Really tough. To compare them is a bit unfair because they're just such different beasts.'

So if that was the case, I wanted to make sure it was on par with an actual Everesting.'

Andy reached out to cyclist/software engineer/IT consultant/smart trainer guru Shane Miller to help devise a set of rules that would govern virtual Everesting, or vEveresting. To be accepted into the Hall of Fame, a vEveresting would have to be done on an electronically controlled 'smart trainer' and on Zwift, the gradient would have to be set to 100 per cent replication of real-world gradient (to make climbs feel as hard as in real life), and the rider's weight had to be accurate – under-reporting would make their avatar climb faster for a given effort.

With the rules locked in and vEveresting officially supported by Hells 500, Frank Garcia was free to go out and ride the first vEveresting. On 13 June 2015 he rode 314 laps of a climb on Zwift called the Watopia Wall – a segment 400 metres (1312 feet) long, with 25 metres (82 feet) of elevation gain per lap. He rode it in 2-hour segments, taking 40-minute breaks in between, including ice baths of 15 minutes. In just under 24 hours, Frank spent more than 17 hours on the bike, completing 264 virtual kilometres (164 miles) with 9051 metres (29,700 feet) of virtual climbing.

'I'm not sure it was the smartest thing I've ever done,' he told the Gizmodo website a couple days later. 'The neat thing about doing this in the virtual world, probably what allowed me to finish, was that I got [hundreds] of people from all over the world – there were flags I didn't even recognise – who would come ride with me for portions of it. That made me keep going.'

With his groundbreaking ride, Frank helped kickstart an exciting new chapter for the phenomenon. Thousands have since following in his virtual tyre tracks.

In the years since Everesting's launch, the phenomenon has grown steadily, with word spreading like ripples on a pond. Cyclists who had ridden the height of Everest before Everesting existed were retroactively added to the Hall of Fame, such as Norwegian Martin Hoff who, back in September 2012, rode 27 laps of the climb up Tryvannshøyden just north-west of Oslo, notching up more than 10,000 metres (32,800 feet) of climbing. By January 2016, the number of successful Everestings in the Hall of Fame had passed 800. And really, that was just the start.

In 2017, Everesting became further ingrained in the cycling consciousness when former professional racer Jens Voigt threw his helmet in the ring. In snowy conditions, the 17-time Tour de France rider climbed the height of Everest on the Teufelsberg ('Devil's Mountain') in west Berlin in a ride that took more than 27 hours.

While Voigt's ride won't be found in the Everesting Hall of Fame – he had a sleep partway through the effort, which is forbidden by Everesting rules – he was the first professional to tackle the challenge. In doing so, he helped accelerate awareness of and interest in the challenge.

By December 2017, the Hall of Fame featured more than 2200 completed Everestings from riders in more than 70 countries. By August 2018, that number was up to 2700, with riders from 80 countries. By May 2019, 3500 Everestings had been completed. A few months later, during the 2019 Tour de France, Everesting was elevated to another level again.

Belgian professional rider Thomas De Gendt is famed and adored by many for his aggressive racing style and formidable strength. Throughout the 2019 Tour de France, De Gendt wrote a column for Belgian newspaper *Het Nieuwsblad*, providing an inside perspective of the world's biggest race. In one column, De Gendt mentioned that during the race, he and other pros in the

Tour peloton had been discussing Everesting. Among those other riders was Australia's great hope for overall victory at the Tour, Richie Porte.

Back in Australia, Andy received a Google Alert notifying him that the word 'Everesting' had been used in De Gendt's article. He got a copy of the article and asked his mum – a native Dutch speaker – to translate it for him. 'Mum read it to me on the phone. Basically Thomas De Gendt was talking about Everesting in such a casual way – he never explained what the concept was; it was assumed the audience knew what Everesting was, which was really cool,' Andy tells me. 'And then he was like, "I was at the front of the peloton and I was chatting to Richie [Porte] about his upcoming Everesting

**Left**
Richie Porte
(right) during his
Everesting with
Cam Wurf in 2019.
The pair were
joined for part of
the ride by fellow
pro (and rival) Jakob
Fuglsang (left).

because he's planning on doing one once the Tour is over and that was really interesting to me. So I was trying to get some info from him because I'd been talking about doing it …" It was just so mind-blowing.'

Sure enough, on 3 August 2019, 6 days after finishing 11th in the Tour de France, Richie and fellow Tasmanian pro athlete Cameron Wurf rode an Everesting on the Col de la Madone. Situated just near Richie's European base of Monaco, the 12-kilometre (7.5-mile) Madone is famous among cyclists as a testing ground. Richie and Cam had done long rides together in the past; on Richie's 29th birthday in 2014, the pair rode 400 kilometres (250 miles) in a day around north-east Tasmania. Five years later, on Cam's 36th birthday, the pair rode nearly 11 laps of the Madone, spending roughly 14.5 hours to ride 271 kilometres (168 miles).

Andy sees that ride as an inflection point for Everesting, a point at which the phenomenon's growth really started to accelerate. 'Nothing just exists overnight – it needs groundswell,' he says. 'Every year I feel that more and more people know about it. It's probably Richie Porte and Cam Wurf's Everesting where it felt like, "OK, this is starting to get known now."'

Sure enough, a look at Google Trends, which maps the volume of Google search traffic for a given term, shows a significant spike for the word 'Everesting' around the time of Richie and Cam's ride. But that was nothing compared to the interest that would follow.

In March 2020 the world went into lockdown as coronavirus swept the globe. Cyclists in some places, including many Europe-based professionals, weren't able to ride outside at all, and instead relied on indoor riding for training. Professional racing shut down entirely in March, leaving the world's best racers without any goals for the foreseeable future. As the pandemic intensified, indoor training boomed like never before. Zwift broke its own records for the number of concurrent users, other indoor training platforms experienced similar growth, and smart trainers were sold out wherever you looked.

With the boom in indoor cycling came an explosion in the number of vEverestings. For many people, events they'd been training for had suddenly been cancelled. They needed another challenge closer to home to fill the void.

Andy decided to give would-be vEveresters a bit of a nudge. On 10 April, Hells 500 threw what it called a 'World Lycra Party', encouraging riders around the world to complete a vEveresting on Zwift at the same time. For many, it was all the encouragement they needed – more than 210 people successfully completed a vEveresting in the one weekend. It had taken more than 6 months to get that many Everesting attempts in the Hall of Fame in the early days.

Around the same time, more pros started taking on the challenge. With racing suspended and coaches not worried about how a 10-plus-hour ride would affect training and racing form, tackling an Everesting was a possibility.

On 2 May, Manx professional Mark Cavendish, almost certainly the greatest sprinter the sport has ever seen, completed a vEveresting with fellow Briton Luke Rowe. A little over a week later, retired American pro road racer turned YouTuber Phil Gaimon attempted to set a record for the fastest-known Everesting. He rode 60 laps of the steep Mountaingate Drive in Los Angeles, California, completing his Everesting in 7:52:12, a new world record by roughly 20 minutes. Phil's ride attracted international attention and kickstarted an arms race for the world's fastest Everesting.

Just 4 days after Phil's record, US cross-country mountain-bike champion Keegan

Swenson knocked 12 minutes off the record, spending 7:40:05 riding repeats of Pine Canyon Road in Midway, Utah. 'The last month or so, I was thinking I should do [an Everesting] because I didn't have any racing or anything to focus on,' Keegan told The Pro's Closet website. 'I didn't train specifically for it, but it was something to focus on for a week. In a way, it was like a race.'

A little over a month later, the record fell again. Or at least it seemed to.

On 13 June, Australian professional road and ultra-endurance racer Lachlan Morton rode 42 laps of the backside of Rist Canyon near Fort Collins, Colorado. Ridden at an altitude of 2400 metres (7870 feet) above sea level, where the air is noticeably thinner, Lachlan's time of 7:32:54 – seemingly a new record by around 7 minutes – was undeniably impressive. But then things got messy.

Some sleuthing from *Canadian Cycling Magazine* suggested Lachlan had ridden less than the requisite 8848 metres (29,029 feet) due to erroneous elevation data on the climb's Strava segment (which he had used to determine the number of laps). Sure enough, a few days after Lachlan's ride, after consulting independent topographical data, Hells 500 confirmed that the Australian hadn't accumulated enough elevation and that Keegan Swenson would hold on to the record.

Lachlan didn't waste any time in trying again – a week later, on 20 June, he went back to Rist Canyon and attempted a shorter, steeper subsection of the same climb. He reached the height of Everest after 7:29:57, his effort was verified by Hells 500, and he became the new record holder by roughly 11 minutes. But then, scarcely a week later, Everesting attracted its biggest name yet: Alberto Contador.

The winner of seven Grand Tours – two Tours de France, two Giri d'Italia and three Vueltas a España – Alberto retired from pro racing at the end of 2017. He clearly hadn't lost too much strength in his retirement – on 6 July, on the steep climb of Silla del Rey in the Castile and León region of north-west Spain, he took another 2.5 minutes off Lachlan's time.

Phil Gaimon's record in May had been the first new mark in more than 3 years. But in the space of 2 months it had fallen four times. And with the new mark set by Alberto Contador, one of greatest climbers the sport has ever seen, it seemed as if the record had been put permanently out of reach. Not so.

Less than a month after Alberto's record ride, Irish semi-professional racer Ronan Mc Laughlin went out and tackled the new mark. He'd previously completed an Everesting in 8 hours and 13 minutes – the fifth-fastest on record at the time. But on 30 July, on a shorter and steeper version of the same climb – Mamore Gap in County Donegal in the Republic of Ireland – he went significantly faster. Ronan's time of 7:04:41 took more than 20 minutes off Alberto Contador's seemingly infallible mark.

To get there he'd made some rather significant weight-saving modifications to his bike: he'd removed all but three gears at the back and his big chainring at the front, he'd ridden without a water bottle (his helpers handed him water when required), and he even cut down his handlebars. 'I in no way consider myself on the same level as Contador,' Ronan told CyclingTips. 'I once heard [British track-racing legend] Chris Boardman say that when he was trying to break the Hour Record on Eddy Merckx rules, that everybody can be world class on their day and their discipline. That was sort of my goal here – to prove that no matter if you've won two Tours de France or not, if you apply yourself and use all the marginal gains or science or whatever you want to call it, and train right, then anybody can be world class … if only for one day.'

Two months later, Ronan's short reign was over. On 3 October, Sean Gardner, a 26-year-old American semi-pro racer and coach, became the first to complete an outdoor Everesting in under 7 hours. His time of 6:59:38, set on the punishingly steep grades of Tanners Ridge Road in Virginia, USA, was 5.5 minutes faster than Ronan's. Sean hadn't gone to the same lengths to reduce the weight of his bike – the closest he got was removing one of the bottle cages on his bike.

Sean's record lasted a little under 6 months. In March 2021, at the end of the Irish winter Ronan returned to Mamore Gap with an even lighter bike and, with a little assistance from a handy tailwind, slashed

nearly 20 minutes off Sean's record. The ride nearly ended in disaster – Ronan had a rear-tyre blowout while descending with 10 laps to go but somehow managed to avoid crashing. After a couple of laps on a spare bike (while a mechanic changed wheels), Ronan was back on his main bike and riding to a staggering time of 6:40:54.

Everesting

Left
Alberto Contador
was easily the
highest-name
rider to attempt
an Everesting. His
record time has
since been eclipsed.

It wasn't just the world's fastest men tackling the record from mid-2020 either – the women's record fell several times in short succession as well.

The charge began with American professional Katie Hall who, on 23 May, took a monumental 2.5 hours off the previous record. One of the best climbers in the world, in what was her final season as a professional, Katie posted a time of 10:01:42 on the Bonny Doon climb near Santa Cruz in California. Her record would stand for just over a week.

On 31 May, American domestic racer Lauren De Crescenzo became the first woman to break the 10-hour mark. Her 9:57:29 up Hogpen Gap in Georgia, USA, wasn't just a record – it was a fundraising platform for the Craig Hospital in Denver, Colorado, and Grady Hospital in Atlanta, Georgia. Lauren had spent 5 weeks in Craig Hospital in 2016 after crashing at the San Dimas Stage Race, suffering a traumatic brain injury.

Lauren didn't have long to bask in the glory of her record ride. Less than a week later, on 4 June, Englishwoman Hannah Rhodes Everested Kirkstone Pass in England's Lake District, obliterating Lauren's record by nearly 50 minutes with a time of 9:08:31. That mark stood for a little over a month before falling to one of the biggest names to complete an Everesting.

On 8 July, former world time trial champion Emma Pooley set out to ride an Everesting to test her limits. Regarded as one of the best climbers of her generation, the 37-year-old Brit didn't have specific ambitions of setting the record, having spent less than a week preparing for the ride. On the leg-sappingly steep Haggenegg climb near the town of Schwyz in central Switzerland, Emma suffered in the extreme heat – she'd brought far less water than she ultimately needed. And yet, she was able to battle through to reach the height of Everest in 8:53:36, breaking the record by 15 minutes and become the first woman to go under 9 hours.

While world-class riders such as Emma Pooley and Alberto Contador were setting new records in 2020, a bunch of other professionals were trying their hand at Everesting as well. In May, Canadian professional James Piccoli spent 17 hours climbing 12,605 metres (41,355 feet) on the Mont Royal climb in Montreal to raise money for healthcare workers during the COVID-19 pandemic. Later that month, German pro Emanuel Buchmann, who finished fourth at the 2019 Tour de France, climbed his way to the height of Everest near Oetz, Austria, and might have set a new Everesting record had he not ridden two different climbs as part of his effort (Everesting rules dictate that only one climb must be used).

US road champion Ruth Winder Everested Flagstaff Mountain in Boulder, Colorado. And later in 2020, Australian pro Nathan Earle rode a very swift 7:10:10 on The Lea near Kingston, Tasmania – then the third-fastest Everesting on record.

The combination of interest from professional racers, plus the COVID-inspired surge in vEveresting, saw Everesting boom in 2020. In May 2020 alone, more than 1100 new Everestings and vEverestings were added to the Hall of Fame. It had taken 3 years to reach the same number in the early days. By the end of May, the number of total Everestings had roughly doubled in the space of a year – from about 3500 in May 2019 to more than 7000 by early June 2020.

There's no doubt Everesting has grown far beyond even the most optimistic projections and continues to grow steadily. More than 16,000 Everestings of different kinds have been completed all around the world. The Hall of Fame on the official Everesting website holds the most up-to-date stats.

As Andy and I chat about the history and growth of the phenomenon, I find myself wondering: did he have any inkling of Everesting's potential?

'Yeah, absolutely – I thought, "one day we will hit 100 riders,"' he laughs.

Back then Colin Bell, a friend and mentor of Andy's, had more of a sense of Everesting's possibilities – not that Andy believed him. 'He said, "Andy, I'm telling you, you'll get 500 people one day,"' Andy recalls. 'This is when we were less than 100. I'd known what had gone into this [completing an Everesting]. I wanted people to do it, but I just didn't expect it to catch on. The idea of 500 people doing it one day was laughable. He may as well have said a million – it was just such a stupid number.'

Since its inception, Everesting has gone from a seemingly impossible challenge attempted by a select few, to a challenge known around the cycling world, and even outside it. A grassroots event has become a global phenomenon, tackled by amateurs and pros alike, building a community that continues to grow at an impressive rate. 🚲

**Right**
Emma Pooley
on her way to the
women's Everesting
record.

The rise

# PART ONE
# EVERESTING

03

# THE REASONS

'll be the first to admit that I never expected Everesting to grow the way it has. When Andy first unveiled the concept to the world I thought it would go the way of his previous epics – a bunch of riders would do it, impressing those around them, and then the ride would fade into memory for those involved.

But, somehow, Everesting has persisted and the number of successful Everestings only continues to grow.

But why? What is the appeal of Everesting? Why would anyone put themselves through such hardship for what is – let's be honest – a rather arbitrary challenge? Why spend most of a whole day (if not more) in great discomfort and pain, riding lap after tedious lap of the same stretch of road, for no prize beyond seeing your name on an internet leaderboard?

As it turns out, there are many reasons.

In late 1992, when George Mallory started his 2-year climbing project on Mt Donna Buang, he didn't do it to impress others. Sure,

**Left**
Some riders
are prepared
to reach Everest,
rain or shine.

he would soon be climbing higher in a day than most cyclists would ever think possible, but he wasn't looking for adulation – rather, he was trying to satiate a curiosity. He wanted to see where his limits were; how many laps of the beautiful but tough climb he could manage. Ultimately, he wanted to know whether he was capable of climbing the height of Mt Everest by bike.

Two decades later, when Andy created Everesting, he wasn't just building on George's idea of climbing the height of Mt Everest. He was also channelling the same philosophy that had guided George's journey in the early '90s.

For years Andy had been designing rides for his Hells 500 crew that would push and prod at a rider's physical and psychological limits. Everesting was a logical extension of that goal. After all, what better way to test one's limits than with a challenge that most dismiss as near impossible?

Oliver Bridgewood is a presenter at the Global Cycling Network, the biggest cycling channel on YouTube. In a video of his 2018 Everesting attempt on the Passo di Valparola in northern Italy, Oliver offered a succinct summary of how many feel about tackling an Everesting. 'This challenge scares me,' he said before starting his ride. 'It's going to be further than I've ever ridden before, with more elevation than I've ever ridden before, and, to be quite honest, I'm not sure that I can do it. But I kind of like that because … nothing worth achieving is easy.'

Oliver is far from alone. In the past year I've spoken to many people who have completed an Everesting, and read, watched and listened to stories from a great many more. The vast majority found themselves tackling an Everesting for similar reasons to Oliver: to see what they were capable of, to test personal boundaries, and to answer a question that had been percolating in their head for some time: 'Could I do that?'

**The reasons**

Facing such challenges is indeed intimidating and scary. But for those inclined to take the plunge, that challenge is also strangely appealing. There's something exciting about testing the limits of your own ability, and learning more about yourself along the way.

That was certainly Idai Makaya's approach ahead of his Everesting in Wales in 2017. 'As an ultra-endurance athlete, that prospect of being stretched to my limit is actually a great one to contemplate!' he wrote. 'Only in the darkness can we really see the stars … It is only when operating at our true limits that we can begin to learn new things about ourselves.' (Fun fact: Idai holds the world record for the most chin-ups completed in 24 hours – 5340, a feat he achieved in September 2020.)

In completing an Everesting, many riders find themselves drawing on reserves of strength – physical and mental – they didn't know they had, as Australian Jane Willmott notes. 'I like to take on these challenges to remind myself that I am capable and that I am strong so I can look back at these achievements and use them to propel me forward in other things that I want to do in my life,' she said after she had completed her first Everesting.

But not everyone's motivation is to push themselves to extremes in the name of self-discovery. For some people it's about doing away with life's challenges and distractions for a time, and simply enjoying a nice long bike ride on a beautiful stretch of road.

That's what Dr Oliver Hambidge took from Sa Calobra, a legendary, serpentine climb on the island of Majorca, when he Everested it in May 2016. 'As I rolled down to the fishing port at the base of this utterly unique dead-end road, the anxiety I had felt rapidly evolved to an inner peace as I realised how utterly content I was with being so very alone on my bike,' he tells me.

Oliver found himself focusing on the simple act of climbing, and little else. He spent most of the 16-hour ride in complete silence – just him, his bike and an incredible, winding ribbon of tarmac. 'My iPod didn't even make it out of the car – I wanted to soak up every last sensation of being there and felt as though listening to music would somehow contaminate the purity of the climb. Every time I got to the top I rejoiced at the prospect of heading back down, and every time I got to the bottom I rejoiced at the prospect of heading back up.'

Rebecca Stone found something similar during her Everesting on the muddy dirt of Centre Road west of Brisbane, Australia. For her, the simple repetition of climbing the same hill over and over was strangely soothing. 'I had expected to feel physically and emotionally exhausted during and after this ride; I did not expect to feel as if I had [pressed] some sort of a reset button,' she wrote. 'The quietness of the track, especially at night, with no traffic noise, nobody to talk to for a large part of the ride, nothing to do but to keep pedalling, nothing to worry about, sent me into a meditative state.'

## WANTING TO BELONG

For some people, joining the Everesting community is motivation enough to attempt such a ride. Ever since 2013, Hells 500 has had a range of cycling clothing available exclusively to those who have completed a Hells 500 epic. Since early 2014, a successful Everesting has been required to purchase the Everesting kit.

For many, wearing Everesting kit has become a badge of honour. For those in the know, the de facto uniform of the Everesting collective is a clear sign of a rider's tenacity and strength.

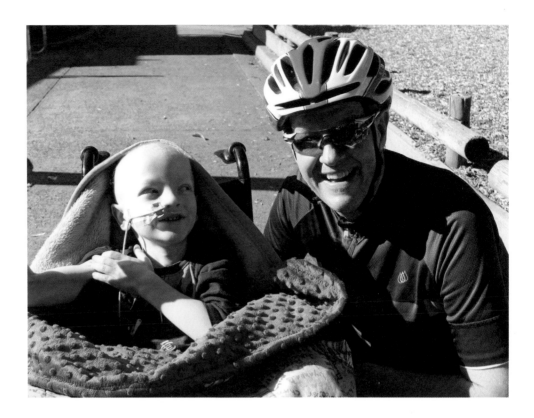

A quick search of the major fundraising websites shows that, for many riders, Everesting is a great platform for altruistic endeavours. It's a way to raise awareness and funding for a cause that's important to them, turning a significant personal challenge into something that can benefit others.

In 2015 Leigh Johansen was the principal of Bimbadeen Heights Primary School in outer-eastern Melbourne. He enjoyed his job, and took great satisfaction and joy from helping children learn and grow. But the job also brought its share of heartbreak.

'A little six-year-old boy, Jake, in his second year of school, was grumpy and complaining of a sore leg,' Leigh tells me. 'One visit to the doctor was enough to cause alarm bells to ring and within days Jake was in the Royal Children's Hospital being treated for serious bone cancer.'

The prognosis wasn't good. The school community was left reeling, struggling to work out how best to support Jake and his family. Leigh, too, was keen to do his part. He'd ridden his first Everesting a few months earlier and spotted an opportunity. 'Perhaps doing another Everest for Jake could be a way to show him that the school community was behind him,' Leigh explains. 'And at the same time we could raise some money to help his family with their increased expenses as both Mum and Dad had to give up work to become Jake's full-time carers.'

Leigh set up a GoFundMe page, recruited some fellow cyclists, and put the word out to the school community. Then, at 4.30 pm on 22 May 2015, he set out to ride the height of Everest on the 500-metre (1640-foot) climb of Bimbadeen Drive, just around the corner from the school.

'We had families or staff members beside the roundabout at the top of the hill or alongside Bimbadeen Drive right up until midnight,' Leigh recalls. 'From midnight to 2 am we had Ray Legione, Bimbadeen's art teacher, walking laps of the roundabout just to keep us company.' At 6.30 am the first supporters of the day came out – two parents and two kids, the latter in dressing gowns and slippers, yelling 'Go Mr Jo!' as Leigh rode past.

Later that day they got to see the boy they were riding for. 'Early on Saturday afternoon Jake's dad, Dave, brought him down to see us,' Leigh says. 'It was just the motivation and encouragement that we needed, as energy levels were low as we neared the 7000-metre (22,965-foot) mark. This little guy with a tube in his nose, no hair but a big smile, and a wave for us every time we came past for over an hour alongside his dad, gave us great perspective of the challenges we faced. There was no way we were not going to finish this despite our lap times slowing down considerably.'

Through his efforts Leigh and his fellow riders helped raise more than AU$8000 for Jake and his family. Sadly, this particular story doesn't have a happy ending.

'Nothing good can ever come from cancer and sadly Jake passed away in January 2016,' Leigh says. 'I know that his family were very grateful and were uplifted by the support of the school community throughout 2015. By the same token, the school community were inspired by the courage and example of tenacity and persistence shown by Jake's family throughout this most tragic of family stories. It was a privilege to be a small part of their journey.'

As you might expect, cancer research has been the focus for many who have raised funds through their Everesting – like former professional racer Jens Voigt, who climbed the height of Everest in west Berlin in 2017. The German was raising money for Tour de Cure, a charity that supports cancer research, prevention projects and support.

Of course, Everestings have been ridden to help combat other diseases too, from juvenile diabetes to lesser-known afflictions such as Rett syndrome, scleroderma and Prader-Willi syndrome.

Medical institutions, too, have been the focal point for many fundraising campaigns, particularly during 2020 when the COVID-19 pandemic put hospitals under significant strain. In one weekend alone, US$130,000 was raised to help battle the disease, thanks to ultra-endurance multi-sport athlete Rebecca Rusch and her 'Giddy Up Challenge' tackled by athletes around the world.

In an encouraging sign of the times, fundraising for mental-health support has been the inspiration for several Everesting attempts, too. Like it was for Canadian Larry Optis.

Larry suffered from depression as a teenager and, by his reckoning, cycling probably saved his life. He wanted to raise money to support other young people who find themselves struggling like he did. 'As a husband and father, I feel that it is our duty and responsibility, to equip our children with the tools necessary to thrive in life,' he posted on Facebook in 2017. 'We have to be the difference-makers. That's why I'm taking on the Everesting Challenge as a way to not only challenge myself, but unite my community in a fight against mental health stigma.'

In May 2017 Larry rode an Everesting on Heritage Hill west of Toronto in support of Jack.org, a youth mental-health organisation. His ride, which took 27 hours and was made even more difficult by wind and rain, raised CA$12,100. It also prompted Jack.org to up the ante.

Below
Larry Optis
raised funds for
mental-health group
Jack.org with his
Everesting.

Six months after Larry's ride, the organisation put on a group Everesting challenge, helping to raise additional funds for youth mental-health support. In wet and cold conditions again, 46 riders came out to tackle the height of Everest in teams. The organisation raised more than CA$50,000 that day.

Mental health came into even sharper focus in 2020 as coronavirus took hold. It was little surprise to see a flurry of mental-health-related Everesting fundraisers pop up throughout 2020, including one from Australian Jeff Davis, who set out to raise funds for the Black Dog Institute, 'a not-for-profit facility for diagnosis, treatment and prevention of mood disorders such as depression, anxiety and bipolar disorder.'

'Some work colleagues and I wanted to do a fundraiser for something COVID-specific, and we felt that mental health would be something that became increasingly in focus during this time,' Jeff tells me. 'With the support of our employer (Macquarie) we raised over AU$56,000 for the Black Dog Institute. Five of our crew rode to base camp [a Half Everesting] and two of us ascended to the top of Everest.'

While 2020 will be remembered as the year of coronavirus, it was a year of so much more, too. In May, the death of African-American man George Floyd at the hands of Minneapolis police brought to a head tensions between Black Americans and local law enforcement, reigniting the Black Lives Matter campaign. The movement

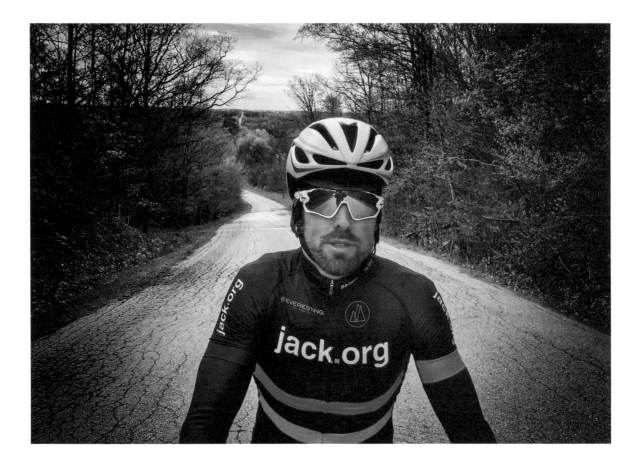

against racially motivated violence gained traction around the world, sparking protests and attracting widespread support. The Everesting community did its bit, too.

'I've been doing a lot of reflecting as of late, as many of us have,' wrote New Yorker Jason Black on his GoFundMe page. 'I've come to realize that I have somehow gotten by on the perception (note my choice of words here) that I have done little to contribute to racial inequality and injustice.' Jason felt like his prior inaction was part of the problem – that he wasn't 'working to ensure the same rights, protections, opportunities, and countless other privileges I've thoughtlessly enjoyed as a White man to everyone else in this country'. He vowed to take action through his job as a venture capitalist, but also wanted to use his 'masochistic love of cycling to help advance racial equality in America'.

Jason's goal: to raise one dollar for every foot in the height of his Everesting: US$29,029. He committed to matching every dollar raised up to US$2902.90. In the end he raised a monumental US$35,000 for the National Association for the Advancement of Colored People with his Everesting on New York's Bear Mountain, taking him 16 hours and 20 minutes.

Everesting attempts have been coupled with other social justice causes, too. When Phil Gaimon broke the Everesting world record in May 2020, his ride was about more than setting a new high-water mark – it was about ensuring children in need were able to eat. 'I work with Chefs Cycle for No Kid Hungry and every summer I try to pick a campaign around that,' Phil said in an interview on the Monster Energy website. He was going to do a fundraiser at the Tour of California – USA's biggest professional road race – but when that raced was cancelled, he had to find another vehicle for his fundraising efforts. '[Everesting] has been a challenge that has been on my radar for a few years now,' he said. 'This now turned into something that I could do close to home that's extreme and will help the fundraiser.'

Through various fundraising projects since July 2019, including his Everesting, Phil has helped raise well over US$200,000 for No Kid Hungry – enough to purchase more than 2 million meals for children in need.

In South Africa, a group of female and non-binary cyclists took on an Everesting in a project they dubbed SHEveresting. The goal, according to the project's co-founder Renata Bossi, was 'to showcase the strength and fortitude of women cyclists, as well as raise funds for a worthy cause supporting women's cycling.'

In September 2020, with gale-force winds blowing, 11 riders set out to ride repeats of the Rotary Way climb in Hermanus, near the southern tip of Africa. Six women made it to the height of Everest, but not without considerable difficulty. One rider, Tyla Setzkorn, hit a rabbit at 70 km/h (43 mph) late in the challenge and crashed hard, losing a lot of skin and damaging her bike. Impressively, she went on to complete the challenge, albeit on another rider's bike.

All told, the initiative raised more than 40,000 rand (AU$3500). 'That money will now go to purchasing bicycles and safe cycling starter kits in order to get more women from historically disadvantaged areas on bikes,' Renata says.

In June 2020 three-time 24-hour mountain bike world champion Cory Wallace rode an Everesting in support of Nepal's Chiwong Monastery and the disadvantaged children it houses. The Canadian completed his effort on the rough 2.8-kilometre (1.7-mile) gravel climb to the monastery at nearly 3000 metres (9840 feet) above sea level.

His tough ride was made even tougher by a rainstorm that turned the steep track to mud, leading to 'a character-building

**Right**
Cory Wallace and
those he was riding
in support of.

final 4 hours through the Himalayan night'. But Cory never struggled for motivation. 'Thinking of some of the young monks up here who lost their parents and now depend on the monastery, the poor who are starving in Kathmandu during this [coronavirus] lockdown, or the up-and-coming Nepali racers that need more support to keep following their dreams and to become leaders in growing cycling in their country, it wasn't so hard to push through a little discomfort.'

Cory had gone into the ride hoping to raise US$1500. He ended up with more than US$6300.

The plight of the Nepalese was the motivation behind another Everesting fundraising drive – one of the largest in the challenge's history.

In the small hours of 25 April 2015, a magnitude 7.8 earthquake struck central Nepal, wreaking havoc in the surrounding region and in the national capital, Kathmandu. The quake triggered an avalanche on Mt Everest, killing at least 20 climbers – the deadliest day ever recorded on the mountain. A major aftershock on 12 May, at magnitude 7.3, served to compound the country's woes. The true scale of the disaster will never truly be known, but official records suggest nearly 9000 died, more than 20,000 were injured, and more than 3 million were left homeless.

In the weeks and months after the disaster, Hells 500 partnered with Strava and fundraising charity More than Sport to raise funds for those affected by the Nepal earthquakes. Riders were encouraged to donate to the fundraising drive, and to climb the height of Mt Everest throughout June.

Nearly 40,000 people completed the climbing challenge. Naturally, many took the opportunity to climb the height of Everest in one ride by completing an Everesting. In just one month, 160 Everestings were completed,

## RIDING FOR REPRESENTATION

For Colorado rider Tina Hart it wasn't a charitable cause that motivated her to ride an Everesting. It was a simple desire to see more women in the Everesting Hall of Fame. 'Of the 6050 folks who have done a regular Everest outside, less than 350 of them are women – less than 6 per cent,' she wrote on her blog after her August 2020 ride. 'So, while I was really happy to prove to myself I could do it ... I was equally excited to add another [woman] to the Hall of Fame.'

Tina wasn't the only one fighting for greater female representation. A few months later, a group called SheRace from Melbourne and regional Victoria launched the Women's Worldwide Everesting Weekend. Their motivation? 'Women are under-represented in the Hells 500 Hall of Fame – let's work towards turning around that trend!'

In early December, on the Ghin Ghin climb in central Victoria, 10 women completed an Everesting and another nine completed a Half Everesting. A handful of others joined the movement remotely, either outdoors or online.

increasing the number of Everestings in the Hall of Fame by a third.

All told, the Climb for Nepal initiative raised a total of US$80,000. Among those who raised funds: Frank Garcia, the first vEverester. Frank alone helped raise US$11,000.

'It will have a significant impact, not just on individuals, not just on families, but on entire villages,' said Andy of the money raised. 'We did that as a cycling community just by going and riding our bike up and down a hill and doing what we are passionate about. It can provide around 16,000 people with clean water, 3 months of food for nearly 90 people, emergency shelter for hundreds, and 3 months of emergency medical treatment for 8000 people.'

Not everyone who rides an Everesting for a cause does so to raise money. Some do it to draw people's attention to an issue they're passionate about. Like Ketil Wendelbo Aanensen did when he rode an Everesting in the UNESCO World Heritage site of Geiranger in south-west Norway, hoping to raise awareness about the plight of Norway's magnificent fjords. 'The last couple of years two mining companies have been given permission to dump vast amounts of waste in two fjords in Norway: Repparfjorden and Førdefjorden,' Ketil wrote in a blog post afterwards. 'This cannot stand. We need to stop the destruction of those fjords, issue a permanent and general ban on further waste dumping, and clean up after the crimes of previous times.'

In April 2015, in the US state of North Carolina, Alex Garcia rode an Everesting (and then some) to raise awareness about the high suicide rate of US military veterans. In 2013, the United States Department of Veteran Affairs had released data showing that, between 1999 to 2010, an average of roughly 22 veterans were dying by suicide every day – the equivalent of one every 65 minutes. To highlight this tragedy, Alex decided to ride 22 laps of the Highway 80 climb east of Asheville.

In a stirring YouTube video from his ride, Alex delivered a heartfelt message to any military vets who might have been watching. 'I know that watching a guy climb a mountain 22 times doesn't do anything,' he said at 2 am, in the pitch dark, gasping for breath every few words. 'It's nothing in comparison to the sacrifice that you've given to this country, the time away from family, going off to foreign lands, staring bullets right in the face. The reason why I'm doing this is because I hope that others will want to watch it just because of the challenge climbing this mountain may present.'

As a rousing music score played underneath, and snippets of military-service commercials flashed up on screen, Alex started speaking to a wider audience. 'If you see somebody in a uniform, you thank 'em. You see somebody with a hat that says that they served our country, take 'em out to lunch, hold the door open for them, or just say thank you. It's little things like that we can all do that'll make a tremendous difference.'

Alex completed his ride in 33 gruelling hours, covering 414 kilometres (257 miles) and climbing nearly 12,000 vertical metres (39,370 feet).

In dedicating his Everesting to military veterans, Alex had something powerful to draw on when things got tough. He wasn't just riding up and down a hill for his own sake – he had something much bigger spurring him on; something that would keep him going through hours of rain, unrelenting fatigue, and an overwhelming desire to stop.

And so it is with everyone who tackles an Everesting with a particular cause in mind. The knowledge that you can make the world a better place, in some small way, just by hurting yourself on a bike? That's a powerful motivator. 🚲

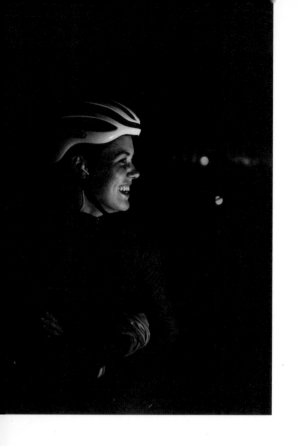

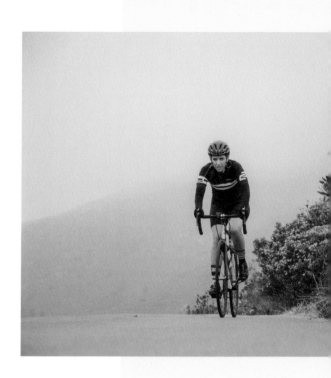

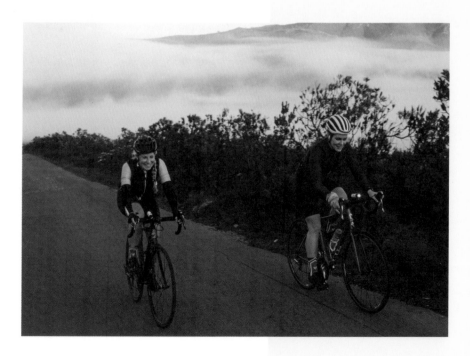

Everesting

# THE INTERNATIONELLES

Professional cycling, like so many sports, has a problem with equality. Professional men have more races and more media coverage, and earn considerably more money. Things are slowly starting to change but not quickly enough. Every year a group of amateur women rides the Tour de France route a day ahead of the professional men, to bring awareness to the fact there's no equivalent women's race, to campaign for such an event, and to show that women can, in fact, ride 3500 kilometres (2175 miles) over 3 weeks.

It started back in 2015 with an event called Donnons des Elles au Vélo J-1. In 2019, a team called InternationElles was created to participate in the project. As planned, they rode the full Tour route ahead of the race. They'd planned to do the same in 2020, but COVID-19 put paid to such plans. Undeterred, the group pivoted to what it called 'Plan B'.

From 29 August to 5 September 2020 the 10 riders from around the world took on a challenge in two parts. First: the team would ride the total distance of the Tour de France as a team relay on the virtual cycling platform RGT Cycling. Together, the InternationElles covered that distance in less than 100 hours, with riders taking turns, then passing the virtual baton to one another.

The second part of the challenge: an Everesting for each of the riders on the team. The five UK-based riders met up in Wales for their effort, with all five making it through. The five other riders, from the US, Australia and the Netherlands, did either a vEveresting or an outdoor Everesting close to home. Four of the five were successful – only one fell short, due to extreme temperatures and forest fires in Los Angeles.

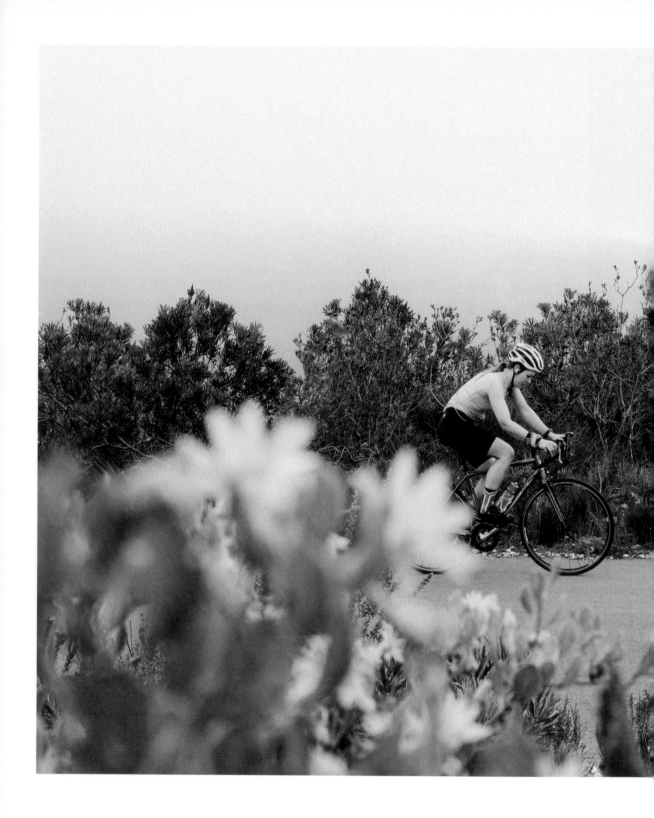

Everesting

The reasons

# PART TWO
# THE CHALLENGES

04

PHYSICAL

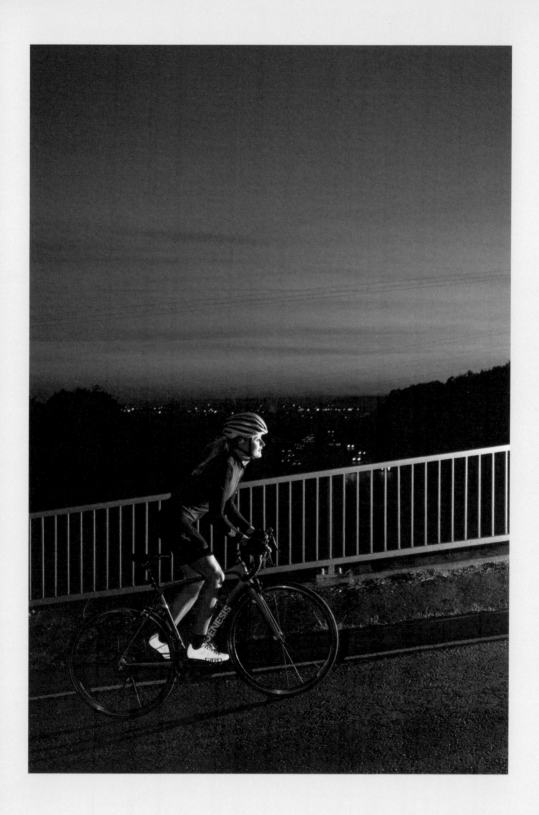

Everesting

**C**yclists don't come much tougher than Jens Voigt. In a professional racing career that spanned 17 seasons and 17 Tours de France, the German was admired for his aggressive racing style, and for his penchant for the sort of self-imposed suffering that bike racing demands.

In September 2014 Jens ended his long and successful career in fitting style – with a tilt at the Hour Record, widely regarded as one of cycling's toughest challenges. In the Velodrome Suisse in Grenchen, Switzerland, Jens set a new record of 51.1 kilometres (31.8 miles) in his 60 minutes of pain, kickstarting a flurry of renewed interest in the Hour Record.

A little over 2 years later Jens climbed the height of Mt Everest on the Teufelsberg climb in west Berlin, a 120-metre-high (394 feet) hill built from rubble after WWI. In snowy conditions, he rode nearly 100 laps of the 640-metre (2099-foot) climb, covering 400 kilometres (250 miles) in more than 27 hours on the mountain.

In reflecting on the challenge, Jens described it as 'one of the toughest things I have done in my life'. Coming from a rider so experienced in the art of suffering, that's saying something.

Other former professionals have been similarly challenged. Like Kiwi Greg Henderson, a pro racer for 12 seasons, who completed a vEveresting via Zwift in April 2020. 'I was not prepared for that kind of suffering,' Greg wrote later. Mark Cavendish, winner of 30 Tour de France stages, described his vEveresting as 'grim', adding that 'it got really ugly'.

Then there's Emma Pooley, former time trial world champion and winner of three stages at the toughest race on the professional women's road-cycling calendar: the Giro Rosa. In July 2020 Emma completed the fastest-known women's Everesting. 'The whole point was to challenge myself: find my limits, and push them,' the Englishwoman wrote. 'It felt more like my limits found me and punched me into a ditch.'

If Everesting is so difficult for some of the world's best cyclists, how hard is it for the average amateur rider? In short: incredibly hard.

Whenever a rider completes an Everesting and submits it to Hells 500 for inclusion in the official Hall of Fame, it's usually Andy who checks whether the ride is eligible. As he explains, most riders are left with little doubt about the difficulty of their effort. 'Anecdotally, I can tell you that three-quarters of the rides that are coming through for the first time, people are commenting "That was the hardest thing I've ever done" or "The stupidest thing I've ever done" or "I'm never doing that again."'

Why is Everesting so tough? What makes it the incredible physical feat that it is?

Simply put, to finish an Everesting is to complete a ride that's simply beyond the vast majority of cyclists, riding further and climbing higher than most would deem reasonable or even possible.

**Left**
British rider Alice Thomson held the record for the fastest women's Everesting for 2 years.

For most, it involves many months of dedicated training. 'You want to start by building an established [fitness] base,' Andy writes in the official guide to Everesting, available through the challenge's website. 'Once you feel you have a solid base generally, you can train for an Everesting in a 10- to 12-week period.' That's 10 to 12 weeks of long, hilly training rides for an already fit cyclist who's well comfortable with riding in the hills.

For almost everyone who attempts an Everesting, the ride will be the longest time they've ever spent in the saddle, and likely the greatest distance they've ridden in one go as well. At some point fatigue will set in and will remain an unwelcome companion until they finally stop.

'At 6000 metres (19,685 feet), my body simply refused to pedal any faster,' wrote Canadian ultra-endurance rider Meaghan Hackinen in an article about her Everesting on Knox Mountain in British Columbia. 'By 7000 metres (22,970 feet), I had to coerce my legs to move at all. Sections that had seemed almost flat in the morning felt as though they were now vertical; I didn't know it was possible for a person to ride a bike this slowly.'

Even the world's best riders are likely to feel the effects of fatigue when they're deep into an Everesting.

When Richie Porte completed his Everesting near Monaco, just after the 2019 Tour de France, he was surprised by how fatigued he became. 'On the seventh time [up the Madone] that was when I really kind of hit the wall,' Richie told me of his 10.5-lap ride. 'I was like "Whoa, this is hard. This is harder than what I thought it was going to be."'

Fatigue is unavoidable even when a rider's got their pacing strategy perfectly dialled – when they're riding at a steady and sustainable speed throughout the effort. If they get their pacing wrong though, they can expend too much effort early, only to hit the wall and accrue further fatigue.

Riding at a steady tempo might sound easy, but it's anything but – with fresh legs and adrenaline pumping at the start of such a monumental ride, it's easy to climb faster than can be maintained throughout the effort. Even the world's best find it tricky to maintain a sustainable tempo.

'The first hour, I feel like it was hard to go that slow,' said Phil Gaimon in a YouTube video after setting a new Everesting record in May 2020. 'It just felt comically easy.' The man who went on to take the record from him, Keegan Swenson, had a similar experience. 'The hardest part was probably keeping it chill the first few hours,' he said. 'For the first few climbs, I was like, "Man this is too easy, I feel like I could go a little harder." I was just trying to keep it chill and not go too deep. It slowly started to get harder by the end. I was pretty glad I kept it at that pace.'

For most, completing an Everesting is an ordeal that stretches beyond 15 hours. That's a phenomenal amount of time spent in the saddle, and for all but the very strongest riders, it means encroaching on time normally spent asleep, further increasing fatigue.

Getting through a long endurance ride like Everesting doesn't just mean pushing through overwhelming fatigue – it also means having enough energy available to fuel the effort because climbing the height of Everest requires a hell of a lot of energy.

By way of context, the average, active adult human male might burn between 10,000 and 15,000 kilojoules (2400 and 3600 kilocalories) a day. For active females that number is somewhere between 9000 and 12,000 kilojoules (2100 and 2900 kilocalories). The amount of energy required to complete an Everesting is many times greater than that. How many times? Let's employ some basic science to find out.

# THE ITALIAN COLONEL

Each Everesting story is impressive in its own way, but some stand above the rest. Like the tale of former Italian Army colonel Carlo Calcagni.

Born in 1968, Carlo started his military career as a paratrooper officer and worked as a helicopter pilot and flight instructor. In 1996 he was sent to Bosnia and Herzegovina as part of a United Nations peacekeeping mission. Here, the dust raised during take-off and landing manoeuvres contained vast quantities of heavy metals that would later wreak havoc on his body.

In 2002 Carlo was hospitalised due to 'continuous physical illness' and was diagnosed with a raft of medical conditions: renal insufficiency, MCS (multiple chemical sensitivity), heart failure, interstitial pulmonary fibrosis, respiratory failure, neurological degeneration with Parkinson's and much more besides.

Doctors who treated Carlo say it's a miracle he's still alive. 'Twenty-eight heavy metals were found in my body, including two radioactive ones: caesium and uranium,' he told Montagna.tv. 'Impressive values, 22,000 times over the reference values. They found them in the liver, lungs, bone marrow, even DNA.'

Carlo says his condition will continue to 'worsen until death. For 18 years, my every day has been marked by the rhythms of drug therapies, by immunotherapy as soon as I get up, by weekly hospital plasmapheresis sessions, by oxygen therapy for at least 18 hours a day, by daily infusions with hundreds of tablets to swallow, by noise of the nocturnal pulmonary ventilator and any other tools my body needs to survive. To live I need something else.'

That something else is cycling.

Carlo claims multiple Italian titles in various cycling disciplines and says he turned down a tilt at being a professional racer in favour of his career in the military. In recent years, he's been back riding whenever he can.

He no longer rides a regular two-wheeled bike – 'Due to a form of multiple sclerosis with Parkinson's, and the need to carry oxygen with me, I have to switch to the tricycle.' He's had some success as a paracyclist, winning two gold medals at the Paracycling World Cup in 2015 and three gold medals at the Invictus Games – the games for wounded, injured, or sick armed services personnel – in 2016. He's also completed an Everesting.

On 2 June 2020, Italy's Republic Day, Carlo tackled a vEveresting on the Alpe du Zwift climb. Over the course of 11 hours and 21 minutes, with tubes feeding him supplemental oxygen through his nose, Carlo didn't just accumulate the necessary 8848 metres of climbing – he pushed on to reach 10,000 metres. He is the first-known paracyclist to complete an Everesting.

'I want to dedicate every single pedal stroke, every breath, and every beat of my sick heart, to the victims, to the fallen of every time and every place, without forgetting those who, like me, have become sick due to the service provided,' Carlo wrote. 'The serious multi-organ disease devastated my life, but it did not destroy me because I never gave up, despite the very heavy therapies and treatments that I am forced to survive. "Never give up" is my identity card, the motto that now echoes everywhere. I have a goal that still keeps me alive.' ▲▲

Cast your mind back to high-school physics and the concept of gravitational potential energy. To get an object to the top of a hill – fighting against gravity – requires a certain amount of energy. Once at the top, the object is said to have 'potential energy' – energy that would turn into 'kinetic energy' through motion on the way down. Thanks to a simple formula – E=mgh – we can make a rough estimate of how much energy it takes for a cyclist to complete an Everesting.

In the formula above, E is the amount of energy (in joules); m is the mass of the rider, their bike and everything they're carrying (in kilograms); g is the force of gravity (9.8 m/s²); and h is the height they've gained relative to their starting point, in metres (in this case 8848 metres).

Let's assume the average male who completes an Everesting weighs 75 kilograms (165 pounds) and their bike and gear weighs 10 kilograms (22 pounds) – a total of 85 kilograms (187 pounds). Plugging these values into the formula yields:

E = 85 x 9.8 x 8848 = 7,370,384 joules, or roughly 7400 kilojoules (1768 kilocalories).

If we assume the average female Everester is 60 kilograms (132 pounds) and their bike and gear weighs 10 kilograms (22 pounds), we get:

E = 70 x 9.8 x 8848 = 6,069,728 joules or roughly 6100 kilojoules (1458 kilocalories).

In reality, these estimates are low: 7400 kilojoules and 6100 kilojoules are just the amounts of energy required to haul riders and their gear to the height of Everest – the calculations don't take into account the energy required to overcome frictional forces such as wind resistance, rolling resistance and any inefficiencies in the bike's drivetrain.

Thankfully, there's an easy way to find out the total work required for an Everesting: by looking at the Strava files of those who have completed one.

If a rider has used a power meter during their Everesting – to show how much power they're pushing through the pedals at a given moment, and over time – the Strava file will show the 'Total Work' done for the effort, measured in kilojoules. By sampling dozens of these Strava files, from riders of different shapes and sizes, from different climbs around the world, I was able to calculate the average amount of work required to climb 8848 metres. For men, it's approximately 8600 kilojoules (2055 kilocalories); for women, roughly 7200 kilojoules (1720 kilocalories).

For context, a particularly mountainous stage of the Tour de France might require an energy output of 4000–5500 kilojoules (956–1200 kilocalories) – roughly half as much as an Everesting.

And those kilojoules aren't the full story. There's a difference between how much energy passes through the pedals to power a rider and their bike up the hill, and how much energy that rider is actually *expending*.

We know from decades of research that the human body isn't terribly efficient at turning energy from food into mechanical energy that can power a bicycle. In fact, our 'gross metabolic efficiency' is something like 25 per cent – that is, for every joule of energy delivered to a rider's pedals, their body has to expend about 4 joules.

Knowing this, we can estimate how much energy the average cyclist will have to burn to complete an Everesting. For males, it's approximately 34,400 kilojoules (8200 kilocalories). That's three times what an active adult male will burn in an entire day, and the equivalent of about 14.5 Big Macs. For women, the expenditure is roughly 28,800 kilojoules (6880 kilocalories). That's also three times what an active adult female might burn for an entire day (and a bit more than 12 Big Macs).

**Right**
Fuel and hydration
are crucial during
an Everesting, even
for elite climbers
like Sean Gardner.

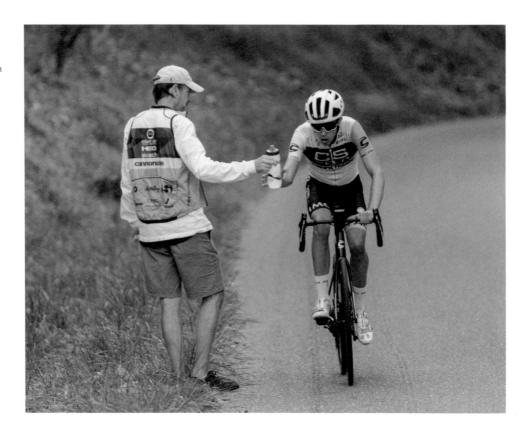

But remember, this is just the energy required to haul a rider and their bike up the height of Everest – it doesn't factor in any energy the rider might expend while riding down the hill. More importantly, it doesn't count the energy required by the body for its usual processes, such as breathing, circulating blood and keeping internal organs operating as normal.

This energy requirement to keep the body operating at rest – an individual's 'basal metabolic rate' – varies from person to person, but researchers believe the average male needs around 7100 kilojoules (1700 kilocalories) per day, while an average female needs around 5900 kilojoules (1400 kilocalories) per day.

Add these to the energy requirements of the Everesting and you get approximate totals of 41,500 kilojoules (9920 kilocalories) for males and 34,700 kilojoules (8290 kilocalories) for females for the day of an Everesting (plus any energy expended while off the bike for the rest of the day!). This is roughly four times the energy an average active male or female might burn in a day.

So where does that leave us? Well, those vast amounts of energy need to come from somewhere – food and drink. In order to stay sufficiently fuelled for an Everesting, riders need to make sure they have a good supply of energy at the beginning of the ride.

**Left**
You need a lot of
fuel to complete
an Everesting.

Carbohydrate loading is a popular and effective strategy – consuming large volumes of high-carbohydrate foods, such as pasta or rice, in the days before the event, to ensure the body's glycogen stores are adequately stocked. Then riders need to make sure they're constantly topping up energy throughout the ride. 'To prevent depletion of energy it is recommended to eat before you are hungry,' suggests the official Everesting guide. 'Commence carbohydrate consumption early on in the Everesting to avoid low stores in the latter stages of the ride.'

Even those with over a decade of experience at the highest level of professional racing can forget these basics. 'I had two pieces of toast with avocado, a Magnum ice cream and some pink grapefruit cordial,' wrote former pro Greg Henderson

about how he fuelled his vEveresting. 'I did not prepare adequately at all. This was the hardest thing I have done on a bike purely because I completely depleted myself. I can't remember a longer day of suffering in my whole cycling career.'

If a rider fails to adequately fuel – as Greg did – they'll likely fall prey to the dreaded 'hunger flat' or 'bonk', which is when the liver's glycogen stores are completely depleted and unable to keep blood glucose levels topped up. It's a feeling most cyclists know all too well. One moment you're riding along fine, then, all of a sudden, you feel completely empty, devoid of energy, your body desperate to stop.

British rider Guy Townsend (aka 'Sir Guy Litespeed') wrote about one such incident while Everesting Stwlan Dam in Wales in 2018. 'By the time I reached the top,

I knew I was in trouble,' he wrote. 'With the temperature down to 8°C (46.4°F), I shivered my way down to the car, got in, turned the engine on and dialled the heating up to full. I was shaking uncontrollably and feeling sick. I'd simply run out of energy. I'm susceptible to GI [gastrointestinal] issues during ultra-endurance events and to combat this, I tend to eat pretty lightly during them. Sat in the car however, it was pretty clear that I'd undercooked it and despite the nausea associated with the worst full-scale bonk I'd ever had, I managed to force down half a bagel, half a gel and half a Veloforte bar. The possibility of failure was staring me full in the face.'

Staying well fed might sound easy enough, but when you've been riding for 15 hours, it can become surprisingly tricky. Riders often lose their appetite, or experience severe nausea as Guy did, or end up with gastrointestinal issues. This might be the result of eating one too many high-sugar energy bars or gels, or it might just be the result of the body prioritising blood flow to the muscles of the legs, rather than the gastrointestinal system.

But it's not just energy levels that need to be kept topped up. Hydration is vitally important as well. Research suggests that the average cyclist is likely to sweat 1–1.5 litres (1–1.6 quarts) of liquid per hour during endurance exercise, with some athletes losing even more. If the weather is warm, that figure goes up again.

Let's say the average Everesting takes 16 hours – that's at least 16 litres (4.2 gallons) of liquid (and likely quite a bit more) a rider will lose through sweat in completing their effort. The question is, how much does a rider need to drink to ensure dehydration doesn't affect their ride?

For years, health organisations – including the American College of Sports Medicine – suggested that weight loss of more than 2 per cent due to dehydration was likely to harm endurance exercise performance. But the research is far from conclusive on this topic, and besides, when it comes to an ultra-endurance effort such as Everesting, weight is lost in other ways beyond sweat, complicating the calculation.

'Because your body's producing so much energy, which comes from fat and carbohydrate, you actually start to lose weight in the form of fat and carbohydrate,' explains sports dietitian Dr Alan McCubbin. 'In 2, 3, 4, 5 hours it doesn't add up to more than half a kilo or something, so it doesn't really affect your calculation. But once you start getting out to 10 or 15 hours, it absolutely does. During a 160-kilometre (100-mile) ultramarathon, runners would be expected to lose 2–5 per cent of their body weight just to maintain normal hydration. No weight loss in this case would result in over-hydration.'

So if avoiding more than 2 per cent of body mass loss isn't a helpful guide, what is? Sadly, given a lack of research on ultra-endurance sport (it's hard to convince people to spend multiple 16-hour sessions riding in a lab), there are no clear evidence-based guidelines. However, a recommendation Alan made in an article on the CyclingTips website might be a good starting point: 'Having inadequate fluid available to satisfy your thirst will most likely degrade performance."

Alan tells me that athletes can estimate how much they'll need to drink during an Everesting by first working out how much they expect to sweat. Over the course of multiple training rides of similar intensity and in similar conditions to the Everesting, the athlete should weigh themselves before and after riding, and adjust for any weight gain (from food and fluid) and weight loss (from toilet stops). From there it's easy to work out how much they're sweating per hour and therefore how much they're likely to sweat during an Everesting.

**Right**
The roads around
Sa Calobra, Majorca,
provide a beautiful
place to Everest.

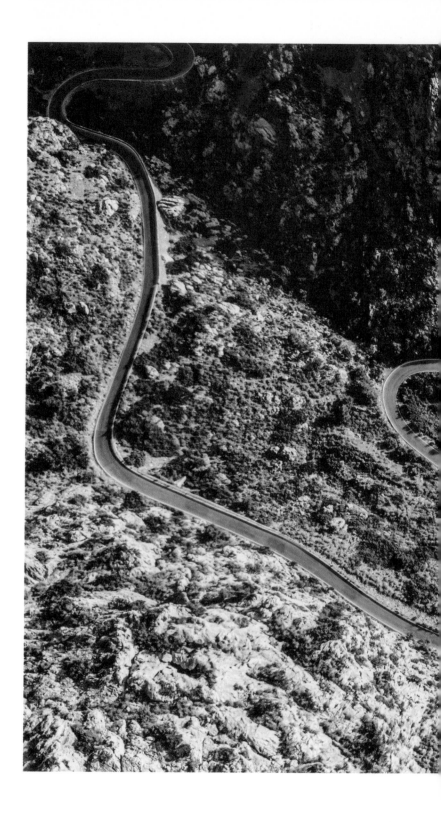

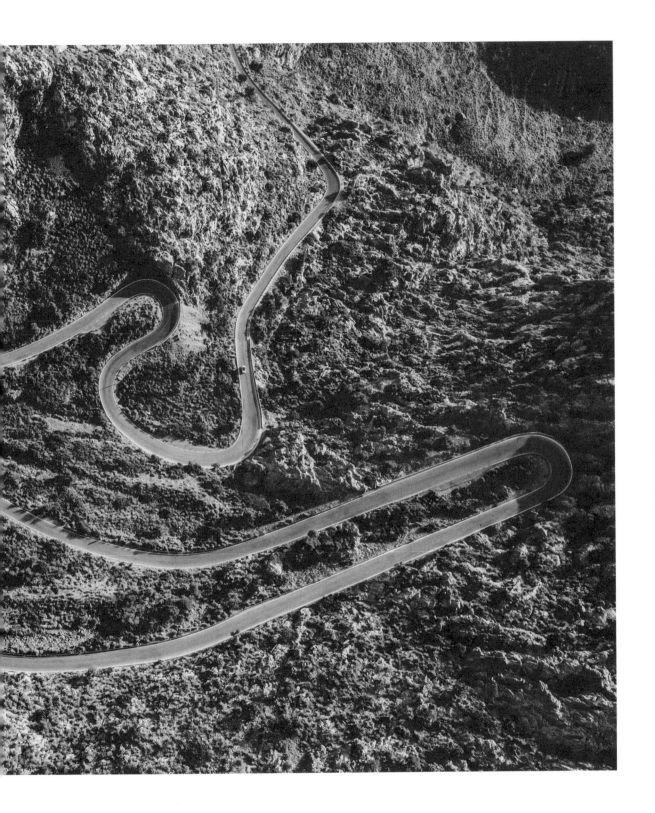

Physical

Having that much liquid available on the day isn't a bad idea, but Alan recommends 'using thirst as a feedback mechanism to increase or reduce the rate of drinking as you go'. But it's important not to drink more than will be lost through sweat. 'This can lead to over-hydration and exercise-associated hypernatremia, a potentially life-threatening condition where excess fluid builds up in the lungs and around the brain,' Alan says.

Let's say a rider is well fed and hydrated, and they're able to battle through the ever-increasing fatigue of their Everesting attempt. Even then, they're still almost certain to face other forms of physical distress. It might be a small niggle they can mostly ignore, or it might be a debilitating injury that brings their ride to a premature end.

Knees are often the first joint to cause problems. That's what happened to Terry Jones on his Everesting of Staunch Hill near Cambridgeshire in the UK. 'At some point, maybe at about 180 laps, I began to notice occasional short sharp pains behind my left knee,' he wrote of his 250-lap ride. 'I had no idea what it was, but I still had at least 7 hours of riding to get through.'

It's little surprise that knees can cause such grief. They're the joints that are put through the greatest range of motion during a pedal stroke, and an Everesting involves an awful lot of pedal strokes. An average rider might climb with a cadence of 80 pedal revolutions per minute. If an Everesting takes 16 hours of riding, and climbing takes three-quarters of that time (with around a quarter spent descending), that's a total of roughly 58,000 pedal strokes. That's a lot of wear and tear on the knees, especially if the rider isn't used to such lengthy efforts in the saddle.

But knees are far from the only problem area for a lot of cyclists. Hands can get sore from maintaining the same position on the handlebars. A rider's neck and back can get stiff and painful from being bent over in the same position for hours on end. 'Hot foot' – nerve pain caused by repeated pressure through the feet over many hours – can be particularly excruciating, particularly as the feet start to swell. Saddle sores can make sitting down extremely painful, if not end the ride entirely.

Often it won't just be one of these issues – it will be a combination. '[After] 8–16 hours on the bike … the real work begins and everything starts to hurt … neck, fingers, palms, feet … you name it!' wrote Jason Potsander after his Everesting in western Michigan. 'At that point it hurt my fingers to grab my water bottle for a drink!'

Then there's cramping. When you sweat, you aren't just losing water – you're also excreting minerals. If the body doesn't replace the minerals it's losing, cramping can result. But cramping can come on in other ways too, such as through muscular fatigue. As we've already established, fatigue and Everesting go hand in hand.

If you've ever experienced cramps, you'll know how debilitating it can be – a cramping hamstring can feel like a knife in the back of the leg, forcing you to stop riding until you get it under control. In some cases it can spell the end of a ride completely.

To successfully complete an Everesting is to navigate a raft of significant physical challenges – incredible fatigue, considerable energy and hydration demands, and other physical afflictions. But the physical battle isn't the only one a rider will face during an Everesting. In fact, for a well-prepared rider, the physical battle mightn't be the biggest hurdle they face in trying to climb the height of Mt Everest. ⚲

**Right**
Sean Gardner was the first to Everest in under 7 hours.

Physical

Everesting

# EVERESTING WITH CANCER

Riding an Everesting is hard enough on its own without introducing additional difficulties. It's certainly hard enough without adding stage 4 pancreatic cancer to the mix. And yet that's what Michigan rider Jason Potsander did in June 2020.

It all began when a guy Jason barely knew, Brent Lockhart, said he was dedicating his Everesting attempt to Jason. Jason asked if he could 'crash their party' and was welcomed along. He had just a week to prepare. At the time of the ride he was due for his 13th chemotherapy cycle.

Jason came into the ride with a feeling of great uncertainty. 'To say I had some demons in my head going into this would be an understatement,' he wrote in a blog post after the ride. 'I had completed six- and nine-hour races before and managed those events OK enough, but was severely wrecked in pain gastrointestinally for up to one week afterward. I did not want to go through that again. Just how my body would respond after an event like this was my greatest fear and greatest unknown factor.'

The riders' climb of choice was Maidens Road near the tiny town of Onekama, Michigan, USA. Just a couple of kilometres from the shores of Lake Michigan the climb rises at an average of 5 per cent for 2 kilometres (1.2 miles).

They started out much too fast. 'We began riding in a paceline with much vim and vigor for the first 2 hours,' Jason wrote. 'In retrospect, our naivety was almost laughable and a bit surprising!' Eventually, the pace started to mellow out. 'I was still delusionally thinking that I could somehow complete the Everest 29,029 feet of elevation by maybe 10.30 pm and be cozy with my wife in bed by midnight,' he wrote, adding a smiling face emoji. It wasn't to be.

Things got ragged as the riders ventured deep into the night. 'Between 11 pm and 2 am were the most soul-searching, heartfelt, and slowest miles I'd ever pedalled!' Jason wrote. 'You really have to wonder why you are still out there – at that point you can be reduced to your worst self.'

Jason finished his Everesting a little after 2 am. He regards it as a miracle on multiple levels. 'Sure there is the fact that I completed the ride,' he wrote. 'But I'm even more impressed with how my body is recovering afterward ... no gastrointestinal distress, eating like a horse, sleeping like a rock, and no headaches! I'm doing stuff on chemo that 95 per cent of the population can't do. I want to shout that from the rooftops and get those socks that say, "Do Epic Shit!" And yet, I'm a bit afraid to actually tell my doctor I did it! He might issue a restraining order between me and my bike!' ▲

# PART TWO
# THE CHALLENGES

**05**

# PSYCHOLOGICAL

Everesting

**B**rendan Edwards's second attempt at an Everesting didn't start well. He'd cut his first attempt short due to illness with just 1400 metres (4590 feet) of climbing to go, and when he returned to Perrins Creek Road east of Melbourne a week later, it looked as if he was destined for further disappointment.

As he was setting up his 'base camp', at around 10.30 pm one evening in March 2014, half a dozen cars zoomed past on the narrow tree-lined road. It was a preview of things to come.

'[In] the first 2 hours I had about 100 cars fly past me very closely on that pitch-black Perrins Creek Road, which was an absolute nightmare,' Brendan tells me. 'And I was, lap after lap, screaming in my head, "What are you doing here? Why don't you just go home? This is crap. This is useless. What are you doing to yourself?"' His head wasn't in the game and, with most of 20 hours still to go, Brendan wanted desperately to throw in the towel.

But then, at around 12.30 am, things took a dramatic turn for the better.

**Left**
Everesting is as much a mental challenge as it is a physical one.

At the end of lap 5, as Brendan was descending towards his car, he noticed a fellow rider waiting for him, the lights of the bike piercing the all-encompassing dark. His mate Stryder had done his own Everesting a week earlier in the nearby Don Valley and now, after finishing a shift in his hospitality job, had come to support Brendan through his second attempt, keeping him company in the middle of the night.

'I was like "What the …?"' Brendan recalls. 'We just started chatting and next minute the laps started flying and flying. My crazy dream of Everest didn't seem so crazy with Stryder riding alongside. And I actually started enjoying myself and the cars stopped showing up.'

At 3.30 am, another of Brendan's mates, Milinda, turned up unexpectedly. 'Suddenly there were three of us and it went from a pitch-black road to the road [being] lit up by bike lights,' Brendan says. 'We were chatting away and having the time of our life.' Two hours later, his mate Geert arrived. He'd been there riding with Brendan the previous weekend and was keen to lend his support once again.

The four riders stuck together until 9 am, ticking off lap after lap of the tough 2.5-kilometre (1.6-mile) climb. Brendan was buoyed by the company – his chances of succeeding had improved significantly. Having his friends around ensured the ride 'went from a nightmare and turned it into a dream'.

When Stryder, Milinda and Geert finally departed, Brendan was back to riding on his own. The buzz of companionship started to wear off and fatigue started to return.

Soon enough Brendan was completely exhausted and, again, ready to call it quits. He was on the brink of failing for the second week in a row. 'That was until Sam and Kate showed up to ride,' Brendan says. Like Stryder, Sam had completed his own Everesting the week before as part of the

## CYCLING SHERPAS

The name 'Sherpa' refers to one of several ethnic groups of Tibetan ancestry, a population native to the highest reaches of Nepal and the Himalayas. Sherpas are known to be elite mountaineers and ever since the early days of Himalayan exploration they have proven invaluable as guides at extreme altitudes.

Nowadays the term 'sherpa' is used rather more loosely, referring to just about any guide or support climber for mountaineering and trekking expeditions in the Himalayas, regardless of ethnicity. Thanks to Everesting, the term 'sherpa' has made its way beyond the snowy peaks of the Himalayas and into the world of cycling.

Since the first Everesting weekend back in 2014, the name 'sherpa' has been used to refer to any cyclist who rides in support of someone else attempting an Everesting. A sherpa might spend time chatting to the Everester, trying to distract them from the pain, or perhaps they'll ride in silence, offering the simple solace of company. In all likelihood they'll do both at different times.

challenge's launch weekend. 'Sam rode most of the way with me, and kept telling me I could do it, and more importantly kept telling me to eat,' Brendan says. 'At that point, I was over-eating, and without a doubt all the food I kept eating over those final 10 laps made the difference [between] finishing [and] collapsing again.' Late in the day Milinda returned with his family in the hope of watching Brendan finish.

Sure enough, at around 7.30 pm, Brendan reached the height of Everest. He'd spent 21 hours on the hill, riding 260 kilometres (162 miles). 'That final lap I went through every human emotion: pain, grief, elation, euphoria,' Brendan wrote. 'Everyone seemed so happy that I finished and I knew it wouldn't have been possible without the help of my friends.'

The mental challenge had nearly beaten him, but the support of others helped him make it through.

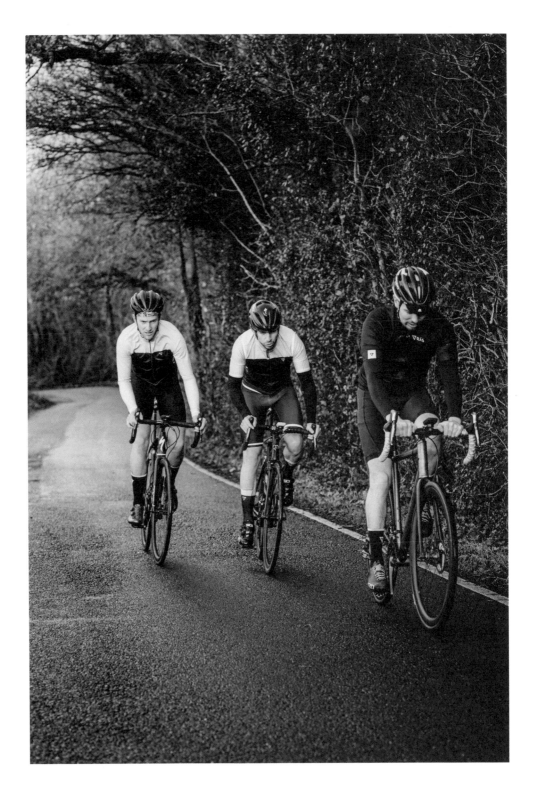

**Right**
Sherpas offer
the Everester
much-needed
distraction and
company during
an excruciating
challenge.

Brendan Edwards is far from alone in having faced the extreme psychological challenge that an Everesting poses. Speak to most who have completed an Everesting and they'll tell you the psychological battle is tougher than the physical.

At some point in an Everesting, a rider's body will tell them it's simply had enough. Fatigue and pain will combine; body and mind will scream, wanting the pain to stop. But somehow, the rider has to find a way to continue. 'Your legs need to get you to 6000 metres (19,690 feet),' writes Andy in the official Everesting guide, 'and your head needs to get you the rest of the way.'

As Meaghan Hackinen wrote of her Knox Mountain Everesting in British Columbia, Canada, the desire to give up can be almost overwhelming when things get tough. 'Those final hours were mostly agony, interspersed with momentarily relief,' she wrote. 'I wanted to quit with every fibre of my being.'

Besides battling an overwhelming desire to stop, brought about by fatigue, a rider must overcome other psychological challenges along the way. Like dealing with the mind-numbing repetition of riding up and down the same stretch of road, over and over again, for hour after excruciating hour. 'The first three or four laps went by OK, and then it starts to sink in: you're not even halfway,' said David Greif about his Everesting on Geiger Grade in Nevada, USA. 'It's going to be 10 more hours of riding.'

For some riders, things can get grim relatively early on – when they first start to understand the magnitude of the challenge. 'At 11 laps, some 8000 feet (2440 metres) in, I was so far away from the prize and having cycled for 5 hours I was beginning to despair,' wrote Hugh Wardrope about his Everesting on Tak Ma Doon near Glasgow, Scotland. 'I went through a difficult mental period. Physically my climb times were fine but deep down I felt dread. This was the toughest part for me so early in the

challenge. It floored me mentally for an hour or so until I got my head back into the task in hand.'

Like Brendan Edwards, many riders will have the company of others throughout their Everesting attempt – 'sherpas' who, like their namesakes on Mt Everest itself, are there to provide much-needed support. But even the most well-supported Everester is likely to spend long sections of their ride alone, usually in the small hours of the morning when it's dark, cold and lonely.

Josh Goodall recalls that feeling all too well from his Everesting ride on the challenge's opening weekend in 2014. 'I've had lonely moments on long rides before, but this sense of isolation and desolation was never more pronounced,' he tells me of his Everesting on the towering Mt Hotham in the High Country of Victoria, Australia. 'I've spent nights in deserts, ridden for hours in rain along empty highways, camped solo on mountain cliffs, and felt closer to civilisation, safety, friends and family.'

With the loneliness of those late-night laps can come a sense of existential dread. At some point, most riders will question themselves, wondering what possessed them to ride the same section of road again and again and again.

Sometimes, it can all become too much; the isolation, the fatigue, the pointlessness of it all. Andy is intimately familiar with the experience. 'These sorts of things can very quickly get in your head and you can have what has to be pretty close to a panic attack,' he tells me. 'I've experienced that a couple of times with these sorts of rides where it becomes so overwhelming. You're sore and tired and you've still got so much to go. If you start thinking of that end goal, you're stuffed. That's where the panic can start to set in.'

Some riders find themselves disassociating from the task at hand, their mind wandering completely. Like Paul Hume in his Everesting

attempt on Clay Bank near Middlesbrough in north-east England. 'I was in such a remote place mentally that four times I went [past] the turnaround point at the top,' he tells me. 'I was away with the fairies and during one of those "extras" I couldn't even recognise where I was until I looked back and saw the car park.'

It's not unusual for riders to hallucinate in the depths of an Everesting. When plagued with exhaustion, the mind can play some elaborate tricks on itself. Whitney Stanbrough experienced that during an Everesting near Statesville, Tennessee, in 2015. 'I'd convinced myself that the sun was never gonna come up again,' he told Outside Online. 'Every leaf in the road was a rock I'd have to dodge. All the twigs looked like snakes wriggling around. When I would get off to fill up my bottles, I would hear people snoring in the woods. It was trippy, man. It was absolutely mind-blowing.'

Typically it's in the final hours of a ride that the mental challenges get most extreme. After more than 7000 metres (22,965 feet) of climbing, and ground down by exhaustion, a lack of sleep and all-over pain, riders still have to push themselves through another few hours of cycling. Somehow. 'You will get to a place where it is just you and the mountain – no pretending – stripped back to your raw humanity,' writes Andy in the official Everesting guide. 'Succeed or fail, you'll discover things about yourself.'

**Left**
Not ideal conditions
for cycling.

Everesting

# THE THUNDERSTORM EVEREST

There's bad weather for cycling, and then there's triathlete Chrissy Kha Khrang's first outdoor Everesting in July 2020. Two thunderstorms, heavy flooding, and a forced break of nearly 6 hours while waiting for the weather to subside – in such conditions most people would have packed up and headed home. But testing her mental resolve was part of why the 34-year-old was doing an Everesting in the first place. 'There were so many inspirational stories [about Everesting] that I was motivated to challenge myself and find my mental strength,' she told Malaysian newspaper *The Star*.

Chrissy was no stranger to tough endurance efforts. She'd already completed two vEverestings, a Half Everesting on the road and more than a dozen Ironman triathlons (each comprising a 3.8-kilometre [2.4-mile] swim, a 180-kilometre [112-mile] bike ride and a lazy marathon to finish). But her Everesting in the Malaysian capital of Kuala Lumpur would prove to be more than just another test of physical strength and endurance.

Halfway through her ride, Chrissy posted a striking video to the Official Everesting Discussion Group on Facebook, asking whether Everesting rules allowed her to wait out a thunderstorm before continuing. Her video shows floodwaters rushing past her as flashes of lightning illuminate the night sky. Ahead of her, a woman steps into knee-deep floodwaters, using nearby posts to hold herself up. 'Can I continue later?' Chrissy asks, her voice still positive but barely audible over the sound of thunder, rain and rushing water.

'I had to wait till the flood subsided and the two thunderstorms were over,' she wrote after getting confirmation that she could indeed wait as long as needed, as long as she didn't sleep. 'I couldn't wait any longer after 6 hours plus, so I decided to resume riding through the night in the rain and finally Everested in 28 hours. The final 1000 metres (3280 feet) wasn't pretty but I used the strongest muscle – my mind – to push through. To me, the greatest achievement in Everesting is that I learned to overcome obstacles, stay motivated and positive no matter what.'

She did that, and then some. The photo she posted to social media afterwards tells the story. It shows Chrissy standing in floodwaters nearly up to her knees, her bike hoisted above the water, a wide, beaming smile lighting up her face. ▲

The psychological challenge posed by an Everesting is considerable even when things go according to plan, but when it comes to big, ambitious bike rides, things don't always go to plan. Dealing with adversity can be tough at the best of times; dealing with adversity when you're already stretched to your limit, physically and psychologically? That's something else entirely.

It could be something as simple as a tyre puncture – what might normally be a frustrating inconvenience can become a seemingly impossible setback, intensifying one's desire to stop riding. Or maybe the rider miscalculated the number of laps they needed to do, as happened to Andy with his Mt Buller effort in 2014. Many people in his position would surely have given up when they realised.

Even riders with 17 Tours de France under their belt aren't immune to the mental challenge of an Everesting that's gone off the rails. 'I started my ride at 12 pm and the plan was to cover 2000 metres, or 6562 feet, of altitude in 4 hours before night fell, but I didn't make it,' wrote former pro Jens Voigt of his ride near Berlin in early 2017. 'The cold and rainy conditions slowed me down, as did the multiple stops I made to do interviews, talk to people, say thank you for donations, and smile for pictures. When I got a tire puncture and night set in, I knew "Everesting" would take longer than expected. At 7 am, after riding through ice, snow, and 14 hours of darkness, I realised I was 2 hours behind schedule and still had 7 hours to go.

'If you are a cyclist, I'm sure you would agree that 5 to 6 hours is a long ride. Well I had 7 hours to go and already had 19 hours of riding in my legs. My speed dropped and the ugly words "give up" started stalking my mind. "The money [for cancer charity Tour de Cure] was already raised, why should I keep suffering?" a little devil inside me said.'

So, if Everesting is such a demanding psychological challenge, what is it that allows some people to succeed? What is it that sets an Everester apart from the average person, or indeed the average cyclist?

Clearly it starts with powerful motivation – a desire to tackle and ultimately conquer the seemingly impossible. Great mental toughness, too, is mandatory. Likewise an ability to push past discomfort and pain for long hours on end. That much is obvious. But what does the world of exercise science and sport psychology tell us about those who willingly tackle such challenges?

While there's virtually no published research about Everesting, and indeed very little on the psychology of athletes attempting any long, one-day cycling events, plenty of research does exist on ultramarathoners – runners who compete in events longer than your standard (but still incredibly tough) marathon of 42.2 kilometres (26.2 miles). Given ultramarathon running and Everesting are both ultra-endurance events that require similar physical efforts and commitment, perhaps there's something we can learn from research on ultramarathon runners?

In 2018, a group of Melbourne researchers, led by Monash University's Gregory S Roebuck, reviewed more than 50 studies about the psychology of ultramarathon runners in an attempt to draw some generalisations about the sort of athletes that attempt these extreme challenges. The common denominator among ultramarathon runners? A strong sense of self-motivation.

Athletes who attempt such long and gruelling events are less motivated by external factors like winning, or the adulation of others; they seem to be more interested in challenging themselves and testing their own limits. 'Studies investigating ultra-runners' motivations for engaging in their sport have nearly universally found that

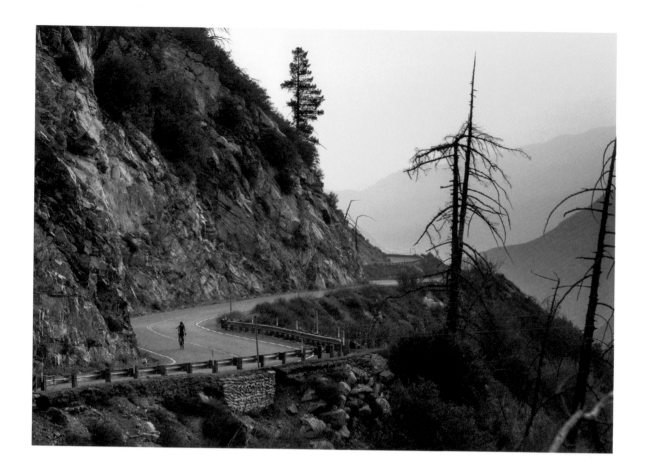

the most important motivating factor is the opportunity to achieve personal goals,' Gregory and co. wrote in their paper, published in the journal *Psychology of Sport and Exercise*. This lines up nicely with what we know about Everesters. Many riders tackle an Everesting for personal reasons – they want to test their limits, and whether an Everesting is within those limits.

Interestingly, this focus on the self seems to be more prevalent among those tackling longer-distance challenges like ultramarathons and Everestings than it does in those tackling shorter events. '[A focus on achieving personal goals] appears to differentiate ultra-runners from marathoners,' the researchers wrote, 'as

marathoners' motivations for running are more mixed with most studies finding that self-esteem reasons and health-related reasons are at least as important for them as personal goal achievement.'

The length of the event surely plays a role. For events like ultramarathons and Everestings, simply completing the challenge is a difficult task for most – enough to test the limits of an individual's strength, endurance and mental toughness, without worrying about things like winning or breaking records.

So Everesters are able to push through when things get tough, they're resilient, and they tend to be self-motivated. But there might be more to the story. In the course of trying to understand Everesting and those who tackle it, I spoke with Melbourne-based sports psychologist Michael Inglis, director of a clinic called The Mind Room. He suggests there's another personality trait common to Everesters: conscientiousness.

It makes sense since, for most, tackling a challenge of this magnitude requires careful preparation – it's a rare rider indeed who can go out and attempt one on a whim. For all but the very strongest it requires dedicated physical preparation – many weeks of training to develop the right physical condition. Mental preparation is also valuable – training oneself in adverse conditions so that things are easier on the day itself. 'No one can guarantee what will happen on the day, but high-conscientiousness people tend to do the best preparation, be super organised, be very specific,' Inglis says. 'They know what their diet and hydration [will be], they'll define their [training] programmes – they'll almost know on the day that they've pretty much done the work.'

Part of that work involves having equipment and logistics sorted out in advance. In the case of an Everesting, that's rather more complicated than you might think. ᳀

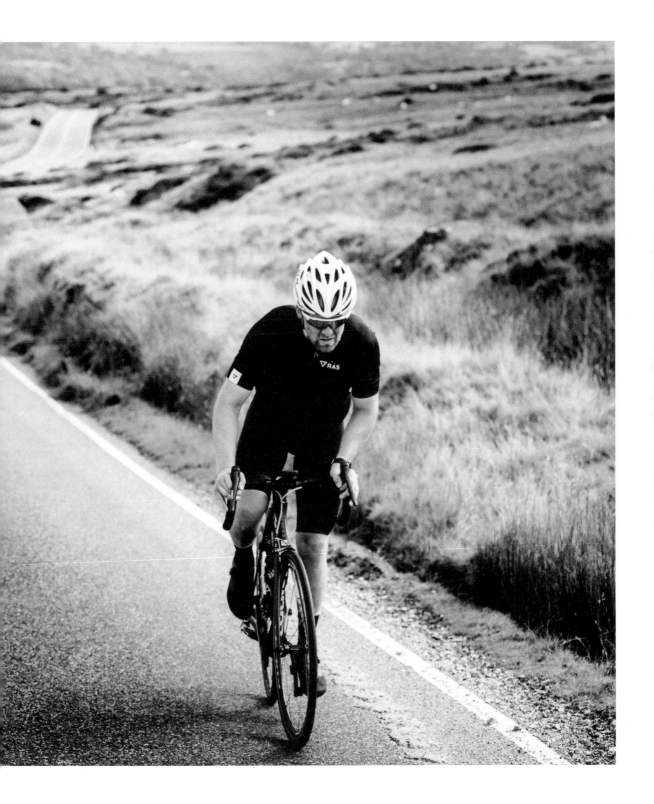

Psychological

# ONE LAP
# SHORT

You can imagine Blake Anton's horror. He'd just spent more than 13 hours grinding up and down See Canyon, south-west of San Luis Obispo, California, USA. The climb is a steep one – 2.3 kilometres (1.4 miles) at an average gradient of 10 per cent – and by the end of the ride he was exhausted. But when he stopped riding, he wasn't entirely sure he'd done the correct number of laps. 'We actually tried to upload the ride there so we could count the climbs just to be sure, but there really isn't any reception where the climb is,' he wrote. 'I even sent my fiancée on a little drive to try and upload it and I just sat in a chair in the side of the road for 45 minutes. She wasn't able to get it [to upload] either.'

Still unconvinced, Blake and his fiancée drove the 40 minutes home. He took a shower, ate some food, unpacked a bit and started getting ready for bed. Finally, as he was about to call it a night, he uploaded the ride to Strava. '[I] counted the laps and was like nooooooooooooo.' He was one lap short.

Blake had a choice to make. He could call it a night and return to the climb another time to do the whole ride from the start. Or he could head back to See Canyon for one final lap. After all, he hadn't slept yet – if he went back and did his final lap it would still be a valid Everesting. 'I figured biting the bullet and suiting back up for one final lap 4 hours after I had "finished" would be easier than doing 39 laps on a future date!' he wrote.

So, at 10 pm, Blake drove back to See Canyon and completed one final climb, summitting at around 11 pm. It was the fastest of the 39 laps he did for the day 'because I was so mad about it'. ▲▲

**Right**
It can be
incredibly tough
to start riding again
after a long break.

Psychological

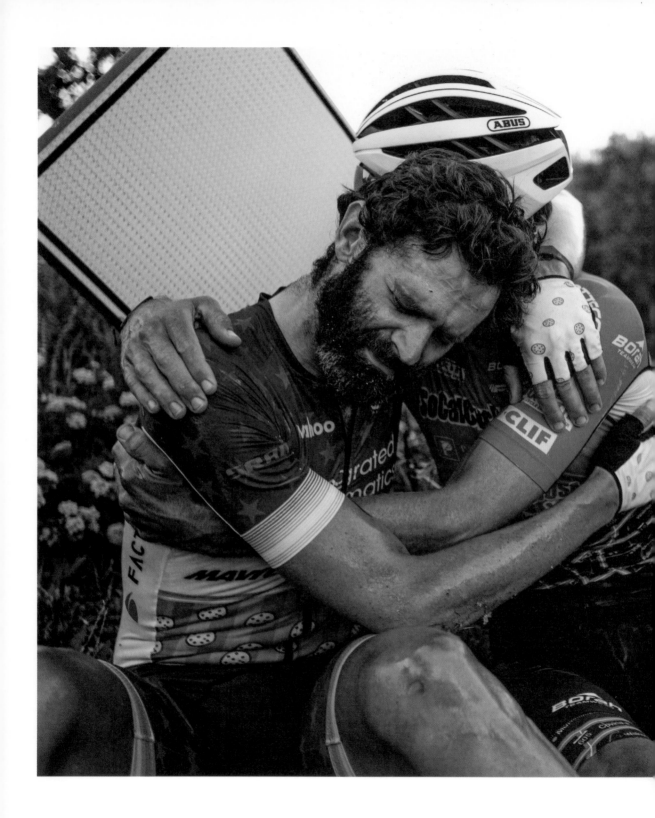

Everesting

Phil Gaimon (left)
and Ben Foster
embrace after
Phil's record-
breaking Everesting.
Ben rode almost
the entire day by
Phil's side.

# PART TWO
# THE CHALLENGES

O6

# TECHNICAL AND LOGISTICAL

Everesting

**Early one morning** in March 2010, I stood over my bike in Falls Creek in Victoria's High Country, my brother Brendan beside me. Like the couple of hundred other foolhardy riders around us, we were there for the inaugural 3 Peaks Challenge (now Peaks Challenge Falls Creek), easily the hardest ride we'd ever attempted.

I stood there at the start line shaking, partially due to the pre-dawn cold, and partially due to nerves, courtesy of the 235 mountainous kilometres (146 miles) that lay before us. Still, I was ready – I'd put in months of training and worked myself into good physical shape. I'd also prepared myself mentally by breaking the ride down into a series of more manageable chunks. All that remained was to actually ride the thing.

Mere minutes after starting the descent from Falls Creek, my ride was in tatters. As I went to change gears, about 5 kilometres (3.1 miles) into the ride, I heard a horrible snapping noise. I looked down and, sure enough, the frayed end of my rear gear cable was hanging from my handlebars.

I was stuck in the smallest cog in the back – the hardest gear to pedal. In a haze of disbelief, frustration and adrenaline, I battled my way over the first of the day's climbs, the 7.6-kilometre (4.7-mile) Tawonga Gap, grinding away at a knee-mashingly low cadence, and descended to the bike shop in the town of Bright. By the time the gear cable was replaced – and with it my barely there brake pads – Brendan and I had lost nearly an hour. We were almost certainly going to miss the time cut atop Mt Hotham. Our 3 Peaks Challenge was over.

We'd both spent many months preparing ourselves for this day and it had all come crashing down because I hadn't gotten my bike serviced close enough to the event. I learned a crucial lesson that day, a lesson that still makes me wince more than a decade later: your physical preparation might be en pointe and your mental game might be rock-solid, but if your equipment isn't up to scratch, you're going to have a bad time.

The same is undoubtedly true when it comes to Everesting.

A safe, well-maintained and recently serviced bike is only the first step. To complete an Everesting, a rider will also need to have appropriate gears for the hill they're tackling. The steeper the hill, the smaller the gear they'll want access to. For most riders, oversized gears will only increase the stress on their knees and force the production of larger amounts of power just to keep moving – likely fast-tracking fatigue.

'Don't be ashamed of easy gearing – put some big rings on your back wheel, despite the sceptical views of your mates,' said German rider Oliver Wilhelm in a YouTube video after his successful Everesting near Hanover in 2015. 'Your knees will thank you later. I would suggest putting even easier gears on your bike than you think you need. It's always better to end up with a gear not being used than a gear missing.'

**Left**
A big gear at the back will make it easier to get up steep climbs.

**Left**
The Everester
needs to be
prepared for all
weather conditions.

When it comes to clothing, riders must be prepared for any and all weather conditions. It might be dry and warm at the start of a ride, but rain, strong winds or worse could strike at any time, leaving the rider inappropriately dressed. Likewise, a warm day might give way to a freezing night, necessitating a different set of clothing.

This is doubly true in the mountains, where temperature extremes can be poles apart, and where the weather can change in a heartbeat. 'One of the challenges, aside from the physical effort, was having along the gear to stay comfortable on the way up and down,' wrote American Jeff Kerkove of his Everesting on Mt Evans, the highest sealed road in North America. 'Night laps had me carrying down jacket(s), down pants and down gloves, while one day lap had me carrying a full rain kit as the skies looked threatening … but never materialised.'

Many riders will go through several changes of cycling kit over the course of an Everesting, helping to ensure they stay as fresh as possible. They'll probably use chamois cream to reduce friction on their nether regions, too, hopefully preventing the development of saddle sores.

Then there's the issue of visibility.

For all but the very strongest riders, completing an Everesting means riding in the dark at least once, perhaps twice. High-quality lights are a necessity – possibly even multiple sets if one lot of lights doesn't have enough juice to last through the dark hours.

In order for a ride to count as an official Everesting, it needs to be recorded with a device that can prove a rider has done repeated laps of their nominated climb. For most, this is a dedicated cycling GPS that records elevation gain, but a fitness watch or smartphone will do the job too, so long as it can create a ride file that can be uploaded to Strava.

Whatever the device, it needs to have an excellent battery life, or the rider will need a way to recharge it throughout the ride.

Most riders bring a second recording device in case their first one fails – no one wants to miss out on the Everesting Hall of Fame because they don't have a record of their hardest-ever ride.

When it comes to gear, it's important for a rider to have a 'base camp' of sorts – somewhere they can stash enough food and drink to fuel their effort, spare equipment (such as tyres in the case of a puncture), tools and anything else they might need to get through their ride.

Having a toilet nearby is a good idea, too. Paul Dalgarno found this out during his second Everesting, tackled on Yarra Street in Kew, an inner-eastern Melbourne suburb. 'I started at 4.30 am, which had some consolations,' he wrote in 2014 in an article on my blog, *The Climbing Cyclist*. 'There were no cars, for a start; and it was dark, which meant peeing in the trees was easy. During my first Everesting attempt a few weeks ago – at Reefton Spur – the call of nature was a wondrous thing: just me, some trees, the occasional wallaby. On a heavily populated urban street with well-to-do residents tending their lawns – the stakes were higher. I'll spare you the mechanics but there's a bidon [water bottle] I won't be using again.'

The would-be Everester also needs a way of keeping track of the number of climbs they've done. As useful as GPS cycling computers are, they can often give erroneous elevation readings. More than a few riders have taken their GPS's word that they've climbed the height of Mt Everest, only to discover later that their GPS over-reported their elevation gain, leaving them short.

## BASE CAMP BURGLAR

In July 2020, John Edward Vanderveen was attempting his first Everesting on Mt Washington in the Canadian province of British Columbia. In the dark of the early morning, John set up his base camp at the top of the climb – 'a cooler on a small wooden table filled with 12 bottles and other nutrition, extra kit, and all the tools/equipment I might need' – then parked his car at the bottom. Before he'd even completed his first lap, someone had ransacked his base camp. He reached the top of the first lap to see just a few bottles remaining.

John kept riding in the hope of getting supplies from a friend who was set to join him in a few hours. But the thief wasn't done yet.

'About 30 minutes later (4.40 am!) I saw the same car and driver descend and I had a sinking feeling,' John tells me. 'I descended and made it to the bottom just in time to see the thief peel out of the parking lot after smashing my car window and stealing sunglasses, bike lights and some change. I actually rode to my car, observed the damage and quickly threw my bike in the car and drove after the thief! Spandex kit, helmet on, driving down the road at Mach Chicken. But no luck, the thief got away.'

John was understandably gutted, having spent so long preparing for his ride only to have it ruined so early: '[I] just didn't think the biggest challenge to overcome would be how not to get robbed'.

# CLYM'S CLIMB

The video starts pleasantly enough. An aerial shot shows a man pedalling his way fluidly up a beautiful, narrow road, surrounded by lush green fields. Wistful but optimistic music plays in the background. We meet our man, Clym Buxton, standing in front of what looks like a university building, talking about his upcoming Everesting attempt.

He's spent the last year training for this ride, including a trip to the French Alps, and he's an experienced long-distance rider, with many multi-day and long day rides under his belt. He's had his bike overhauled with new gear and rebuilt from the ground up – new parts, new gears to make the climbing easier, new brake pads.

And then, some foreshadowing. 'I've got a spare set [of brake pads] in the bag,' he says with a smile. 'The forecast is supposed to be thunderstorms and rain so I think the descending is going to be a lot harder than going up ...'

It's raining as Clym and his crew drive to the start of his chosen climb – Gospel Pass, the highest road pass in Wales. As he starts his first ascent, the wind is blowing a gale. He later recounts his thoughts at that moment: 'I'm not going to finish this. This is going to be pure hell.'

The first ascent takes 41 minutes. The road's wet, the wind is howling, and Clym looks thoroughly miserable. By the second lap, it's clear he's riding into a massive headwind – the worst conditions he's ever ridden in. He struggles against his invisible foe, veers off the road, and tries in vain to keep his bike upright on a grassy embankment. He loses balance and falls. After a moment he stands up, smiling, unhurt. 'If it's going to get worse tonight ... I can't ride it worse than this.'

As night falls in the video, ominous music starts to play. Clym looks like he's hating life. He shakes his head at the camera, then drops his head, despondent.

Now Clym's riding at a snail's pace as his friend Matt runs alongside. Clym comes to a stop, and his head sags over the handlebars. He tries to extricate himself from the bike as Matt holds the handlebars for him. Clym grunts and groans. 'Which leg is going?' asks Matt. 'Both!' replies Clym, tersely. And then he's yelling out in pain, clutching his right hamstring, as winds gusts of nearly 100 km/h (60 mph) create distortion in the camera's microphone.

'It was probably at this moment that I knew the ride was over,' Clym tells me.

'For me, as soon as cramp sets in, it is game over. In terms of nutrition, taking on liquids and salts to prevent cramp was never an issue, I was taking on plenty. It was the pure strain of forcing each pedal stroke that caused the legs to cramp up.'

The ominous music continues as we see Clym battling on through the night. He's got Matt riding beside him now, which seems to provide something of a boost. At the top of the lap, Clym looks like death warmed up. Someone drops an electrolyte tab into his drink bottle. More shots of darkness follow. More of the seemingly incessant rain. More wind-distorted audio.

Cut to Clym unfolding himself from the bike and falling onto roadside grass between two nasty-looking thistle plants. His breathing is laboured and he is clearly distraught. 'I was incredibly light-headed, every part of my body was in agony, my heart rate was through the roof,' Clym recalls. 'It was at this moment that I knew I had to stop.'

A moment later, a voice crackles over the radio in Clym's ear. 'You want to stop?' someone asks. 'Yeah,' Clym replies.

And so at 10.49 pm, distressed and disappointed, Clym clambers into the car, his effort done. He's climbed 3003 metres (9850 feet) – nearly 6000 metres (19,685 feet) short of his goal. Mother Nature has won the day.

Looking back, Clym admits the ride was 'pretty much doomed to failure' from the start. He would love to have postponed the ride to a day with better weather, but his schedule and that of his support crew didn't allow it.

Clym hasn't gone back to Gospel Pass to try again – someone has since completed an Everest there, so the climb has less appeal than it once did. But he's not ruling out another attempt somewhere else sometime. 'That ride has certainly left a mental scar,' Clym says. 'In some ways it is gnawing away at me that I have unfinished business, but I also am rather scared of doing another because that ride was just brutal.' ▲

The consensus is that it's better to work out, ahead of time, how many laps are required for an Everesting, then track those laps independently of GPS. For many people that's with a whiteboard and marker. For others it's a pen and a strip of masking tape on the top tube of their bike. Some people just use a lap function on their cycling GPS.

Others have come up with more creative methods, like Austin Horse when he completed an Everesting on the Williamsburg Bridge in New York in 2017. 'I used old metro cards as my token for each crossing as backup for my GPS (good thing I did as rain on my second morning sent my GPS into a frenzy),' he tells me. 'I hole-punched and slit them and would pull one off the line each time I got to the line.'

There are important logistical considerations when it comes to a rider's chosen climb, too. Things like safety. Will there be an abundance of traffic, making the ride uncomfortable and potentially unsafe? Will there be a bunch of parked cars, creating

## DAY OR NIGHT?

Is there an optimal time of day to start an Everesting? I put that question to Dr Chiara Gattoni, an exercise physiologist who wrote her PhD about sleep deprivation and how it affects endurance exercise performance. Chiara told me that there's a dearth of research when it comes to ultra-endurance efforts such as Everesting. What little research does exist seems to suggest that it's best to get a solid night's sleep – at least 8 hours – before an endurance effort. As a result she doesn't recommend starting an Everesting at night after having been awake all day.

the same issue? Is the chosen climb and its descent safe to be riding at all hours of the day and night?

Descending on a bike is an intrinsically dangerous activity as it is; those descending after 15 hours of riding are at an increased risk of losing concentration. And when that descending is done in the dark? That's a not-insignificant challenge, even with good lights.

The successful Everester will also likely have given some thought to the timing of their ride. Some climbs might be busier during the week than the weekend (near schools, say), while others might be busier on weekends (near sports grounds, for example).

The conscientious rider will also give thought to the best time of day to start their effort. Most opt to start in the early morning or even late at night, riding through darkness when they're at their most alert. But this isn't a foolproof strategy: start too long before dawn and regular sleep patterns can be significantly affected, adding further fatigue.

Riding at night brings another challenge – wildlife. This can be problematic enough in urban areas; in rural and mountainous regions it's a real concern. Aaron Petersen found this out the hard way on Everesting's opening weekend in 2014, on his ride near Kinglake, north-east of Melbourne. It was on his very first descent that a 'dopey kangaroo' ruined his ride. 'As I tore around a corner I spied a roo in the pre-dawn light,' Aaron wrote on his blog. 'I slammed on the brakes but knew almost immediately that it was too little, too late. By the time I'd hit the deck, the roo was gone. A quick body check revealed some blood and a few aches but nothing too major. I briefly considered stopping then and there, but figured I was already up – I may as well make the most of it.'

Aaron continued on for many hours, until his body decided enough was enough. 'The abrasion on my knee had leaked all down my shin and even after some baby wipe–based

first aid it continued to bleed. It looked nasty and the pain was getting worse. In the end I made the choice to spare any heroics for another day and pulled the pin after eight laps, 185 kilometres (115 miles), and 4000 metres (13,120 feet) of vertical. Of this, seven and a half laps, 165 kilometres (103 miles) and 3500 metres (11,480 feet) of climbing was undertaken with a broken bike and body.'

A crushingly difficult physical challenge that tests the limits of a rider's strength and endurance. A cumulative psychological challenge that pushes a rider's determination and motivation to the edge. A complicated logistical exercise that requires anticipating a raft of needs and desires before they've even appeared.

Everesting challenges a rider on many different axes, each presenting a series of hurdles that, on their own, are enough to thwart all but the most motivated of athletes. Combine them all and you've got one of the toughest endurance challenges you can complete on a bike.

How hard is an Everesting exactly? There was only one way for me to find out. 🚲

**Right**
For most people,
completing an
Everesting means
riding in the dark
at least once.

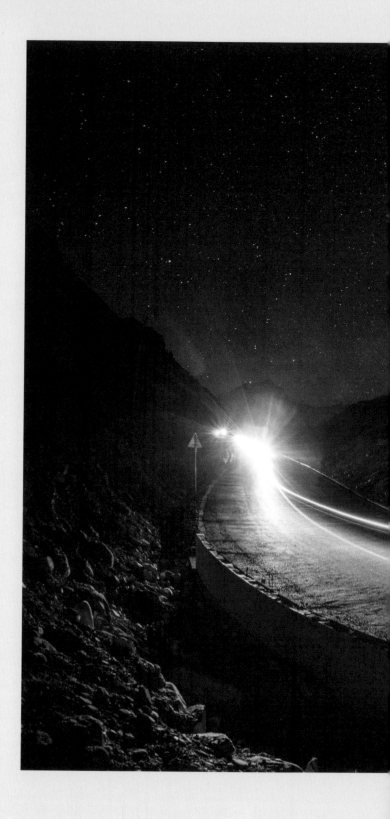

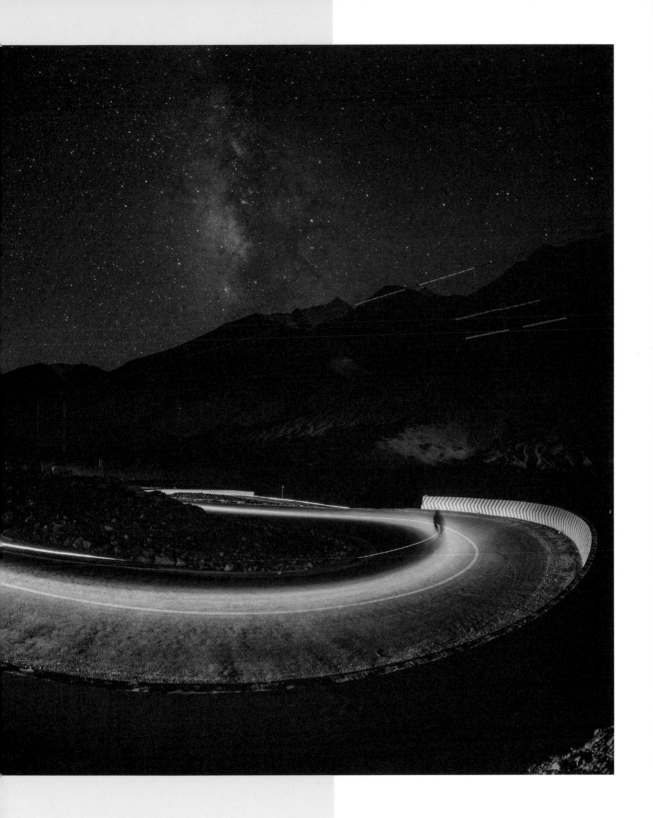

Technical and logistical

# PART THREE
# THE RIDE

# MY ROAD TO EVERESTING

Everesting

I watched on through social media as the first batch of riders conquered the challenge in March 2014, awed by their physical toughness and their mental resolve. In the years that followed, I watched as thousands of intrepid riders around the world joined the Hells 500 community, feeling a sense of wonder every time I read or heard about another rider completing an Everesting.

Yet, through it all, I never came close to feeling the need to try Everesting for myself. The dreaded fear of missing out – FOMO – that I might have expected never really came. In my mind, the challenge was simply beyond me. It was pointless even to consider it.

But in May 2020, as I made the first tentative steps towards the book you're now reading, I realised it was time to re-examine that years-old assumption. I couldn't possibly write about Everesting, I surmised, without truly understanding the challenge, without at least attempting it myself. Sure, I could tell the story of Everesting's impressive rise, and share stories of those who had tackled and conquered the challenge, but I didn't feel I could write about Everesting with any authority without experiencing it for myself.

And so it was decided: whether I thought I was capable or not, I would prepare for and tackle my very own Everesting, to understand what it takes for the average cyclist to do so.

Whether I succeeded or not, I would have a story to tell.

To understand my approach to this challenge, it's worth knowing a little about my relationship with cycling and, more specifically, my relationship with cycling uphill.

Like most Australians, I first started riding a bike in early childhood. I rode the couple of hilly kilometres to primary school whenever I could and spent many a weekend using my bike to explore the back streets of Ringwood East in eastern Melbourne. In all 6 years of high school I attended 'Bike Camp', a 5-day

*I* **remember when** the first emails about Everesting started to come in. I remember shaking my head, incredulous, convinced that after years of creating insane challenges through Hells 500, Andy had finally gone too far. We'd been friends for a couple of years, and I'd watched from the periphery as he and his small crew of hardened riders tackled increasingly ridiculous adventures by bike. I'd even experienced the madness firsthand at Crux in 2013. But Everesting was on another level entirely.

Like many of the 120 who received an invite to complete an Everesting in early 2014, I opted out almost immediately – I'd read and re-read George Mallory's account of his Everesting on Mt Donna Buang and knew that replicating his mammoth feat was simply beyond me. And that wasn't just unfounded pessimism – by the time Everesting was out in the world, I'd climbed Mt Donna Buang three times in a day, on two separate occasions. Both rides had pushed me to my limit. The thought of continuing on for another five and a half laps was laughable.

trip to Victoria's north-east, held in the scorching heat of the Australian summer. The highlight of each edition: a King of the Mountain (KOM) challenge near Beechworth on the trip's second day. This surprisingly steep 2-kilometre (1.2-mile) climb struck fear into nearly all of us untrained adolescents.

I enjoyed the trepidation leading up to the annual Beechworth KOM, and always relished the chance to test myself on the climb. In year eight, aged 14, I was the first student to the top of the hill. Even to this day, it's one of my happiest cycling memories.

A couple of years later, in 2003, a family holiday took me back to Victoria's north-east to camp in the shadows of the imposing Mt Buffalo. On a whim one day, I said to my dad, Ron, 'I want to ride up Mt Buffalo.' I fully expected him to laugh off the suggestion; instead, to my great surprise, he replied 'Sure!', without a moment's hesitation.

I spent more than 2 hours that day grinding the 20 kilometres (12.4 miles) up the mountain on my heavy, hardtail mountain bike with Dad and my brothers Brendan and Ash leapfrogging me in the car throughout to make sure I was still alive (Brendan rode the opening kilometres with me before getting in the car). It was the hardest thing I'd ever done – a gruelling challenge for someone whose longest climb to that point was the 2 kilometres (1.2 miles) of the Bike Camp KOM. But I was determined to finish what I'd started.

That ride up Mt Buffalo was a defining moment for my cycling. It opened my eyes to the satisfaction of conquering big mountains by bike. And while it didn't prompt me to dive headfirst into road cycling right away, that moment would come eventually.

In 2008, aged 21, I bought my first road bike. Like so many before me, I'd been inspired by the Tour de France. That entry-level Trek 1.2 road bike would be my ticket to a world I'd only really seen on TV in the small hours every July.

Moving house to the hilly suburb of Eltham in Melbourne's north-east meant every ride had some volume of climbing. I loved the challenge and got fitter, stronger and more invested in the sport.

The following year I started a journalism degree at La Trobe University, and as part of a subject on online publishing, started a website about riding uphill. *The Climbing Cyclist* would document the many great cycling climbs around Victoria and tell stories of those riding them. I wrote about my own cycling adventures, travelling around the state to tackle new mountains for the first time, and headed out to the local hills of Kinglake and the Dandenongs regularly. My love of riding uphill continued to grow.

In 2012, Andy and I started running cycling events together. Our Domestique 7 Peaks Series encouraged riders of all abilities to climb the mountains we loved so much, challenging themselves and meeting others along the way. Over five summers we ran a total of 32 Domestique 7 Peaks rides, helping thousands of riders get a taste for the satisfaction of cycling uphill.

Through *The Climbing Cyclist* I also organised seven annual editions of the Dirty Dozen, a tough recreational ride comprising a baker's dozen of short but very steep climbs around Melbourne, inspired by a ride of the same name in Pittsburgh, USA. From 2012 to 2018, thousands of riders came to challenge themselves at the Dirty Dozen. Throughout the same period Andy was building Hells 500, running his epics, and eventually launching and building Everesting.

My love of a challenge saw me tackle a handful of long, tough events. Three times I rode Around the Bay in a Day, one of Australia's biggest mass participation rides, comprising a 210-kilometre (130-mile) lap of Port Phillip Bay south of Melbourne. Around the Bay led to three successful visits to the 3 Peaks Challenge (now Peaks Challenge Falls Creek), one of Australia's toughest

**Right**
Clockwise from top right: my first bike; with my brother Brendan after cycling to the snow atop Mt Donna Buang; climbing Mt Buffalo in 2003; at Crux in 2013; with my best mate Nick (left) during Bike Camp in high school.

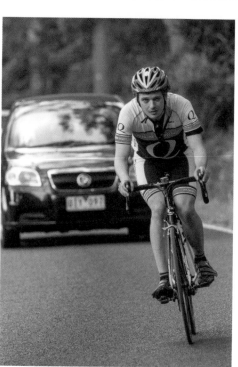

My road to Everesting

recreational events. Hells 500's Crux came shortly after my third 3 Peaks. In 2011 and 2015 I even threw myself into a different sort of endurance challenge, completing two Melbourne Marathons, in times of 4:26 and 3:58.

In 2012 and 2013 I dabbled briefly in bike racing, trying my hand at a grand total of seven D-grade events. My best result: third on the hilly final stage of the 2013 Northern Suburbs 3 Day Tour north of Melbourne.

Nowadays, my cycling looks a little different. I'm still riding to work, as I have been for most of my working life, and I still ride for fun almost every weekend. But I'm not doing nearly the same volume of riding I once was. Generally speaking, I've traded the long, challenging rides in the mountains for shorter rides focused on exploration and the simple joy of being out on the bike.

So if I had to sum myself up as a cyclist, I'd say I'm a keen recreational rider who loves the challenge of riding uphill but doesn't do it terribly well. I've got more cycling experience and pushed myself harder than the average person who rides a bike, but relative to those with actual cycling ability – even amateur club racers – I'm a spectacularly average rider. If you plotted out the cycling ability of everyone who's ever attempted an Everesting, I suspect you'd find me somewhere in the bottom half.

I'm not genetically predisposed to cycling long distances – neither of my parents have any history of endurance sport – and at 183 centimetres (6 foot) in height and somewhere around 75 kilograms (165 pounds) I'm not exactly built like your traditional, flyweight climber. Yes, I've done

some hard endurance challenges, and along the way I've learned how to push through great discomfort and fatigue, but completing an Everesting? That's a level beyond anything I've ever done.

All of this was swirling around in my head in mid-2020 as I tried to make sense of the journey on which I was embarking. I knew that completing an Everesting would mean pushing to the very edge of my physical capabilities. I was fully aware that finishing might even be *beyond* those capabilities.

But there was much to be done before I found out. For starters, I'd need to choose a venue for this almighty challenge.

The beauty of Everesting is that it can be completed on any climb, of any length, anywhere in the world. It's a challenge ripe for personalisation. But as I sat down to work out potential climbs, I was quickly overwhelmed by the possibilities – literally any uphill stretch of road, path or trail would do the job.

Thankfully there were plenty of factors to consider to help me narrow down my choices.

Length was first. Did I want a longer climb – a proper mountain ascent like Mt Buffalo, say – and only have a small number of laps to do? Did I want something shorter, like a suburban street, which would require many more laps? Or was it better to go for something in between? There were positives and negatives wherever I looked.

A longer climb would mean a longer descent, and therefore longer breaks between climbing efforts. That was good but not all good – cold legs at the bottom of each long descent would take a while to warm back up.

A shorter climb would offer a shorter period of respite while descending, but that respite would come more often. A shorter climb would also give me less time to find a rhythm each lap – by the time I was finding my groove, the climb would be over again. Something shorter would mean more turning around too, increasing the strain on my neck and shoulders through braking, and increasing the total time spent, due to all the slowing and turning around I'd have to do.

It seemed like something in between was the ideal option – something a few kilometres long that would smooth out the negatives of both shorter and longer climbs.

With that decided, it was all about finding the climb with the right gradient.

Few topics in the Everesting community generate such impassioned discussion as the optimal gradient for an Everesting attempt. As with climb length, there are positives and negatives that need to be balanced.

## CYCLING GRADIENTS EXPLAINED

In the world of cycling, the gradient (or steepness) of a given hill is denoted by a percentage. A flat road is said to have a gradient of 0 per cent, and the steeper the hill, the higher the percentage gradient.

You might recall from high-school mathematics that the gradient of a given slope is defined simply as 'rise over run' – the amount a slope rises over its length ('A' in the image above), divided by that length ('B' in the image). We can use this as a close approximation* for gradients as they apply to cycling.

For example, if a road rises 350 metres (1150 feet) over the space of 5 kilometres (3.1 miles), the average gradient would be 350 divided by 5000 multiplied by 100 (to turn it into a percentage), which equals 7 per cent.

So how steep is a given gradient and how hard is it to ride? Here's a quick guide:

**0%**: A flat road.
**1–3%**: Slightly uphill but not particularly challenging. A bit like riding into the wind.
**4–6%**: A manageable gradient that can cause fatigue over long periods.
**7–9%**: Starting to become uncomfortable for seasoned riders, and very challenging for new climbers.
**10–15%**: A painful gradient, especially if maintained for more than a few minutes.
**Above 16%:** Very challenging for riders of all abilities. Maintaining this sort of incline for any length of time is very painful.

* This isn't exact because cyclists actually ride the hypotenuse of the triangle you see above (marked 'C'), not the bottom (marked 'B'). The hypotenuse will always be slightly longer than the bottom, but for the sort of gradients at which roads rise, the difference is negligible.

The general trade-off looks something like this. Do something steeper (above 10 per cent) and you'll accumulate elevation gain more efficiently, which means a shorter Everesting (in distance covered and time spent). On the flipside, steeper gradients put increased stress on the body, hastening the onset of fatigue. Do something shallower (less than 5 per cent) and you'll reduce the strain on your body, but the relatively inefficient climbing will make for a much longer Everesting.

And so it's a case of finding the sweet spot – what gradient will allow you to finish the challenge in a reasonable time (if riding for most of a day can be considered 'reasonable'), while not destroying your legs?

Ultimately, it comes down to the individual – some people are more comfortable riding at steeper gradients than others. Or, as Everester Andrew Coveney put it in the Official Everesting Discussion Group on Facebook, 'Asking what the ideal [gradient] is like asking what brand/size shoe should I wear. You have to do what works for you. Some people will like 5 per cent, others like 20 per cent (or more) and then everyone else falls somewhere in between. Find a hill and go ride 1000 metres (3280 feet) of it. You'll know if it's too steep for you or not steep enough.' (For what it's worth, a sample of more than 2000 Everestings shows that the average Everesting is completed on a climb with a gradient of roughly 7.5 per cent.)

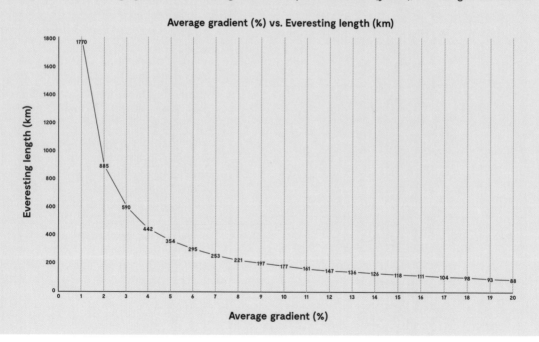

### AVERAGE GRADIENT VS. EVERESTING LENGTH

The steeper the climb, the shorter the distance required for an Everesting.
This graph plots average gradients (x axis) against the required distance (y axis), including the descent.

Average gradient (%) vs. Everesting length (km)

**Right**
This is an incredibly
steep gradient for
a road – steeper
than most cyclists
can get up.

For as long as I've enjoyed riding uphill, I've felt relatively comfortable on steeper gradients … but only to a point. I might relish the challenge of climbing a 15 per cent hill once or twice, but the prospect of repeating that climb for 15 to 20 hours – that sounded far less appealing. I liked the idea of finishing the challenge with cartilage left in my knees.

From experience I figured that an average gradient of around 7–8 per cent was my sweet spot. Not so steep that I'd blow my knees out after 2 hours but not so gentle that I would still be climbing a week after I started.

But an average gradient of 7–8 per cent can mean a lot of things. It can mean an erratic climb with shallow parts and steeper parts, or it can mean something more consistent. I knew I wanted the latter – too many changes of gradient would make it hard to find a rhythm.

Then there was the question of road type. While many people have completed an Everesting off-road, I knew I wanted bitumen. The way I figured it, Everesting was going to be hard enough without increasing the difficulty with a softer road surface, demanding a greater energy expenditure. I wanted a good road surface that wasn't going to chew up my tyres or have me riding into potholes.

I also wanted a climb that was relatively straight without too many turns – something that would be safe and easy to descend, even when tired. In the same vein, I was keen to avoid traffic or an abundance of parked cars. Finally, I wanted a climb where turning around at the bottom would be easy and safe.

Everesting

# A CLIMB
# TOO STEEP

John Van Seters, uncle to Everesting founder Andy, had been working his way through Everesting some of the steepest climbs in the Dandenongs east of Melbourne. He'd succeeded on two of the range's most infamously difficult climbs – Invermay Road (April 2014) and Terrys Avenue (November 2014) – and wanted to keep pushing the envelope. A few weeks after conquering Terrys Avenue, John set out with the goal of Everesting McCarthy Road, perhaps the toughest climb in the Dandenongs.

It's just 450 metres (1476 feet) from top to bottom but at a savage gradient of 22 per cent. Each lap took John at least 6 minutes – a climbing speed of little more than 4 km/h (2.5 mph). He could have walked it at the same pace. 'For the first half it is so steep you have to remain standing,' he wrote on Strava after his attempt. 'Your legs scream to sit down but you can't otherwise your front wheel lifts. You get a bit of respite for the last bit until it kicks up again for the last 20-30 metres where you have to stand again. Then it turns to gravel where you just try to squeeze those last few metres before quickly sitting down, unclipping [from the pedals] before you fall over, pivot on one foot [and] turn the bike around.'

McCarthy Road isn't just a hard climb; it's also an awful descent. At the bottom of this steep wall of road is a sharp left-hand bend where a rider needs to wipe off much of their speed – creating significant strain on neck and shoulders.

John made it through 29 gruelling laps before calling off his attempt. He'd ridden less than 30 kilometres (18.6 miles) in nearly 4 hours on the bike, and climbed 2760 metres (9055 feet). 'Is this one achievable as an Everest? That is the question,' he wrote. 'I really don't know!'

John's quest to Everest super-steep climbs in the Dandenongs didn't end there. In June 2015 he became the first to complete an Everesting on the infamously tough Mast Gully Road – a 1.5-kilometre (0.9-mile) ascent that averages a savage 13.5 per cent and peaks at more than 20 per cent. ▲▲

I'd also need somewhere to set up my base camp to store food, clothing, water, tools and anything else I might need throughout the ride. I was also keen for a nearby toilet, so I didn't find myself in the same situation as Joseph Kendrick when he started his Everesting in London in 2016. 'I had a stressful start – I really needed to poop,' he said in a YouTube video of his ride. 'It was 8 am Sunday morning, bank holiday weekend, the pub was closed, the toilets in the park were closed – I ended up holding it in for a few reps. I took a break and I almost pooped myself. I ended up just going to a church – lucky the church was open.'

As I considered all of these factors, I realised there were a couple of other important items on my wish list – I wanted to be the first to Everest whatever climb I chose, and I wanted that climb to mean something to me – for it to have some sort of personal significance and emotional connection.

With my wish list complete, I started hunting around.

In July 2020 I moved with my partner, Imogen, to Ringwood, in the eastern suburbs of Melbourne – one suburb west of where I'd grown up. The cyclist's playground of the Dandenong Ranges was mere kilometres away – the closest they had ever been in my adult life. With a smorgasbord of beautifully scenic climbs on offer, it's a place I've loved riding ever since I got into cycling. And with many of those climbs in the few-kilometres-long range, it seemed like the obvious place to start looking for an Everesting candidate.

The Everesting website has a handy map in its Hall of Fame section where you can see all of the climbs that have been conquered in a given area. It didn't take long looking at that map to realise that most climbs in the Dandenongs – certainly most of the climbs at a gradient I'd be willing and able to tackle – had already been Everested. The same was true when I widened my search to consider longer, more mountainous climbs around Victoria. I was starting to realise the downside of waiting more than 6 years to tackle an Everesting.

I got wondering if there was a suitable climb closer to home.

A few weeks later I was out exploring Ringwood East, reminiscing about times spent in the area as a teenager. It was on that ride I rediscovered an ascent mere metres from the house in which I'd grown up: the leafy suburban climb up Walhalla Drive and Isabel Avenue. If I was going to Everest something with meaning, a climb I'd done a bunch of times as a kid, right next to the house where I had my formative years, seemed to fit the bill perfectly.

I rode the climb a few times, reacquainting myself with any changes in gradient. I noted happily that those changes happened seldom, and that the steepest sections weren't particularly tough. I noted too that even with cars parked by the roadside, there was ample room to descend safely. There was also plenty of room to turn around safely at the bottom.

A slight bump on a left-hand corner on the way down gave me some slight pause the first time I rode it, but I soon convinced myself it was nothing terribly problematic – as long as I was even slightly careful, it wouldn't cause any problems.

A park near the bottom of the climb would be the perfect place for a base camp. There was plenty of room to set myself up and, as an added bonus, it was a park steeped in memory. Here my brothers, my dad and I had often kicked a footy or thrown a frisbee together. Importantly, a larger park with a public toilet I could use was just 350 metres (1148 feet) away.

This leafy, suburban climb seemed perfect. Sure, it wasn't the few-kilometres-long ascent I had initially hoped for, but it ticked all the other boxes.

As Melbourne suffered through endless months of coronavirus lockdowns in mid-2020, my rides were limited to one short hour at a time. I made several trips out to Walhalla Drive and Isabel Avenue during lockdown, riding as many laps as I could in my hour, trying to imagine myself riding that same stretch of suburban backstreet over the course of 16 to 20 hours.

Back at home, I consulted a range of mapping services to confirm the length and height of the climb. From its start on Hender Street to the top at Alexandra Road, the climb rises 37 metres (121 feet) over the course of 530 metres (1740 feet) – an average gradient of 7 per cent. I ran the quick calculation – an Everesting would take 240 laps and 261 kilometres (162 miles) of riding.

In the blissful naivety of 10- to 15-lap sessions over the coming weeks, I started to get used to the idea. There was something strangely approachable about the idea of riding it 240 times – for some reason, that sounded far more achievable than eight and a half times up Mt Donna Buang.

It was settled – I'd chosen my climb. Now to start training. &#x1F6B2;

---

**THE CLIMB**

**Climb:** Walhalla Drive & Isabel Avenue
**Location:** Ringwood East, Victoria, Australia
**Length:** 530 metres (1740 feet)
**Starting elevation:** 120 metres (394 feet) above sea level
**Finish elevation:** 157 metres (515 feet) above sea level
**Elevation gain:** 37 metres (121 feet)
**Average gradient:** 7 per cent
**Maximum gradient:** 10 per cent
**Laps required for an Everesting:** 240

Everesting

My road to Everesting

# PART THREE
# THE RIDE

# 08

# THE PREPARATION

Everesting

I expected that I would be 'absolutely trashed' by 5000 metres (16,400 feet). But I also figured that a solid training schedule would give me my greatest shot at success.

I was happy with my plan, but I didn't want to take any chances. So I called in a professional.

Dr Stephen Lane has a PhD in exercise science and is a well-respected cycling coach based in Victoria, Australia. Through his HPTek coaching business, he's helped several riders make it to the WorldTour, the highest level of professional men's road racing. He also coached former professional racer Dr Bridie O'Donnell to a women's Hour Record in 2016.

In short, Stephen knows coaching and he knows the science behind cycling performance. As we chatted in August, he said my training plan was looking solid, but he had a couple of suggestions.

While I'd planned on a rather general approach to training – just riding up a bunch of hills at low intensity – Stephen recommended adding more structure.

For starters, he suggested I focus on building my muscular endurance – my muscles' ability to exert the same force over and over for long periods of time. He explained that the most efficient way of doing that was with structured training 'efforts' at a moderate intensity, ideally for around 20 minutes. 'In your first little block of training, to get some legs, do it at about 75–80 per cent of FTP [functional threshold power] and you want to do them over-geared [low cadence],' Stephen told me.

FTP is the maximum amount of power a rider can produce for an hour. Why did Stephen suggest I do these efforts at 75–80 per cent of my FTP, and in a harder gear than I normally would? To 'load the legs up so that the stress isn't on the cardio-vascular system [heart and lungs] – it's actually on the legs themselves'.

**I gave myself** 3 months to train for an Everesting: from mid-September through to mid-December. According to the official Everesting guide, this would be the perfect amount of time.

My training plan was simple: get out into the hills a lot, do a bunch of low-intensity climbing, and increase the distance I was riding and the elevation gain from week to week. I'd aim to hit several milestones along the way – 2000 vertical metres (6560 feet) in a ride, 3000 vertical metres (9840 feet), a Half Everesting (4424 metres/14,510 feet) – and end my training with a repeat of Crux, the 5600-vertical-metre (18,370-foot) ride in the Dandenongs that I'd done with Hells 500 in 2013.

Getting a decent chunk of the way to the height of Everest in training seemed like a good idea, and the successful Everesters I spoke to agreed. Among them, Everesting pioneer George Mallory. 'Before you go for the Everest, first try and do a 5000-metre (16,400-foot) session to get pacing notes and to find out just how tired you get at 5000,' he advised. 'Almost certainly, unless you're a super-duper athlete, you'll be absolutely trashed at 5000. Think to yourself, you've got another 4000 (13,120 feet) to go on the real deal.'

The idea is to 'wear down some of the different types of muscle fibres' so that they strengthen over the weeks of training. This, he explained, would help me avoid painful or debilitating cramps during the Everesting.

Stephen added that if I really wanted to supercharge my training, I could ride my climbing efforts closer to my FTP (while being sure not to go over it). This would serve to fatigue my legs quicker, forcing me to spend more time riding on tired legs. This wouldn't just be great training; it would help prepare me for the feeling of fatigue I'd experience during the Everesting itself.

'You want to expedite that feeling of fatigue in the legs in training so that by the time you're 5 or 6 hours in, you're like, "OK, I'm actually feeling like I will when I'm in the later stages of my Everesting because I've been going harder than I would have on the day,"' he explained. 'So to get to there, the safest way possible is probably around 90 per cent of FTP.'

I tried to suppress a wince when he said this. I knew all too well that climbing at 90 per cent of FTP for hours on end is far from comfortable. But then, being uncomfortable is the name of the game when it comes to training. Besides, there's another good reason to do long training efforts at around 90 per cent of FTP: it's an efficient way to increase aerobic capacity – the highest power a rider can sustain without creating metabolic by-products that lead to muscle fatigue. Building my aerobic capacity wouldn't just increase the amount of power I could sustain for an hour – my FTP – but also the power I could sustain for long, sub-threshold efforts such as an Everesting. And on the day of the Everesting, the more power I could sustain for longer, the better.

Armed with Stephen's wisdom, it was time to start putting it all into practice.

Through mid-2020, Melbourne, like much of the world, suffered through the coronavirus pandemic. After an initial lockdown period in March, a second wave of infections sent the city back into lockdown in July. A spike of cases in August tightened restrictions even further, limiting all Melburnians to just one hour of exercise per day, within a 5-kilometre (3.1-mile) radius of home.

In July and August I made the most of my one hour a day, trying to cram in as much climbing as I could. I spent time exploring local climbs near Ringwood I'd never ridden, and I did a bunch of one-hour sessions on Walhalla Drive and Isabel Avenue, the climb I'd chosen for my Everesting.

Everything was going according to plan. With lockdown restrictions due to ease in September, and 12 to 14 weeks to go until my Everesting, I was excited to start training in earnest. Then, in early September, things took a frustrating turn for the worse.

The week after speaking to Stephen about my training, I started incorporating low-cadence climbing efforts into my daily one-hour rides. In the space of 5 days I did five such rides, with all of my climbing done over-geared as Stephen had suggested. What he hadn't suggested was doing so much of it so soon.

Below
Exploring quiet
roads north of
Ringwood with
my friend and
CyclingTips
colleague Iain
Treloar.

Early the following week I noticed a dull twinge at the front of my left knee. It wasn't painful exactly, but it was certainly uncomfortable. In the days that followed, my discomfort only grew, despite taking some time off the bike. It wasn't long before I was feeling both frustrated and concerned – my knee was showing no signs of improvement.

When Melbourne's lockdown eased fractionally in mid-September, allowing residents 2 hours of exercise per day, I was stuck at home, nursing a patellar tendon injury. I was angry at myself for doing so much over-geared climbing so quickly, I was frustrated by a lack of training progress, and I was becoming increasingly anxious that I wouldn't be ready to complete my Everesting by mid-December.

My plan of doing longer, hillier rides each week was in tatters. I was already behind by a couple of weeks and my knee still wasn't getting any better.

With the help of physiotherapy, I started to make progress by late September. Within days I'd convinced myself that I was ready to pick up my training plan where I'd left off, despite weeks of limited riding. In hindsight, it's little surprise my next ride made my knee worse – I hadn't just increased the distance and volume of climbing, I'd also tackled steeper climbs than planned, putting further strain on my knee.

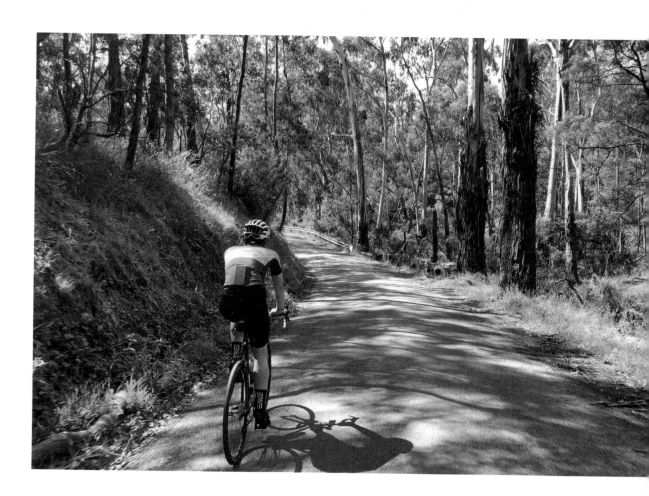

By the end of September, my knee was at its most painful. By early October I was weeks behind schedule. I'd stopped all riding and even avoided walking when I could, but nothing made a difference. 'This is horrific,' I wrote in my training diary. 'I feel like my knee is never going to get better.' I felt like screaming in frustration.

Another physiotherapy session provided some relief and my knee slowly started to improve. As I started riding again, I had to remind myself not to increase the distance or volume of climbing too quickly.

I decided to push my Everesting back by 2 months – until February – which helped ease the mounting stress. I resolved to take as long as I needed to get the knee right, rather than sticking stubbornly to a training plan that seemed destined to cause further problems and pain.

As I focused on resting and rehabilitating my knee, I turned my attention to another aspect of my physical preparation.

It's simple physics: the greater the mass, the greater the effort required to haul that mass uphill. It's why professional cycling's best climbers are tiny – sub-60 kilograms (132 pounds) for men, and sub-50 kilograms (110 pounds) for women. For a challenge like Everesting, where you're hauling mass up a very big hill indeed – even if it is in

Left

There are a bevy
of challenging but
beautiful climbs in
the Dandenongs
for intrepid cyclists
to tackle.

small chunks at a time – there's real value in reducing the weight of the combined bike-and-rider system.

Keeping the bike as light as possible is one way of doing it. A light frame, light wheels, light components, carrying less on the bike – these all save weight and, in turn, the amount of effort required to complete an Everesting. Some people go to extremes in this regard, such as one-time Everesting world-record holder Ronan Mc Laughlin, who went as far as cutting off part of his handlebars to save weight.

I had no plans to take a hacksaw to my bike, nor was I willing to shell out for a newer, lighter bike. The way I figured it, those measures might save me a kilogram or two, at the very most. I could save many times that by another method: losing some weight myself.

When it comes to riding uphill, few metrics are more important than a rider's power-to-weight ratio. The higher a rider's power output for each kilogram of mass, the faster they will climb. To put it another way, if I could lose some weight but maintain the same power output, I could climb at the same speed with less effort (or climb faster for the *same* effort).

When I spoke to Dr Stephen Lane in late August, my weight was at 77 kilograms (170 pounds) – about where it had been for the previous few years. I set myself the goal of dropping to 74 kilograms (163 pounds), or even 73 kilograms (161 pounds) if I could manage it.

I stopped drinking alcohol, reduced my meal sizes and stopped eating sweets. With that, I started to lose weight with relative ease – I was down to 75 kilograms (165 pounds) by late September. By the end of October I was at 74 kilograms (163 pounds), the lightest I'd been in my adult life. My weight-loss plan was going swimmingly.

My training was another story entirely.

After pushing my Everesting attempt back from December to February, I had plenty of time to get my knee right. By mid-October I was finally starting to ride pain-free and, with coronavirus lockdowns easing further, I was finally able to get out to the Dandenong Ranges to do some longer climbs. But on one ride in late October, with my knee feeling the best it had in weeks, I got excited and pushed hard up one short, steep rise while out of the saddle.

That brief lapse in discipline, barely 10 seconds in length, was all I needed to re-injure the tendon. I was back to square one.

As October turned into November, my knee showed no sign of improvement. 'This is the most frustrating and longest-running injury I've ever had,' I wrote in my training diary in early November. 'I'm feeling so defeated.' Two days later I was feeling even worse. 'I'm losing my freaking mind,' I wrote. 'The days keep bleeding away.'

Again a physio appointment righted the ship. The following day I was seeing signs of improvement, and in a few more days I felt like I was back on track. 'This felt like the first day of actual training that I've done,' I wrote after a 60-kilometre (37-mile) ride with 1000 metres (3280 feet) of climbing. 'The first day where my knee wasn't an issue, where I felt like I was starting to work towards something. My saddle was considerably more uncomfortable than my knee,' I wrote in an unfortunate case of foreshadowing.

With my knee finally on the mend, I was able to update my training plan and (carefully) start doing longer rides with more climbing. In late November, I went to the Dandenongs and put in 1500 metres (4920 feet) of climbing over 73 kilometres (45 miles) – a tough day that reminded me how fit I wasn't. My knee was fine, but my undercarriage? Not so much. 'It's definitely time to get a new saddle,' I wrote. 'Maybe even a bike fit.'

What started as some perineal discomfort in the second half of that ride turned into tingling and discomfort for several days. I bought a new saddle with a wider cut-out to help relieve pressure, but it had little impact. The discomfort lingered and feelings of frustration started to return. No sooner had I managed to get my knee under control than another injury had cropped up.

I took a week off the bike to let the issue resolve, but that wasn't enough. By the end of that week I was in Victoria's High Country for a work trip, unable to ride my bike for fear of making the issue worse. The previous months of interrupted riding had been frustrating, but being in Australia's best cycling region, unable to ride with my mates, took the feeling to another level entirely.

A doctor's appointment in early December confirmed I should stay off the bike and take anti-inflammatories until the discomfort had gone. A few days later, the tingling seemed to be fading. A few days after that it was back.

As December rolled by with minimal riding, it became clear I wasn't going to complete anywhere near as much training for my Everesting as I'd hoped. Extensive training had been key to my strategy – the way I figured it, the only way I could complete an Everesting was if I trained hard for it. What would happen now that I couldn't? That thought kept me up most nights.

**Everesting**

I had another concern, too. Even if, by some miracle, I was *physically* ready in time for my Everesting, what about psychologically? Would I be mentally tough enough?

Sure, I'd climbed 5600 metres (18,370 feet) in one ride before – 8 years earlier – but how would I cope in the rarefied air beyond that, when the crushing fatigue, a sense of pointlessness and the sheer boredom of riding the same stretch of road created an overwhelming desire to give up?

I decided it was time to get some professional advice on how to prepare myself *mentally* for an Everesting and, crucially, how to tackle the psychological challenge on the day itself.

Michael Inglis is the principal sport psychologist and director of The Mind Room, a wellbeing and performance psychology clinic based in inner-eastern Melbourne. He's worked with professional athletes across a range of sports, including Australian Rules Football ( or AFL) and, crucially, cycling. He's also personally familiar with Everesting, having ridden some support laps for a mate during an Everesting attempt a few years back.

He was the perfect person to help me with the psychological battle ahead.

As Michael and I chatted, I explained what I was most worried about: an overwhelming desire to stop when things got tough. He was decisive in his response: such feelings are virtually unavoidable, and they'd be exacerbated by any physical discomfort I was in at the time. 'The physical sensations – they'll send signals to the mind, telling you to stop,' he said. 'And that's a survival mechanism – just going "you don't need to do this anymore", because you don't. There's no survival instinct that makes you want to keep riding.'

The strategy, Michael explained, is to avoid giving those negative thoughts any more weight than they deserve. 'We have approximately 60,000 [thoughts] a day and we have this severe negative bias as part of our survival mechanism,' he explained. 'Not all [thoughts] are important. Not all of them are orders that you have to follow. And none of them are necessarily true – they're not facts. Just because you have a doubt doesn't mean you need to listen to it.'

Michael suggested that in moments of difficulty it can be useful to categorise thoughts as 'helpful' or 'unhelpful'. 'The helpful thoughts are knowing your "whys" – knowing why you're doing this,' he told me. '"I can't do this", "I want to stop", "my legs hurt" – these are all unhelpful thoughts.' He explained that it can be useful to stop and identify such thoughts, rather than letting them overwhelm. 'You just see it for what it is, as opposed to feeling like you need to engage in it,' he said.

Michael had other strategies for when things got tough, too: 'association' and 'disassociation'. Association is what he describes as 'a deeper dive into what's actually going on', which can include taking stock of how individual parts of your body are going. '"Are my hands nice and relaxed? Are my shoulders?" It's almost like [you're] saving energy by [having] nice restful hands. "My buttocks are equally on the seat." You're doing a position check. It's a more mindful approach,' he said.

Another method is to focus on the pedal cycle itself. 'Pointing the toe forward, dragging the heel back, lifting it up,' he said. 'I've worked on that with a few cyclists to help them kind of meditate on the bike.'

Disassociation is the opposite approach. It's about disengaging from the task at hand, instead focusing on something entirely different. For a lot of Everesters, that means listening to music, podcasts or audiobooks to help distract them from the effort at hand. Then there's perhaps the best disassociative tool of all – good company and conversation.

Having others ride with you, providing a distraction, can prove invaluable. 'Rope in some people to come along in shifts and ride with you,' suggested Dr Stephen Lane. 'As soon as you go in that deep dark well of "This is crap, I'm not enjoying it anymore," you start thinking about it too much. If you can turn that switch off and have someone to chat with the whole time, you'll be better off.'

Michael agreed, suggesting the support of others would help reframe the challenge in my mind. 'It changes from a solo task to "I'm building a team around me; I'm just the person's that's achieving it,"' he explained. 'A bit like a Tour [de France] ride, if you like – it's all in the service of one person but it's actually a collective approach and sometimes that can help you psychologically take the pressure off [the fact] that it's just you doing this.'

It made me wonder: were there other things I could do in the lead-up to my Everesting to help prepare myself mentally?

Michael explained that I should view mental toughness like physical toughness – as something that can be developed. He said I should be using my training to get experience doing the things that would be toughest psychologically during the Everesting. 'Riding in the dark, being lonely, being bored, repeating the same [climb] that you're doing is all going to help you on the day,' he explained. 'So a 4 am get-up,

for example, and beginning in the dark, or doing the same climb over and over again on another day. Mentally tough athletes become more comfortable with the uncomfortable, so I'd encourage you to do the same.'

As the end of 2020 approached, I found myself brimming with motivation, desperate to get out and ride some repeats of my hill, building my mental toughness and my physical strength. But my body simply refused to cooperate.

The perineal tingling and numbness I first experienced in late November plagued me into the new year. After three doctors' appointments, two ultrasounds, one X-ray, one blood test and one urine test, I still had little clarity. The prognosis seemed to be that I'd irritated a nerve, but doctors could provide little guidance on how long it might take to settle. I took more time off the bike to give the area a chance to heal.

One day in mid-December, I got to thinking. My knee was feeling great, so why not just get back to riding, but stay out of the saddle the entire time? It wasn't a textbook plan – I ran the risk of irritating the knee again, but at least it would give me a chance to do some climbing and feel like I was making progress.

So on a drizzly Wednesday afternoon, I drove to Walkerville in south-east Victoria, a short jaunt from my uncle's holiday house where I was staying at the time. I figured I'd see how my knee held up, but if all went to plan, I'd aim for 2000 metres (6560 feet) of climbing – 20 laps of a beautiful 1-kilometre (0.6-mile) ascent from a quiet beach up through lush, temperate rainforest.

I got to 2000 metres (6560 feet) in around 4 hours of riding. I was tired but had plenty left in the tank. Best of all, my knee was feeling good – despite the hours of out-of-the-saddle climbing – and 3000 metres (9840 feet) loomed as an ambitious but very realistic goal. So I pressed on.

The preparation

Laps 25 to 27 proved the toughest of the day, and I found myself taking breaks every two or three laps rather than every five. But the final three ascents felt easier than those before them and, after 6 hours of riding, I reached 3000 metres (9840 feet) feeling like I could have continued on.

Those final laps were uncomfortable for my knee and I knew there was a chance I'd aggravated the tendon again. But it seemed like a worthwhile trade-off: yes, I might have to spend a couple of weeks in recovery, but a big day of climbing had given me a significant psychological (if not physical) boost. I told myself that even with a few weeks off the bike, I'd still have time for a 4000-metre (13,120-foot) ride, a Half Everesting and maybe even Crux Redux before the Everesting itself – more than enough preparation.

Of course, my knee deteriorated. And as I should have expected, recovery took much more than the few weeks I'd counted on. Combined with the lingering perineal discomfort, my frustration and anxiety returned.

As 2020 became 2021, things didn't get much better. The few short rides I did at the turn of the year did little to instil me with any confidence that either my knee or my undercarriage was improving. And my Everesting was only 7 weeks away.

In mid-January, little more than 6 weeks out from my Everesting, I finally got some answers. A physiotherapy session revealed my perineal discomfort wasn't a nerve issue at all – rather, it seemed to be referred pain

from over-tight gluteal and hamstring muscles. To my great relief, a couple of weeks of dedicated stretching and strengthening eliminated the issue entirely.

As the end of January approached, my knee was finally back to normal as well. Things were starting to look up. Three hours and 1200 metres (3940 feet) of climbing in the Dandenongs went by without a hitch, giving me confidence that maybe, just maybe, I'd get close to feeling like I was prepared.

On a drizzly day in late January, I headed back out to the Dandenongs with the aim of climbing 2000 metres (6560 feet). I felt strong, and so did my knee, so once I reached my goal I kept on pushing. I got home having ridden 145 kilometres (90 miles) over 6.5 hours, with more than 3000 metres (9840 feet) in the bank. It was only a third of the way to an Everesting, but after the anguish of the preceding months, it felt like a massive victory. Better even than my 3000 out-of-the-saddle metres (9840 feet) at Walkerville.

For the first time since my training began in September, I was starting to feel a sense of cautious optimism about my Everesting.

With my attempt planned for 3 weeks' time, I figured I had a chance for one more big ride before tapering for the final 2 weeks. In early February I headed to Ballarat, 90 minutes' drive west of Melbourne, to report on the Australian Road Cycling National Championships for CyclingTips. On a quiet morning between major races, I went out to nearby Mt Buninyong with a clear goal: to complete a Half Everesting – 30 laps of the 2.9-kilometre-long (1.8-mile), 150-metre-high (490-foot) climb used in the Nationals road races.

The early morning laps passed with ease. I was feeling good on the bike and motivated to reach my goal. I stopped after 10 laps (1500 metres/4920 feet) for a quick snack break and to refill my water bottles before carrying on. I reached 20 laps (3000 metres/9840 feet) just after lunchtime, still feeling strong, but my knee was starting to feel irritated.

I had a decision to make: press on to 30 laps and reap the psychological rewards of having gone halfway to an Everesting in training but risk injuring the knee and jeopardising the main event in 2 weeks' time. Or, I could stop right away, preserving my knee as best I could, but leave myself with much greater uncertainty come Everesting day.

I had some lunch and told myself I'd start again afterwards, and see how I went. Lap 22 was the toughest of the day – I was tired and flat, and it was a real struggle to drag myself to the top. But my knee was starting to feel a little better, so I carried on.

As the laps piled up, I started to feel stronger, and my knee improved. By the time I'd completed 25 ascents I'd made up my mind – I was going to push on to 30 laps. I reached a Half Everesting after 9 hours and 15 minutes on the bike, having ridden 175 kilometres (109 miles).

There were a lot of positives to take from the ride. The only thing that made me want to stop was fear of damaging my knee – I never got close to feeling fatigued enough to want to stop. I'd minimised the length of my breaks – less than an hour off the bike for more than 9 hours of riding. I ate and drank regularly and never felt particularly hungry or thirsty. I paced myself well – my lap times were all within 4 per cent of one another – and I didn't fade as the ride went on. Best of all, when I finally did stop riding, I could easily have continued.

The preparation

That evening, as I reflected on the day's exertions, my cautious optimism about Everesting grew into something closer to cautious confidence.

Sure, the training plan I wrote out months earlier hadn't come to fruition. I never got to re-ride Crux with its 5600 metres (18,370 feet) of climbing. I never got a chance to use the training techniques Dr Stephen Lane taught me, and I didn't get to do more than 15 laps of my Everesting hill in training (I'd hoped to do a Half Everesting there). But despite all that, I was feeling positive.

After months of doubt and uncertainty, I was starting to believe that finishing an Everesting might actually be possible.

My knee pulled up fine from the Half Everesting and as I started my 2-week taper I was feeling a rare optimism about the challenge ahead. But it didn't last long.

A few days later, on an innocuous one-hour ride in the suburb of Heathmont, I cycled up one slightly too-steep backstreet and my knee flared up significantly. I was cursing my stupidity but couldn't help but laugh that a 9-hour ride had seemingly been fine for my knee, but a single 100-metre (328-foot) stretch of residential backstreet was too much.

The knee settled a few days later and my spirits rose again. I got my bike serviced and an easier gear installed (34 × 32T) to help in the fatigue-drenched final hours of my Everesting. I weighed myself and discovered I was down below 72 kilograms (158 pounds), easily the lightest I'd been in my adult life. I was feeling ready and excited to tackle this almighty challenge. But the universe had one final twist in store for me.

Eight days before my Everesting attempt, the Victorian Government announced a 'snap lockdown' to battle a surge in local coronavirus cases. The state would be locked down for 5 days, with exercise limited to 2 hours a day. If all went well, restrictions would lift 2 days before I was set to do my ride, but given how a 6-week lockdown in mid-2020 had turned into more than 110 days, I wasn't overly confident. To my surprise, restrictions lifted as planned and everything fell into place at the last minute. It was finally time to attempt an Everesting. 🚲

The preparation

Everesting

**Left**
I did most of my training solo, but when it came time to do my Everesting, I had plenty of support.

The preparation

# PART THREE
# THE RIDE

# THE EVERESTING

**Everesting**

**M**y alarm went off at 3 am and I sprang into action with unexpected ease – I was keen to get moving as quickly as possible. I'd organised as much as I could the night before – all that remained was to get myself dressed, wolf down some breakfast, put a cooler full of drinks in the car, strap my bikes to the roof (no harm in having a spare) and drive the 10 minutes to my climb.

In the eerie silence of the early morning I pulled up at the small park in Ringwood East and made my final preparations as efficiently (and as quietly) as I could. I pulled out the whiteboard I'd prepared a day earlier, ready to mark off sets of 10 ascents. I turned on my GPS units (again, no harm in having a spare) and let them find satellites. Finally, I strapped my left knee like the physiotherapist had shown me 2 days earlier. If I was going to get through an Everesting, my knee would need to cooperate.

A few minutes before 4 am I clipped into my pedals for the first time, turned on my lights, rolled to the bottom of Walhalla Drive, and turned around to begin my first of 240 ascents.

It was showtime.

There was a certain relief in finally starting to ride. I'd been a bundle of nerves in the lead-up, but now there was nothing else to do but ride.

And yet, those first few hours in the dark – just me, the silence of the sleeping suburb, and the occasional fox skittering across the road – proved almost overwhelming. I was all too aware of the magnitude of the challenge before me.

I tried to zero in on the minutiae of the effort, just as sport psychologist Michael Inglis had suggested. A gear change here to combat the steeper gradient at the top of Walhalla Drive; out of the saddle there to unload my quadriceps; a smooth, seated pedal stroke as the road flattened off briefly on Isabel Avenue; another short stint out of the saddle for the final ramp to the top.

At 5.30 am, a local resident, Owen, emerged from his house to join me for a lap. He was off for a ride of his own but wanted to wish me luck before setting off. 'You got this,' he said assertively before rolling away. It was a simple gesture, but one that served to bolster my resolve.

The first light of day started to bleed over the Dandenong Ranges around 6 am. I was grateful for the daylight, even if it did signal the start of a warm day ahead. The forecast had promised significant humidity and a top temperature of more than 30°C (86°F) – far from ideal conditions.

As day broke, I caught sight of my childhood home for the first time – a place of happy memories that would prove a welcome distraction throughout the day. Daylight also revealed some markings on the road near the top of the ascent – someone had written 'Go Matt' in chalk, accompanied by a big smiley face. A day earlier I'd dropped a note in the letterbox of each house I'd be riding past, sharing my plan with local residents. The chalk message that resulted made me smile and provided a gratifying boost of motivation.

The rising sun brought with it the discovery of another such message: the words 'GO MATT GO' printed out and stuck to the front window of a nearby house. This community support was a mere taste of what was to come.

As I closed in on lap 40, my best mate Nick joined me for a few laps before heading out for a ride in the Dandenongs. A short time later, a local resident offered a 'good luck mate!' as I climbed slowly past his house. All was right with the world: the early laps were ticking away nicely; my knee, though tetchy at times in the first couple of hours, had settled completely; and I felt like I had support wherever I looked.

My partner, Imogen, arrived as I ticked off lap 60 – a quarter of the ride complete in around 4.5 hours. The coffee and muffin she brought offered a much-needed boost of energy but not as much as her smiling face and our brief exchanges each time I climbed past. I might have been riding on my own, however, with Imogen there I felt anything but alone.

That feeling lasted through the morning. A resident across the road from my base camp at the park asked how I was getting on and whether I needed anything. Higher up the climb, a woman wished me luck from her balcony, promising she'd check on me later in the day. She was true to her word, asking after me periodically until late in the evening.

While I was vaguely aware of the morning's passing, I had no real concept of time. My life had been reduced to blocks of 10 ascents. I aimed for 70 laps, then 80, then 90. Occasionally I'd find myself calculating how much longer I might be riding. Each time I regretted it immediately; each time I quickly refocused on the next immediate milestone – the next multiple of 10 laps, the next short break, the next square I could cross off my whiteboard.

With 85 laps behind me, I stopped briefly to apply sunscreen for the first time – the temperature was nudging 30°C (86°F) and I was starting to feel it. No sooner had I done so than the first of the day's rain arrived. Normally rain would have left me frustrated, but with temperatures rising, the brief drizzle offered refreshing respite.

There'd be other such showers throughout the day, but none lasted more than a few minutes, and none had me close to needing my rain jacket.

As I reached lap 100, the complexion of the ride changed significantly. Until then, I'd ridden all but six laps on my own; from that point on, I barely rode alone at all.

My brother Ash arrived late morning and when I started lap 101, he was there beside me for the next 10 laps. Down at the park, a strong family contingent was starting to arrive, joining Imogen in supporting from the sidelines. Meanwhile on Instagram, I started receiving a flurry of responses to posts I'd shared earlier in the morning. People had my back wherever I looked, and it meant the world.

This flurry of encouragement couldn't have come at a better time – laps 101 through 120 were perhaps the toughest of the day. Fatigue was starting to set in, the heat and the humidity were taking their toll, and I was in need of food, drink and a rest.

With 120 laps in the bag, I rolled to a stop at the park and began what would be my longest break of the day – roughly half an hour off the bike. I changed out of the sweat-drenched cycling kit I'd been wearing for the last 9.5 hours and wrangled myself into a fresh set. It too was drenched within minutes, such was the humidity.

I took a seat to catch my breath and say hello to family that had gathered, making sure to eat while I did. After two mouthfuls of a cheese and bacon roll, I felt like I was going to vomit or pass out, or possibly even both. Light-headed and ashen-faced, I stood up and tried to stop myself from spiralling into a vortex of negativity. 'You're only halfway and

you feel *this* rubbish?,' something inside me asked. 'There's no way you're going to finish.'

I got myself back on the bike as quickly as I could, hopeful that I'd feel better once I was moving again. Ash joined me for a few laps as I limped into the second half of my Everesting, his conversation offering much-needed distraction. A few laps later, nearby resident and two-time Everester Jeff Servaas arrived to ride a few support laps. He'd been out for a ride that morning, seen my whiteboard with 'Everesting' scrawled across the top, and recognised a job for a sherpa when he saw one.

Like Ash, Jeff would prove instrumental in those halting, gut-churning laps after the halfway mark, regaling me with stories of his own Everestings, his cycling exploits more generally, and anything else he could think of to pull my attention away from the battle I was clearly engaged in.

I started to feel better as the afternoon wore on, and the laps began to pile up nicely. It certainly helped that Jeff was still tapping away beside me, and that Ash had rejoined us after a short break. Then my friend and CyclingTips colleague Iain Treloar arrived to ride some support laps, giving me the luxury of three wonderful sherpas to help share the load.

In the best moments of the day, Everesting felt like a smooth and simple transaction: I was merely exchanging my time for elevation gain. At the worst moments, it felt like riding through treacle – a battle for every single metre. As the day went on, the two states were often mere moments apart. One lap I'd be sailing along, climbing with relative ease, the next I'd be wrestling with my bike and myself.

When Jeff and Iain headed home and Ash took a break, I opted for a quick rest as well. I was doing it tough, but for the first time all day I started to think about the finish line.

With 150 laps complete and 'just' 90 to go, I realised I was starting to feel cautiously optimistic.

Then I started doing the maths. 'Each lap is taking around 4.5 minutes, so that's about 45 minutes for 10 laps. Nine sets of 45 minutes, plus breaks? That's another … 7 hours? Oh god.'

The panic came on quickly. 'I've already been out here for more than 12 hours,' I reminded myself, seemingly intent on self-sabotage. 'How can I possibly do another seven?'

I remembered my conversation with Michael Inglis and his explanation of 'unhelpful thoughts'. My internal monologue, I realised, was the very definition of unhelpful. I quickly pushed the negativity away and instead focused on my next milestone. 'Ten more laps,' I told myself. 'Just aim for 10 more laps.'

Ash joined me when I set off again. The temperature surged as we rode into the late afternoon and the humidity that had accompanied most of the daylight hours was replaced with a drier, more uncomfortable heat. I tried to make sure I was getting enough liquids and salts into my system – the last thing I wanted was for cramping to derail my efforts. My dad Ron had arrived a few hours earlier, and he and Imogen proved invaluable in handing up fresh water bottles or handfuls of food when required.

Friends and family members came and went. Nick returned with his two girls, bringing potato cakes that offered the perfect blend of the salt I was craving and the carbohydrate I needed. Local residents, too, dropped in, checking on my progress, offering any assistance they could provide. I felt truly humbled.

As I closed in on 160 laps, Ash stepped off his bike for the final time and my other brother, Brendan, saddled up for his first stint – a touching and inspiring tag-team effort. Brendan rode with me all the way to the three-quarter mark, providing excellent company as my energy waned and my fatigue grew.

I stopped again at lap 180, had something to eat, another drink, and took stock of my progress. I had much to be proud of. With 6600 metres (21,650 feet) in the bank, I'd easily trumped my biggest day of climbing – 5600 metres (18,370 feet) at Crux back in 2013. Best of all, I was three-quarters of the way to a goal I'd been working towards for months.

Then I started running the numbers again. 'Sixty laps to go, 45 minutes for 10 laps,' I thought, unable to help myself. 'There's still another 4.5 hours to go?! How is that even possible?' I couldn't wrap my head around it. How could I be three-quarters done, yet still be so far from the finish? It was as if the ride was never going to end.

Again I started to panic. Again I batted the feeling away and turned my attention to the next set of 10.

It was strange starting up again on lap 181. For the first time in what felt like hours, I was riding on my own. By lap 190 I was past ready for the ride to be over. By lap 200 all daylight had drained from the sky and I was back riding in the dark, just as I had been so many hours (or was that days?) earlier.

Brendan joined me on lap 201 for 10 more laps, and by the time Jeff returned on lap 207 for another valuable sherpa stint, I'd found a burst of energy and motivation. I was still desperate for the ride to be finished but, strangely, I was feeling stronger than I had in many hours.

I stopped briefly after lap 210, grabbing some more food and drink to help power me through the next block. As I got myself ready to push on, Imogen said that I seemed to be doing it easy. She was right – I was feeling surprisingly good – but I knew that could all change in a matter of moments.

Sure enough, no sooner had I begun lap 211 than I was struggling again. I'd gone from feeling fluid and efficient on the bike to incredibly sluggish in the space of 5 minutes. Jeff shepherded me through to lap 220 before heading home at around 10.30 pm, a big and very welcome day of sherpa-ing complete.

As I began my final two sets of 10 laps, it finally felt like the end was in sight. Brendan saddled up, determined to support me through to the very end. Out of nowhere I started to feel strong again, my spirits rising with every lap we completed. I was actually going to make it.

We didn't say much in those final two sets. Brendan and I were both exhausted, ready to head home for bed. As we neared one final break with 230 laps complete, I told Brendan I wanted to ride 12 laps for the final set rather than 10. I didn't want to miss out on the Everesting Hall of Fame, I explained, on the off-chance I'd miscounted the number of laps I'd completed. Best to do a couple of extra laps, just to be sure.

Those final 12 climbs sailed by. Brendan and I counted the laps as we went, as did Dad, Imogen, Nick and my grandfather Rob, all of whom had stuck around, late into the night, to see me finish.

On the penultimate lap, Brendan asked whether we should ride the last lap a little harder, to finish things off in style. Sure enough, as we reached the bottom of Walhalla Drive and began our last ascent, Brendan worked up through his gears and increased the pace. I found something in my legs to power past him and surge to the top of the hill for the 242nd and final time. It was easily my fastest lap of the day.

I unclipped from my pedals for the final time a little after midnight. The sense of relief was palpable. I could finally – *finally* – stop riding.

With my head draped over my handlebars, I took some deep breaths as those gathered took photos and offered their congratulations. I thanked them for all their support, including Brendan, who'd ridden an impressive and invaluable 54 laps throughout the evening, despite having barely ridden in 4 months. Exhausted but tremendously satisfied, I put a red 'X' through the final square on my whiteboard.

I'd done it – I'd completed my Everesting.

It had been more than 20 hours since I started my first ascent and in that time I'd spent a little less than 18 hours on the bike. It wasn't just my longest-ever ride by more than 7 hours, it was also the most climbing I'd ever done in one ride – a grand total of 8954 metres (29,377 feet).

I'd covered 265 kilometres (165 miles) on the same 530-metre (1740-foot) stretch of tarmac and burned more than 36,000 kilojoules (8600 kilocalories) – the equivalent of more than 15 Big Macs – in the process.

We didn't linger long – Nick put my bikes on the roof and helped pack the car, and then, bare minutes after we'd stopped riding, the park was empty, all of us on our way home.

In truth, the ride proved slightly easier than I'd expected, at least physically. I'd anticipated long stretches of excruciating, soul-crushing drudgery like I'd experienced on other epic rides, but those moments never really came. It certainly wasn't easy, though – the sheer length of time spent on the bike was enough to make this one of the toughest battles I've ever faced. And as many others have found, it was the psychological battle that proved most taxing.

Until the final set of 12 laps, the summit of Everest always felt impossibly far away. Keeping that feeling from overwhelming me took considerable and consistent effort.

The fact I was able to complete an Everesting at all is testament to the wonderful support I enjoyed throughout. I was genuinely touched by the words of encouragement from the dozens of local residents who left notes or checked in on me throughout the day. Many spent long stints chatting to my friends and family at the park, some even staying late into the night.

**Right**
I started the
day in the dark
and finished it in
the dark.

Those who urged me on with messages via social media provided a significant morale boost when I needed it most. And those who rode by my side offered more assistance than they might have realised. Brendan, Ash, Jeff, Iain, Nick and Owen – all helped the laps tick away much faster than they would have otherwise. After riding most of the first 100 laps on my own, I'd been alone for just 32 of the last 142.

The support I had at the park was equally heartwarming. From the family members who brought handmade signs to spur me on, to Dad and Imogen handing up food and drink whenever I asked for it, to the simple knowledge that I would see some friendly faces at the start of every lap – it all played a very real role in getting me to the finish.

It took a few days for the significance of my achievement to sink in. I'd been working towards an Everesting for more than 9 months, and for almost the entire time I doubted whether I could complete it. Indeed, I'd assumed Everesting was beyond me ever since I first heard of the concept, way back in 2013.

In completing an Everesting I didn't just achieve what I thought I couldn't; I did so after a series of seemingly interminable injury setbacks. For more than 5 months, I battled a knee injury that repeatedly derailed my training and had me questioning whether I'd be adequately prepared to attempt an Everesting, let alone complete one. I lost further weeks of training to perineal discomfort that had me scared to ride at all.

To get through an Everesting after all that? I couldn't be prouder or more relieved.

🚲

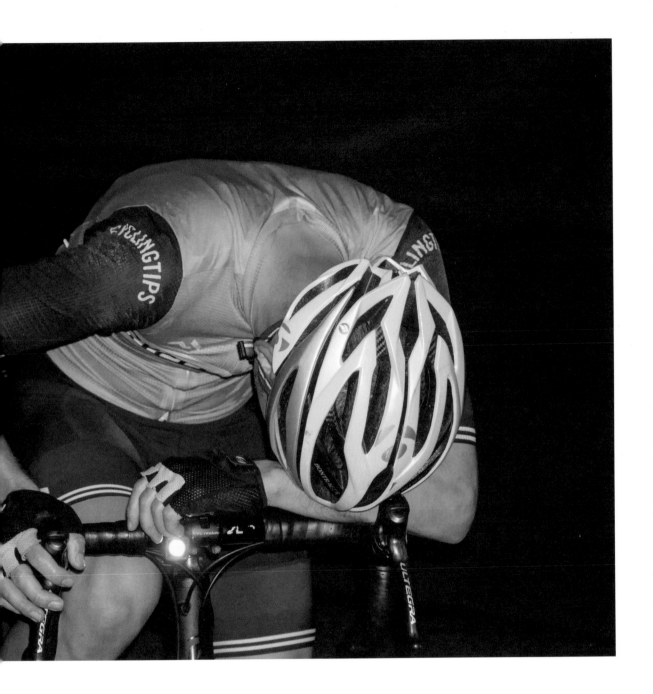

Above

Exhaustion,
joy and relief,
all rolled into one.

# PART FOUR
# THE TRAILBLAZERS

io

# CELEBRATING THE FINISH LINE

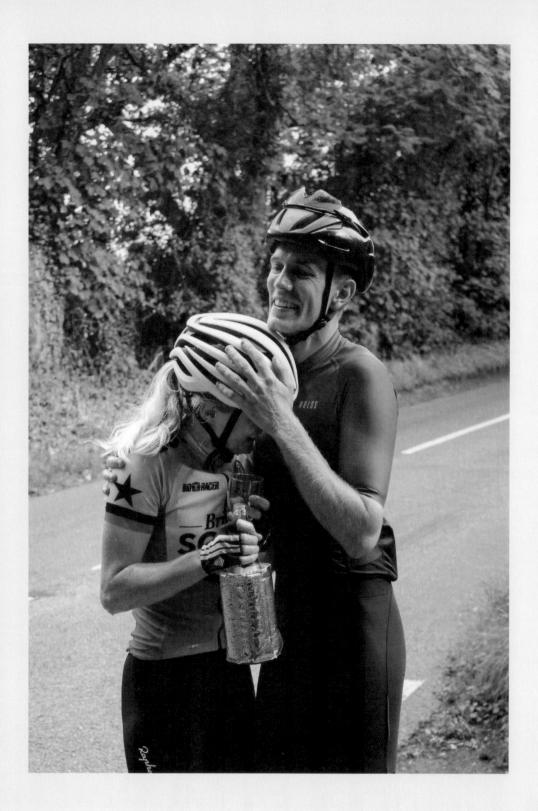

Everesting

On 23 April 2016, Alex Garcia turned his bike off US Highway 70 near Marion, North Carolina and into a nondescript car park in front of a few nondescript shops. As he rolled down the hill to end his monumental ride, Alex was welcomed by the deafening cheers of around 15 friends and family members who had gathered to celebrate his arrival.

Alex rode through a length of red tape that two people had stretched in front of him, symbolising the end of his ride. He slowed to a stop, wheezing, his time in the saddle finally coming to a close. 'Love y'all,' he said to those gathered, as a handful of children took great delight in covering him with silly string.

Alex had spent the past 32.5 hours slogging up and down the Highway 80 climb in the state's west, covering 415 kilometres (258 miles) and climbing well over the height of Mt Everest in the process. In completing 22 laps of the 8.9-kilometre (5.5-mile) climb, he'd pushed himself to his limit, riding to raise awareness about US military veteran suicides.

He'd ridden through one day, through the night, and through another day – his longest ride by some 24 hours. He'd persevered through 6 hours of continuous rain, he'd struggled to stay warm, and he'd dealt with such fatigue that he didn't think he could carry on. But ultimately, with the support of many others – on the bike and off – he'd battled through to achieve his goal.

Alex's satisfaction was clear from his exhausted smile as he made his way gingerly through the gathered crowd, thanking each and every person who had come to support him and his mission.

For most riders, completing an Everesting is cause for great celebration. They've completed a monumental physical challenge, drawing on significant mental resolve in the process. But for most that cross that imaginary finish line, in some sense hauling themselves onto the summit of Mt Everest, satisfaction and joy aren't the only emotions at play. Many experience a palpable sense of relief – a sense that the job is done, that they can finally stop punishing themselves. That was certainly a feeling I had.

But as I read, watched and listened to a raft of other Everesting accounts in the process of researching this book, I realised many riders experience something entirely different upon finishing: a feeling of anti-climax. A sense that the magnitude of joy at completing the challenge doesn't match the magnitude of the challenge itself.

'There were no fanfares and fireworks; no finish line … no clapping, T-shirt and medal with a goodies bag,' wrote Dr Alex Stavrinides after his Everesting on The String on the Scottish Isle of Arran. 'No one met me, it was just me in the dark by my car, my front light dead and my rear light blinking red. Now

## DYNAMIC DUO

There are many couples who ride bikes together. There are significantly fewer who complete Everestings together. Peter Short and Kristen Slade are one of those rare couples. They show that completing an Everesting can be about more than your own personal accomplishment – it's an opportunity to share the experience with a loved one.

In June 2020, Peter and Kristen ventured out to a steep section of bike path in Gladstone Park in Melbourne's north-west to tackle their third Everesting together. The 370-metre (1214-foot) section of path rises at an average gradient of 10 per cent, with a savage ramp of above 20 per cent right near the end.

The couple spent 21 hours on the path, riding more than 240 laps together. 'It was a tough day on the bike – we started 1.30 am Sunday and finished 11 pm,' Peter wrote afterwards. '[It was] very cold during the night. Hit the wall at about 220 laps so the last 24 laps were slow but got done. Kristen was amazing and great support to finish it.'

It's clear from Peter and Kristen's respective Strava files that they enjoy tackling such challenges together, and revel in supporting each other through them. 'Thanks to my crazy strong partner for another adventure – our toughest yet,' he wrote on her Strava file. She replied: 'Love you baby – you pushed through those last few so well whilst in the hurt box – one of so many reasons I love you like crazy my crazy boy.'

time for a very quiet "woo hoo!" and drink a kids Yazoo chocolate milkshake while I took off my shoes. I put the bike on the roof of the car, quietly closed the car doors, and did the short drive to the cottage.'

While Alex had a brief, personal celebration at the finish, some people find there's actually little joy in the moment of completion. The feeling of satisfaction might come later, or perhaps it never comes at all.

British author Max Leonard tackled an Everesting in 2014 as research for his book *Higher Calling: Road Cycling's Obsession with the Mountains*. Upon completing his Everesting on Firle Beacon in southern England, Max wrote that 'It took me a few days, weeks even, for the events of that day to settle. We had succeeded but, bizarrely, it was an anticlimax. In all honesty I hadn't countenanced the possibility of failure, correspondingly, there didn't seem to be all that much to celebrate. We had passed the time and the itch had been scratched but I was not elated.'

For others, there's even a sense of sadness upon completing the ride. John Applegarth had that feeling after completing an Everesting on Bacombe Lane in Wendover, southern England. 'As I came towards the end of the ride I felt a certain sense of sorrow and disappointment that I'd reached the end of my journey,' he wrote in a blog post. 'Elation eluded me. I'd put my heart and soul into training through the winter and I think that is really where the enjoyment, sense of progress and achievement was to be found. Perhaps the answer to the question of why we climb lies somewhere between the base and the summit of the mountain.'

To some, completing an Everesting is a celebration of personal achievement, of setting an ambitious goal for oneself and conquering all obstacles en route to that goal. For others, Everesting is something less inward-looking – it's a celebration of shared experience, of completing something

**Right**
Peter and Kristen
on one of 240 plus
laps of the steep
bike path in
Gladstone Park.

difficult with the support of others. Sure, Everesting is ultimately a solo endeavour – no one else can turn the pedals for you – and there are a great many who enjoy Everesting as such, riding alone throughout. But for perhaps the majority, finishing an Everesting is a celebration of companionship and community spirit as much as it is a personal achievement.

For such individuals, it's not reaching 8848 metres (29,029 feet) that stands out most vividly in memory – it's the time spent with others, the conversation with a fellow rider while riding laps in support, the completion of a challenge with family and friends in attendance. Remember Andy on the challenge's first weekend in 2014?

Among Andy's most poignant memories of the day was riding the final lap with his wife, Tammy, and sister-in-law, Bree, after several laps with fellow rider Chris Archer.

Paul Dalgarno, who also Everested on that first weekend in 2014, had a similar experience when he attempted his second Everesting a month later. Paul was riding Yarra Street in Kew, just 5 kilometres (3.1 miles) east of the Melbourne CBD, a notoriously steep climb that ramps up from Yarra Boulevard, one of the city's most popular cycling thoroughfares. Most riders pass by Yarra Street, ignoring its painfully steep grades. Those that brave it rarely tackle more than one ascent.

## THE BAIL-OUT LETTERS

In February 2015, a group of 20 Australian women set the record for the largest group Everesting with an incredible ride on Mt Donna Buang – a climb of great significance in the Everesting story.

Perhaps the most touching aspect of the day was something Andy helped organise for each of the riders. 'We asked for something in secret from each of the riders' family and friends,' Andy wrote on the Official Everesting Discussion Group on Facebook. 'Their task was to write a bail-out letter. We gathered each rider's letter, sealed it, and popped it in a ziplock bag, and each of the riders then took that with them without knowing the contents. The idea was simple: when things got dark, when it looked like they couldn't pedal another stroke, when it was time to pull stumps, they were instructed to take out the letter and read it. When you are in that dark place yourself, the best people to get you out of it are those that love and care for you the most.'

Several of the riders replied to Andy's Facebook post saying they still have their letter – a beautiful keepsake from a brutal day.

Paul started his effort mostly alone, but when Andy posted about the ride on the Hells 500 social-media channels, Paul started to be joined by a steady stream of fellow riders. 'For the next few hours barely a lap went by in which someone wasn't riding with me; and, as if it was orchestrated, when that rider left another would turn up to do some,' Paul wrote for my blog, *The Climbing Cyclist*. 'Having a wheel to follow, a person to talk or say nothing to, made a massive difference – instead of the endless Garmin-watching and failed attempts to break free of Garmin-watching, there was another body, on another bike, showing solidarity. And not just people on bikes. Six or seven cars passed throughout the afternoon, with drivers and passengers I'd never seen before winding down their windows and shouting "Keep it going, Paul", or similar.'

It wasn't just the quality of the support that Paul found so heartwarming; the spontaneity of it was, too. He described it as 'one of the most unexpectedly life-affirming experiences I've had' – a feeling I can certainly relate to. He went on to finish his Everesting in around 15.5 hours. Reflecting on the ride more than 6 years later, the support of other riders is among the elements he remembers most keenly.

It was a similar story for RJ Sauer in May 2020, north-east of Vancouver, Canada. RJ was riding to raise money for COVID-related charities and spent nearly 25 hours slogging up and down Mt Seymour, towing his son Oliver's bike trailer behind him.

Oliver came along for the ride on some laps; most of the time he didn't. But RJ spent the entire ride towing that trailer. It was, in his words, a logical decision after spending so much time with Oliver during the coronavirus pandemic. 'I quickly became acclimatised and accustomed to the efforts and appreciated having Oliver perpetually drawing behind me,' he wrote on the Salsa Cycles website. 'Not to mention, our next

big riding plans were likely an expedition pulling the chariot, so what better way to continue training?'

Reflecting on the day, RJ explained how powerful the support of others was: 'The emotional impact of the company and camaraderie was the part I hadn't fully accounted for. I knew having family, friends, and neighbours riding by my side would be uplifting, help pass the time, and distract from some of the repetition and monotony, but I didn't realize how special these chummy pelotons would feel.'

A ride as hard as an Everesting has the ability to inspire riders and non-riders alike. That's what Dutch brothers David and Job de Bondt found in July 2020 when they Everested one of world cycling's

most legendary climbs: the Muur van Geraardsbergen ('Wall of Geraardsbergen').

'The Muur' is a narrow 1-kilometre (0.62-mile) ascent that winds its way through the streets of Geraardsbergen in the cycling-mad region of Flanders, north-west Belgium, ending at a quaint chapel atop the Oudenberg. The climb's average gradient of 9.3 per cent would be tough enough already, but climbing The Muur is made considerably more difficult by the rough cobblestones that comprise much of the climb.

One Sunday every April The Muur is lined with screaming fans cheering on the world's best bike racers as they tackle the climb as part of the Ronde van Vlaanderen (the Tour of Flanders), one of road cycling's most prestigious one-day races.

**Right**
Everesting is often a family affair as RJ Sauer found.

**Celebrating the finish line**

**Left**
Brothers David
(in blue) and Job
(in red) de Bondt
during their
Everesting on
the Muur.

Everesting

The De Bondt brothers didn't have quite the same crowds when they tackled their Everesting on The Muur, but the community support they did enjoy was still the highlight of the experience.

'The atmosphere throughout the day and night was the most special,' David told me. 'From a town that was fully asleep when we set out, slowly waking up as we were making our way up and down the climb, to more and more people noticing what was going on …'

The crowds grew through late afternoon and into the evening, with townsfolk cheering on the brothers as they repeatedly tackled the tough climb and the rough, jarring descent. Just before midnight, a chef at a nearby restaurant baked *mattentaarten* – a local delicacy comprising a puff pastry pie with a filling of almond-flavoured cheese curd – especially for the pair. When the brothers finally stepped off their bikes a few hours later, a handful of townsfolk were there waiting with champagne. Among those waiting, Geraardsbergen's *Belleman* (town crier), decked out in his red ceremonial robes.

It was a fitting celebration of a remarkable ride. It had taken the De Bondts roughly 20 hours of riding over a 25-hour span to get the job done, in which time they'd impressed and inspired a great many people. 'The thing is,' David says, 'we just rode, but the town of Geraardsbergen made the day.'

When Andy created Everesting in 2013 he did more than codify a simple concept – climbing the height of Mt Everest with repeats of a single hill. He helped build a community around that concept. He created something that ambitious athletes around the world could gravitate towards, connecting with like-minded riders along the way.

In truth, the foundations of that community were laid in the years before Everesting was launched, fostered through several years of grassroots Hells 500 epics in the hills around Victoria, Australia. But as Everesting has grown, so too has the community around it, from a handful of hardy Australian riders, to cyclists, runners and many others all around the globe.

For Andy, it's always been about community. Listening to him, you get the sense that Everesting was created as much as a vehicle for bringing people together as it is to challenge people's limits. After years of hard graft building Everesting with his wife, Tammy, Andy's heard a lot of Everesting stories. It's telling that when I ask him about the ones that stand out most to him, it's not a story of physical strength or perseverance that first comes to mind – it's a story of human connection.

'The little moments that really stick out with me, and they still affect me now, are when I pull up an activity [on Strava] and whenever there's photos, I'll always look at them because I'm interested to see the smiles or the buckled faces,' he says. 'But invariably there's also a picture of the family member that's holding up a handmade sign … if that doesn't get you, I don't know what will.

'I don't need to know those people, they don't need to know me, but they've done this thing which is so personal to them and it means so much for their community that their community will come out and sit on the side of the road to watch this thing. How can I not continue to be involved where there are these amazing touchpoints that mean so much to people along the way?' ⚲

Everesting

**Left**
Saulius Speičys
shares a hug with
his community of
supporters.

# LYCRA
# PARTY

A rider doesn't need to attempt an Everesting outdoors to enjoy terrific support. Where playing sherpa for an outdoor Everesting requires geographical proximity and, usually, an agreeable time of day, vEveresting throws the doors wide open.

Those attempting a virtual Everesting are encouraged by Hells 500 to put the word 'vEveresting' in their Zwift avatar's name so riders can see what they're up to. Anyone from around the world can ride alongside the vEverester, joining them in virtual solidarity, and send messages of support. While the average sherpa mightn't be willing to ride laps outdoors at 3 am, the global nature of Zwift means there's always someone in a friendlier time zone who can join along for a few laps.

During Easter 2020, Hells 500 capitalised on this fact with what it called a virtual 'lycra party'. The goal: to get as many people to complete an Everesting that weekend as possible, all riding on the same virtual climb: Alpe du Zwift. The volume of riders on the same hill meant that no one was riding alone – someone would always be there, either a fellow vEverester or someone else out riding the virtual climb.

All told, 216 completed a full vEveresting (or more) that weekend, while another 48 completed a vBase Camp, or Half Everesting. Andy was one of the riders to complete a vEveresting that weekend. He looks back on it with great fondness. 'It was one of the most enjoyable days I've suffered on a bike,' he tells me. 'Not only are you surrounded by your mates like you would be in real life, but there's this incredible community that's chatting to each other the whole way and supporting and getting e-sherpas riding with you from all over the world.

'Literally from the first moment I ticked over the first lap at three, four in the morning through to the last one I was punching out at nine or 10 o'clock at night, there were people the whole day happily riding alongside you, which is pretty cool.'

▲

# THE FACEBOOK GROUP

Social networks like Instagram and Strava have been instrumental in the growth of Everesting, providing a platform for riders to share their stories and infect others with the Everesting bug. But nowhere is the online Everesting community stronger than on Facebook.

Created in September 2018, the Official Everesting Discussion Group was set up as 'a space for Everesters past and future to discuss plans, ask questions, and share knowledge.' Thousands have since joined the group.

As Scotsman Billy Sturgeon found, the page is brimming with fellow riders ready to offer support and encouragement.

In May 2020, Billy attempted an Everesting on the Isle of Arran, south-west of Glasgow, Scotland. He rode the same 1.4-kilometre (0.9-mile) stretch of road for nearly 14 hours, clocking up 7300 metres (23,950 feet) of elevation gain – less than 1600 metres (5250 feet) short of his target. Ultimately, he fell short due to extreme tiredness.

The following day Billy posted about his failed Everesting in the Facebook group. 'Gave it a go and failed,' he wrote. 'Not sleeping the night before due to excitement turned out to be my downfall. Upset a little cos I had great legs, even once the sun had set. On to the next effort through the summer I suppose.'

Billy's post received dozens of responses, the vast majority incredibly positive.

'There will be a next time and you will succeed,' replied group member Michael MacDonald. 'Now you know both the mental and physical challenges of this ride.'

'Great effort – and so close to hitting 8000 metres (26,245 feet),' wrote Alice Thomson, former record holder for the fastest women's Everesting. 'Sure you'll get it next time,' she added with a flexing muscle emoji.

'It's not a failure fella! Just a learning curve,' wrote Paul Nicholls, another group member. 'Next time it's yours. Great effort regardless.' He too added a flexing emoji, followed by a thumbs up. ▲▲

# PART FOUR
# THE TRAILBLAZERS

# 11

## OTHER PATHS
## TO EVEREST

Everesting

**E**veresting was first conceived as a challenge for road cyclists. That's how George Mallory had done it in 1994 and that's how virtually everyone did it on the launch weekend in 2014. But Everesting hasn't stayed as a road-cycling challenge.

We've already learned about vEveresting – completing the challenge online, indoors – but Everesting has extended much further than that, too.

In September 2014, 7 months after the launch of Everesting, Andy introduced a new challenge for those who had already completed an Everesting and were looking for their next monster ride. 'The SSSS is an elite (and slightly evil) class of #everesting,' Andy wrote in a post on the Hells 500 Facebook page. 'It's totally nuts.'

The SSSS challenge comprises four separate Everestings, one of which must include more than 10,000 vertical metres (32,808 feet) of climbing:

- **Short:** a ride of less than 200 kilometres (124 miles)
- **Significant:** an iconic climb, as adjudicated by Hells 500
- **Suburban:** an urban climb
- **Soil:** a ride completely away from sealed roads

For riders looking to take Everesting to the next level, heading off-road is a sure-fire way to amplify the difficulty. Welsh rider Marcus Leach found this out firsthand.

'Gravel Everesting done. 9315 metres (30,560 feet),' he wrote in the Official Everesting Discussion Group on Facebook. 'I've now done three Everesting rides and this was, without a doubt, the hardest of them all. It's on a totally different level to a road Everesting in my opinion, and that includes having done a steep road one. There's never a moment to switch off and relax whilst on the bike, the descents are just as hard, mentally and physically, as the ascents and it makes for a long day.'

The soft surfaces of an off-road Everesting make for less-efficient power transfer from rider to the ground. Even on a gravel bike or mountain bike, with bigger tyres that help increase traction, an off-road Everesting is always going to take more energy than one on a sealed surface.

As Christian Lloyd experienced during his MTB Everesting up Bluff Spur on Mt Stirling back on the opening weekend in 2014, off-road Everestings don't just take more energy, they can also mean dealing with rough, unforgiving surfaces. 'The climb up Bluff Spur is always as much a battle with the surface as it is with the pitch,' he wrote in a blog post. 'The trail is always covered deep with loose bark, sticks, leaves and plants.'

And then there were the corrugations. 'I had this great idea that I'd use my rigid mountain bike for the gravel road section below TBJ [Telephone Box Junction] and the dual suspension mountain bike for the rough section of Bluff Spur above TBJ and swap bikes on every lap,' he added. 'That great idea lasted about 3 minutes. As soon as I took off, I realised how corrugated the Mirimbah–TBJ road had become since I last rode it. The corrugations on a rigid frame bike took their toll on my hands in just one descent.'

In all, Christian spent 26.5 hours out on the mountain, including 2 hours pinned inside a shelter as an alpine thunderstorm settled over the area – the same thunderstorm that had soaked Andy during his nearby Mt Buller Everesting.

Other riders, meanwhile, have found different ways of increasing the difficulty of an Everesting.

Fixed-gear bikes are beloved of bike messengers and other urban riders for their simplicity. With only one chainring at the front and a single cog at the back, 'fixies' are great for those who want hassle-free riding. There's no fussing about with a cassette full of cogs or derailleurs to shift between those cogs. But while fixies might be simple and easy to maintain, they're also wholly unsuitable for a ride like Everesting.

**Right**
Everesting on gravel is significantly more challenging than on smooth tarmac.

For starters, on a fixie, the drivetrain and rear hub are connected. Where most bikes have a freewheel at the rear hub, allowing you to stop pedalling while the back wheel is turning – helpful while descending – a fixie's cranks are always turning whenever the back wheel is turning. When descending, this means pedalling at extremely high cadences – much higher than most cyclists would ever choose.

Then there's the fact fixies only have one gear.

Choosing the right gear ratio for a fixie is a case of personal preference, but that gear will usually be most comfortable on flatter surfaces where the rider will spend most of their time. While climbing, the rider is forced to grind away at a much lower cadence than any geared bike would offer. While descending, as noted, they'll usually be 'spinning out' at an uncomfortably high cadence.

Simply put, fixies are not ideal for riding up and down hills. You can see where this is going.

In May 2016, British cyclist Joseph Kendrick became the first-known rider to complete a fixed-gear Everesting when he rode 234 laps of Pepys Road in London, England. Conventional wisdom would suggest the 42-tooth chainring and 23-tooth cog he was riding were much too large for a *single* comfortable lap of the 7 per cent climb. As for doing it 234 times with that set-up? My knees ache at the thought.

A video documenting Joseph's ride only emphasises the absurdity of Everesting on a fixie. First, he had to complete each slow, grinding lap, mashing away on the pedals (and presumably the cartilage in his knee). Then at the top, he'd turn around and be faced with a decision: spin his legs at breakneck speed as his rear wheel spun faster and faster on the descent, or take a rather different and considerably more dangerous option.

## HIGH ROULEURS SOCIETY

In early 2015, a year after letting Everesting out into the world, Hells 500 launched another ridiculous cycling challenge: the High Rouleurs Society (HRS). To be admitted into the HRS, a rider had to climb 10,000 vertical metres (32,808 feet) and cover 400 kilometres (249 miles) in the space of 36 hours.

Like Everesting, the challenge was immense. But unlike Everesting, sleep was allowed, and the ride didn't have to be done on one climb – a rider could, and was indeed encouraged to, roam far and wide.

Hells 500 incorporated HRS into Everesting in early 2020 and an HRS ride is now considered its own sub-type of Everesting, known as an 'Everesting Roam'.

He went with the latter.

As he started to descend and his bike gathered speed, Joseph would unclip his feet from the pedals and rest them on the downtube of his bike. He would descend each lap this way, feet precariously balanced as his pedals spun furiously beneath him. 'I ended up "riding" a total of 170 kilometres (106 miles) like this, with just a front brake on a carbon rim,' Joseph declared in his YouTube video. 'It was sketchy as f!!!'

He'd started his ride at 8 am and had hopes of finishing by midnight. It took him until 5.20 am the next morning to rack up the equivalent height of Mt Everest.

As if Joseph's ride wasn't wild enough, how about an Everesting on a brakeless fixed-gear bike.

Joseph could afford to unclip his feet from the pedals while descending because he had a front brake on his bike to slow him. True fixed-gear bikes – including track bikes raced on velodromes – have no brakes besides transmission braking. By resisting against the cranks' desire to spin (as a product of being fixed to the real wheel), a rider can slow their bike. It works, but it's not nearly as effective or as safe as slowing with a regular rim or disc brake. Which brings us to Charli Mandel.

**Left**
The road that
Charli Mandel
chose for her
Everesting.

Charli had been inspired by Joseph's Everesting but she went on to raise the bar even higher. In September 2018, Charli completed a Half Everesting on Lookout Mountain just south-west of Golden, Colorado on the same bike she'd end up using for her full Everesting. It was her main work bike at the time – she worked as a bike courier – and had no brakes, a 48-tooth chainring up front and a 17-tooth cog at the back. That's a ridiculously large gear with which to be climbing hills, and considerably larger than the gear Joseph was riding.

As Charli found out with her Half Everesting, climbing at a knee-grindingly slow 50 rpm wasn't the hardest part – descending was. 'The descent, familiar though it was, would not provide the relief I had become accustomed to in my road bike Everestings,' she wrote on CyclingTips. 'The closest I would get to coasting would be spinning my legs neutrally at a not-exactly-comfortable 120 rpm, and I would have to expend yet more energy (and knee cartilage) to slow down for the two sets of several tight switchbacks [with transmission braking].'

Charli completed her Half Everesting in just short of 7 hours, having covered 167 kilometres (104 miles). 'My legs weren't exactly happy, but they weren't quite dead either,' she wrote. 'A full track bike Everesting was now terrifyingly within the realm of possibility.'

And so it was decided: 8 months later, on her 23rd birthday, Charli would attempt 23 laps of Lookout Mountain, enough to reach the height of Everest. As if the Everesting itself wasn't going to be hard enough, Charli would be doing it in the middle of hormone replacement therapy, as part of her male-to-female transition. 'Puberty 2: Feminine Boogaloo' she'd call it later.

Training proved tricky as her body adapted to the extra oestrogen she was taking. Things got worse when a 'dumb little fixie skid' led to a broken collarbone and surgery. Recovery proved tough, and when Charli was forced to abort a road-bike Everesting, her self-doubt about the track-bike Everesting only increased.

But eventually, in late May 2019, Charli headed out and faced Lookout Mountain again. It took her nearly 15 hours to grind through 334 kilometres (208 miles) but somehow she battled her way through it. She'd blasted her knees into oblivion and torn through a rear tyre with skidding – via hard transmission braking – but, remarkably, she'd achieved what she set out to. 'Coming up that final climb, in the rain, accompanied by blinding lightning flashes and [listening to] Sunn O)))'s *Life Metal* was probably the closest I've come to enlightenment on the bike,' she wrote.

While we're on the subject of inappropriate bikes for an Everesting, how about tackling one on a BMX? Traditionally used for stunt riding or racing, BMX bikes have tiny wheels, a single gear and a tiny frame, forcing the average adult to hunch over while riding one. Needless to say, BMX bikes aren't usually ridden uphill and downhill for 20 hours on end … but that doesn't mean no one's tried. In September 2020, two riders were brave enough to tackle and complete Everestings by BMX.

Damijan Hočevar was the first. In early September, the 47-year-old Slovenian rode repeats of a 720-metre (2362-foot) climb with 73 metres (240 feet) of elevation gain – a steep 10 per cent – in the Slovenian town of Postojna. He tackled the effort on flat pedals – in contrast to virtually all Everesters who use clip-in pedals for maximum efficiency – and notched up the necessary elevation gain in just shy of 22 hours, a little over 16 of that on the bike. Incredibly, Damijan had only planned to do a training ride for a later Everesting – 'but somehow I was in the right mood and kept going until I did it,' he told me.

It wasn't Damijan's first endurance ride on a BMX. In July 2020 he'd completed a 4-day, 615-kilometre (382-mile) cycling tour from south-west Slovenia to Dubrovnik in Croatia.

Damijan didn't wait long to complete his second BMX Everesting. On 21 September, less than 3 weeks after his first, he tackled the climb to Ljubljana Castle – a key landmark in the Slovenian capital. Again riding with flat pedals, this second effort took more than 29 hours, nearly 19 of which he spent on the bike. He found this second ride harder. 'We had rain, [the] concrete is quite rough and required some extra strength,' he said. 'But I'm not a quitter.'

The only other known BMX Everesting was completed by English YouTube personality Francis Cade. Francis bought an old BMX from a charity organisation for £100 and set about making it more appropriate for road cycling. Unlike Damijan, Francis opted for clip-in pedals for better power transfer, he added a front brake (most BMXs have a rear brake as standard), installed narrower tyres (for reduced rolling resistance and weight), and put a longer seat post on the bike, to make sure he could extend his legs while pedalling. Still it proved uncomfortable – Francis's YouTube video from the ride shows him hunched over the bike's low front end, rocking vigorously from side to side as he monsters the big, single gear (35 × 18) up a 7 per cent climb in County Durham, northern England.

Part of Francis's discomfort was a result of limited preparation – where Damijan was accustomed to riding long distances on his BMX, Francis was anything but. As he quipped in his video, his longest ride on the bike prior to the Everesting attempt was all of 30 seconds. A fit rider Francis might have been, but the different riding position created considerable strain.

Still he got through it, completing his Everesting in just under 16 hours, with 14 hours of that spent on his wholly inappropriate machine. His summary of the experience at video's end was succinct: 'I wouldn't recommend it.'

Spaniard Jose Nicolas 'Pepe' Uribe Mayor managed to find a different way of making Everesting harder. By February 2020 Pepe had already completed every flavour of cycling Everesting available through Hells 500 and was looking for a new challenge; a challenge of his own making.

On a 1-kilometre (0.6-mile) climb near Cartagena on Spain's south-east coast, Pepe tackled what he dubbed a 'Vintage Everesting', climbing the height of Everest on a BH road bike from the 1980s. The bike had been sitting in his garage for 15 years.

Other than installing new tyres and tubes, Pepe didn't make any modifications to the bike – he wanted the experience to be as true to the bike's heritage as possible. To really immerse himself in the retro vibe, he dressed in period-appropriate cycling clothing as well.

At 13 kilograms (28.7 pounds), the bike he was riding was nearly twice as heavy as a good modern road bike, and with a 42 × 24 as its easiest gear, this would be no easy Everesting. Pepe did have five cogs at the back to play with, but given the age of the bike he was worried about 'involuntary movement of the chain to the next smaller sprocket', so he stuck to his smallest gear.

Despite the handicap of using decades-old technology, Pepe completed his Vintage Everesting in a touch over 23 hours, around 17 of which he spent riding. He believes it was the first Everesting completed on a bike more than 30 years old.

Other riders have increased the difficulty of Everesting by using a heavier bike, too. Like David Sims who, in July 2017, Everested Hunters Hill near Manchester in northern England on a 14.5-kilogram (32-pound) Raleigh Chopper – a fold-up children's bike

**Right**
Pepe Uribe didn't just have an old bike for his 'Vintage Everesting' – he went for era-appropriate clothing as well.

**Below**
Damijan Hočevar was the first-known person to complete an Everesting on a BMX bike.

Other paths to Everest

with tiny wheels. Or German rider Martin Schmidt who spent 38 hours – 25.5 of it in motion – completing an Everesting on the Grunewaldturm climb in south-west Berlin on a 20-kilogram (44-pound) Bullitt cargo bike.

Then there was Jason English, a seven-time 24-hour mountain-bike world champion, and Dave Edwards. In June 2015 the pair rode bikes from Melbourne's now defunct bike-share scheme to an Everesting as part of the Climb for Nepal charity drive. At a hefty 18 kilograms (40 pounds) – nearly three times the weight of a modern road bike – the bikes Jason and Dave were riding weren't made for cycling up hills. They certainly weren't made for Everesting.

Still, on an 18-metre-high (59-foot) street next to the Melbourne Cricket Ground, the pair spent a backbreaking 25 hours in the

saddle to ride 500 laps of the 450-metre (1476-foot) climb. 'The last few hours really dragged on,' Jason wrote on Strava. 'At 6 pm I recall estimating we [would] be finished by 10 pm. At 7 pm I estimated 11 pm, but the required laps weren't completed until just after 1 am. This was by far the hardest event I have completed.' Coming from a world-class 24-hour racer, that's saying something.

Dave had his own challenges to deal with. 'The rear brake died with around 100 laps to go, so front brake only (which was pretty dodgy to start with),' he wrote. 'I strained a nerve in my left forearm, so couldn't really hold on with my left hand anymore. The four speed bumps on the descent hurt a lot. I was no longer pulling a sweet jump off of the last speed bump on the way down. It was enough just to still be rubber side down.'

**Below**
Everesting on a regular bike is hard enough; doing it on a super-heavy share bike only increases the difficulty.

**Right**
Ben Soja on his way to the first-known unicycle Everesting.

Why climb the height of Everest on a bike with two wheels when you can do it on one? That's right, someone has completed an Everesting on a unicycle.

'I heard about Everesting about a year ago and immediately started wondering if I could do it on a unicycle,' Ben Soja wrote on his blog in 2018. 'It seemed almost impossible but at the same time very intriguing.' In March 2018 Ben spent 23 hours slogging up and down Mt Lowe in California, USA, covering 165 kilometres (103 miles) on his Mad4One geared unicycle.

Riding a unicycle at all is hard enough – keeping your balance on a single wheel is no mean feat – but throw in a steep climb of 11 per cent and things get considerably tougher. Then do that climb for most of a day? Incredible. If all that wasn't hard enough, Ben also had a crash that he had

to bounce back from. 'Everything was going well, but on lap 10, the last before sunset, I had a high-speed crash on the descent,' he wrote. 'As a result, my elbow is now missing some skin, but at least my legs were fine – the knee pads had saved me!'

If Everesting on a unicycle isn't impressive enough, how about riding an Everesting on one wheel, on a bike that has two wheels?

In June 2017, Spain's Markel Uriarte put in one of the most unbelievable Everestings yet recorded. On a climb near Pamplona in the Basque Country of north-east Spain, riding a hardtail mountain bike, Markel 'wheelied' his way up each of the 21 ascents of the 6.8-kilometre (4.2-mile) climb. He was the first to complete such a feat. 'Many people told me it was impossible, even at times I have also thought about it!' he said

after his 19-hour ride. 'But after a lot of work and suffering today I can say that I have succeeded.'

Completing a wheelied Everesting isn't just an endurance challenge – it's also a challenge of balance and of core and upper-body strength. It's hard to imagine riding with one wheel in the air for 100 metres, let alone for the length of a 6.8-kilometre (4.2-mile) climb. Doing that for 21 ascents over the course of most of a day? Extraordinary. (You won't find Uriarte's effort in the Hall of Fame – he never submitted his ride to Hells 500.)

Remarkably, Markel isn't the only rider to have completed a wheelied Everesting. Swiss rider Manuel Scheidegger went on to match Markel's feat in June 2020 near the Swiss town of Thun. It took 21 hours of riding, 14 of it in the saddle.

From one rider on one wheel, to two riders on a total of two wheels. For more than half a decade, Ann and John Jurczynski have been riding long distances together on their tandem bike. In 2015, aged 58 and 51, the American couple rode the legendary Paris–Brest–Paris, a 1200-kilometre (746-mile) challenge ride that only happens every 4 years. Ann and John were the first of 100 tandems across the line that year, more than 16 hours ahead of the next pair, having conquered the ride in just under 52 hours. They returned 4 years later and were again the fastest tandem pairing.

In June 2020, now both retired, the couple set out to challenge themselves with a ride of a different kind: a tandem Everesting. The climb they chose was Left Hand Canyon, just north of Boulder, Colorado, USA, a 13.3-kilometre (8.3-mile) ascent that rises at a shallow average gradient of just 3 per cent on its way up to Jamestown. At that gradient, they were in for a long and slow Everesting.

Still, they weren't perturbed – indeed they'd set out with the goal of doing a super-long ride. 'It got down to 36 degrees [Fahrenheit, 2°C] early on Saturday morning, but overall it was a beautiful weekend to ride a bicycle all day and night,' the pair wrote in an article for the *American Randonneur* magazine. 'During the day we enjoyed seeing over 400 other cyclists on the road, while at night the many deer sightings were making us more cautious than we wanted to be when descending. The headwind on 19 of our 22 ascents got to us after a while as well. Now that it is over, we are happy we did this; but during the challenge we constantly questioned this crazy idea of ours!'

It took the couple a total of 33 hours to complete their Everesting, 28 of which they spent on the bike, pedalling in lockstep, racking up elevation. By the end of the ride they'd covered an impressive 595 kilometres (370 miles) – very nearly the longest Everesting on record.

Then there are those who have completed Everestings on even stranger bikes, if such contraptions can even be called bikes.

In May 2017, British endurance athlete Tim Woodier became the first person to complete an Everesting on an elliptical bike, also known as a stand-up bike. According to the website of the ElliptiGO brand, a stand-up bike allows a rider to 'experience a true running stride without the impact of running with a long-stride elliptical motion.' Given the extra machinery needed to facilitate a striding motion, such bikes are considerably heavier than a regular road bike – Tim's ElliptiGO weighed in the vicinity of 18 kilograms (40 pounds).

Tim's groundbreaking ride took him roughly 17.5 hours, in which time he climbed the steep 1.2-kilometre (0.7-mile) Porth-y-Parc climb near Abergavenny in south-east Wales a total of 59 times. The steep road and heavy bike saw him average around 6–7 km/h (3.7–4.3 mph) for most ascents – just above walking pace.

From bikes you can run on, to actual running itself. What began as a cycling challenge didn't stop there. Hundreds of Everestings have been completed on foot.

According to the official rules, an Everesting runner can take alternate transport down after each climb (a shuttled Everesting) or they can walk/run down themselves (unshuttled).

Relative to Everesting by bike, someone on foot can tackle much steeper grades – the more efficient elevation gain helps to offset the slower movement speed. So while on-foot Everestings have been completed on tracks and paths the world over, they've also been completed on staircases, both outdoors and indoors.

Transvulcania is one of the world's hardest mountain-running ultramarathons, held on La Palma in the Canary Islands, Spain. When the race's 2020 edition was cancelled due to COVID-19, Englishman Rowan Wood started looking around for other challenges to replace it. 'I'd seen a few clips of people doing challenges indoors or in their garden, so I ended up looking up at my stairs and thinking, "How many of those will it take to reach Everest?"' Rowan wrote on his Facebook page. 'A little bit of maths and a flippant, throwaway post on Facebook and the whole thing took on a life of its own.'

With the staircase in his house measuring 234 centimetres (7.7 feet) from bottom to top, Rowan would need to climb the 11 steps a ridiculous 3782 times. He'd done some training runs outdoors but his biggest indoor session on the staircase was just one hour long. Not exactly the ideal preparation.

One Sunday in April 2020, Rowan went for it. He figured he might as well raise some money along the way and set himself a target of raising £200 for the Rosemere Cancer Foundation. He live streamed his run on Facebook and, as the hours dragged on, more and more donations rolled in. Impressively, Rowan kept running until the very end of the effort, bounding up the stairs then jogging back down.

Even for such an experienced ultra-endurance athlete, completing the challenge was an almighty effort. 'It turned out to be the hardest thing I have ever done,' he wrote. 'I was aware that it would be harder than I thought, but I still managed to underestimate it by several magnitudes. When the cramps hit at about 800 flights, I really thought I was done for. With a bit of stretching, foam rolling and plenty of regular rests I managed to keep the cramp at bay. I'll be honest, I wanted to give up many times throughout the day. Doing the whole thing feeling sick and always 10 seconds

### RIDE VS RUN

Which is harder: completing an Everesting by bike or on foot? There aren't many who have done both, but Martyn Driscoll has. In what was a busy few months in 2020, the Welshman completed an outdoor bike Everesting in May, a vEveresting by bike in June, and a run Everesting in July. His verdict: 'Running is the hardest for sure.' And that's coming from a man who sees himself as a runner first and a cyclist second.

Other paths to Everest

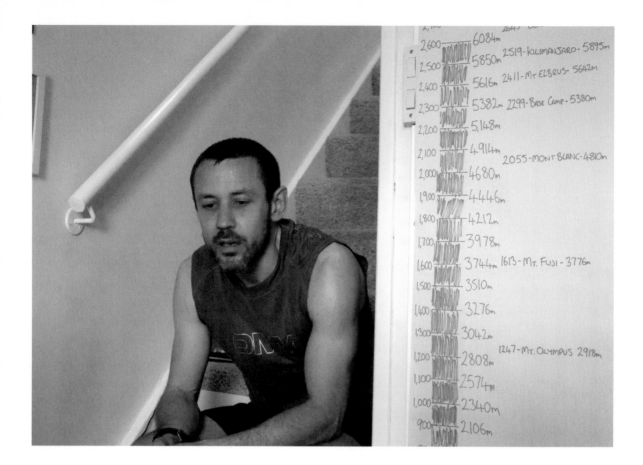

2,100
2,600 ——— 6084m
★ ——— 5850m  2519-KILIMANJARO-5895m
☐ 2,500
☐ 2,400 ——— 5616m  2411-MT ELBRUS-5642m
2,300 ——— 5382m  2299-BASE CAMP-5380m
2,200 ——— 5,148m
2,100 ——— 4,914m
                 2055-MONT BLANC-4810m
2,000 ——— 4680m
1,900 ——— 4,446m
1,800 ——— 4212m
1,700 ——— 3,978m
1,600 ——— 3744m  1613-MT. FUJI-3776m
1,500 ——— 3510m
1,400 ——— 3276m
1,300 ——— 3042m
                 1247-MT. OLYMPUS 2918m
1,200 ——— 2808m
1,100 ——— 2574m
1,000 ——— 2340m
900 ——— 2106m

**Above**
Rowan Wood
showed you don't
even need to leave
home to complete
an Everesting
(assuming your
house has stairs!).

away from full-on cramps was really hard. The whole second half was also just physically exhausting.'

In the end, Rowan blew his fundraising goal out of the water – he ended up raising £4000 pounds, 20 times what he'd hoped for. In a humorous twist, a local carpeting company offered its support by paying for new carpet for the stairs Rowan had run up and down more than 3700 times.

But why stop at running? Why not push the concept of Everesting even further? Like Italian pair Paolo Bonandrini and Emanuele Orsini who, in January 2020, completed a backcountry-skiing Everesting. Seventeen times the pair tramped their way up the steep slopes of the Spiazzi di Gromo ski resort in the northern Italian province of Bergamo. It took them 16.5 hours, just under 14 of which they spent on the move. Their total distance covered: just 87 kilometres (54 miles).

A video from the day shows the pair arriving at a restaurant at the bottom of the mountain having finished their effort, and being greeted by a room full of friends and family. As Queen's 'We are the champions' plays over the PA, the crowd sings along and offers a rousing round of applause to celebrate the pair's success.

Andy tells me there are other flavours of Everestings in the works as well. 'I've just responded to a guy who wants to do an Everesting on inline skates,' he says. 'I've had a rock climber say he wants to do rock climbing in a gym [to] the height of Everest. It is all sort of within the rules.' At least one person is planning one on rollerskis.

Then there are the even more esoteric Everesting attempts. In November 2020 Lance Lee Davis freedived (i.e. while holding his breath) the equivalent height of Everest over the course of 14 hours and 24 minutes, near Redondo Beach in California.

Andy's reticent to expand the scope of Everesting too much, but as long as the difficulty is there, he's open to it. 'I don't want to turn Everesting into [something] you can do by bouncing up on a beach ball or something like that,' he says. 'At the end of the day, the flexibility within the framework means that this is also a community-owned asset. If the community is saying "We want to do it on inline skates" or "I want to do it in a rock-climbing gym", as long as there's a way to make sure efforts are on par with each other, and there's not one particular form which is some sort of golden ticket or a shortcut, then that's OK.' 🚲

# RUNNING RECORDS

Just as there's been an arms race to set the fastest time for Everesting by bike, so the running world has taken up the challenge. Irish cyclist Ronan Mc Laughlin's effort in taking the cycling world record from former Tour de France winner Alberto Contador, in July 2020, inspired Ronan's fellow Irishman and elite runner Ian Bailey to do something similar for the running record set by Canadian runner (and obstacle course world champion) Ryan Atkins.

In a terrific report about his record attempt on Slieve Donard, the highest mountain in Northern Ireland, Ian explained that he was half an hour ahead of Ryan's time after 20 of the 37 laps, but things got pretty ragged thereafter. 'Around lap 21, my wife Anna and two boys arrived at the col,' he wrote. 'Shouts of "Come on Daddy" brought rising waves of emotion and all was good in the world. Unfortunately, the legs were on a different wavelength, still smooth and powerful on the climbs but robbed of fluidity on the jolting steps and freefall gradients of the way back down. Lap pace disintegrated and suddenly the reality of how distant the end was smacked me hard, and the first slimy creep of self-doubt began to poke at the edges of resolve.'

Ian's buffer drained away with every lap that followed, but in the end he had enough time up his sleeve – the 42-year-old reached the height of Everest after 11 hours and 17 minutes, setting a new record by just 2 minutes. ▲

# THE SHORTEST EVERESTING ON FOOT

For most of 3 years, Martin Riches scoured Suffolk, England, in search of the perfect hill for an on-foot Everesting. He found several candidates, but none as good as the one he eventually settled on. 'I remembered an old pit I used to play in when I was a kid with well over 45 degrees of slope,' Martin tells me. 'I realised not only could I complete the job but [I'd] set a new record by some margin in the process.'

Tucked just off a main road near Harleston in south-east England, this pit is roughly 10 metres (33 feet) deep. Martin believes it might have been formed when clay was dug out for some nearby construction. When Martin revisited the pit for the first time, he discovered it was covered in vegetation nearly a metre tall. He spent the winter hacking away at it and training in the pit. 'I spent several short 1000-foot (305-metre) sessions during the winter after work preparing the bank for spring, kicking footholds into the bank and clearing debris whenever the weather permitted.'

He placed footholds for both the ascent and the descent 'as your strides are different on the descent. There were 36 footholds up – I never counted how many down. Each rep had to start with right foot first and follow the exact path and steps.'

In May 2020 Martin returned to the pit for his first visit in nearly a month. The vegetation had grown back and, when he arrived at the pit in the small hours of the morning, it took him a while in the dark to even find the track leading in. He decided he'd just trample down the plants as he started his effort, but that 'turned out to be an epic fail'.

'The plants were too sinuous and slippery and I went down so many times in the first hour on my butt, back, headfirst, rolling, and it was only a matter of time before I hurt myself properly,' Martin recalls. 'As it was, I had been stung, prickled and took the skin off my knees, elbows and thighs and I had only been going an hour. After that I steadily cleared the path by pulling up the undergrowth on each rep.'

Martin had left home at midnight telling his wife that, based on his training efforts, he would be back 24 hours later. 'Oh boy how wrong I was,' he says. 'I started according to plan and soon the pace dropped dramatically as the hill took its toll, slowly grinding me down to the point where two or three repeats and rest was needed. I began to realise I was a bit nuts after about 4000 metres (13,120 feet). More than once I phoned the wife and said "I'm coming home – it's beyond me," but she was having none of it. I was banned from the house until the job was done. [It was] definitely by far the hardest thing I've ever done and without the support from my wife [I] would have never completed [it].'

All told, Martin spent 38 hours in that pit, 18 of which he spent hauling himself up and down his carefully placed footholds. He completed the effort entirely alone.

Ultimately, Martin clambered up the height of Mt Everest in just 16.2 kilometres (10 miles), less than half the distance of the next shortest Everesting completed on foot.

'I can't say it was particularly fun,' Martin says, 'but ultimately [it was] very satisfying.'▲▲

**Right**
Despite being
a multiple-time
Tour de France
champion, Alberto
Contador's
Everesting speed
record lasted less
than a month.

Other paths to Everest

# PART FOUR
# THE TRAILBLAZERS

# 12

# BREAKING
# RECORDS

Everesting

**R**emember George Mallory, the man who climbed the height of Mt Everest on Mt Donna Buang one day in late 1994? The man whose report from that epic ride spawned the whole Everesting craze? Well, 18 years after his historic ride, George returned to Mt Donna Buang and continued blazing a trail.

When George's report from his 1994 ride was published on the CyclingTips website in 2012, it prompted a flurry of comments. Among them, a cheeky contribution from a commenter named 'ryder' who suggested, 'If it's not on Strava, it didn't happen' – a satirical nod to the fervour with which the cycling community had flocked to the then fledgling social sport platform.

George knew it was a joke but saw merit in the challenge – he'd spent time in the world of mountaineering where, in his words, 'it's best to have proof'. And so, in October 2012, George went back to Mt Donna Buang to log another Everesting on Strava.

The then 52-year-old wasn't just trying to make a point; he had another goal, too. He wanted to complete an Everesting as fast as he could.

'I've always thought since 2012, which was my second [Everesting], that when you've done your first one and you know you can do it … after that what you really want, and I wanted all the way through pretty much, except towards the very end … was a faster time,' George tells me.

'In my opinion, going fast is the real measure. Cycling is always measured by speed, laps, time, fastest time, first across the line – that is the measure. This is just going to sound terribly elitist: I'm very happy for all these people who take a long time – I really am – but elapsed time, that is the thing.'

George completed his second Everesting on Mt Donna Buang in 15 hours, more than 3 hours faster than he'd climbed the height of Everest in 1994. But that was really just the beginning.

In late 2013 George ventured to New Zealand for work (he was a civil engineer, sent to help with earthquake recovery efforts in Christchurch). He took with him an interest in reducing his Everesting time as much as possible. Between October 2013 and July 2014 George rode an additional four Everestings, all in the vicinity of Christchurch, all on increasingly steep climbs, and all in progressively shorter times.

George slashed his time down to 13:15 (Mt Pleasant, October 2013), to 12:35 (Summit Road, February 2014), then 11:08 (Port Levy, March 2014) and finally 10:12 (Glenstrae Road, July 2014). With each of those last three times, George set a new world record for the fastest Everesting and helped pave the way for other speedy attempts.

By late 2014, as word of Everesting started to spread around the globe, others started to eye the fastest time in the Everesting Hall of Fame. In September 2014 Craig Tregurtha bettered George's record by more than an

hour, setting a time of 9:01 on the climb up Morgans Valley, also near Christchurch. In October 2015, American former pro racer Scottie Weiss pulled the record inside 9 hours for the first time with an 8:58 on Mill Mountain, just south of Roanoke, Virginia. Then, in February 2017, Australian Tobias Lestrell took nearly half an hour off the record with a staggering 8:29 on the punishingly steep Terrys Avenue in the Dandenong Ranges east of Melbourne.

Tobias's time would remain at the top of the leaderboard for 3 years and 3 months.

Between May 2020 and March 2021 the overall Everesting record fell seven times. When the dust settled, Irish former racer Ronan Mc Laughlin emerged with the new best time: a mind-blowingly fast 6:40:54. He'd completed the challenge in less than half the time of the average Everesting.

Between February 2014 and March 2021 the Everesting record dropped from an already speedy 12:35 down to just 6:41. The limits of the Everesting experience had well and truly been defined.

The women's Everesting record tells its own story. On the challenge's opening weekend in February 2014, Sarah Hammond became the first-known female to complete an Everesting. Her time: 18:25 for her eight laps of Mt Buffalo in Victoria's High Country. Gaye Bourke took the first major leap forward with a 16:41 on the nearby Tawonga Gap, 6 months after Sarah's ride. Gaye took the next big jump too, knocking her own record down to 13:54 in June 2015 on the Arboretum climb in the Australian capital of Canberra.

By August 2018, the record was down to 12:32 courtesy of Alice Thomson's effort on Naish Hill, near Bristol in the south-west of England. Impressively, Alice had only really been cycling for a little over a year by that point.

Her record would stand for nearly 2 years, until a COVID-inspired flurry of attempts from pro and semi-pro riders in mid-2020.

### SEAN VINTIN'S vEVERESTING RECORD

While the outdoor Everesting record is now under 7 hours, the indoor record on Zwift is even faster. Australian amateur racer Sean Vintin set a new mark in January 2019 when he completed 57 laps of the super-steep Radio Tower climb on the Zwift island of Watopia – a 1.1-kilometre (0.7-mile) segment with an average grade of 14 per cent.

It took Sean 136.4 virtual kilometres (84.8 miles) and 5:57:43 to reach the height of Everest. His average weighted power for that time was a hefty 306 watts – roughly 4.6 watts/kilogram. Incredibly, his power-to-weight ratio was 0.2 watts/kilogram higher than that of Alberto Contador, the two-time Tour de France winner, when he completed his then fastest-ever outdoor Everesting. Sean's effort was remarkable for an amateur athlete.

'Everything after the 5000-metre (16,400-foot) mark was dark,' Sean tells me. '[I] was close to pulling the pin when I thought I couldn't go sub-6 [hours], but I think about three reps from the end I realised I might just make it. That's when the drooling would have been next level if I wasn't so dehydrated.'

**Right**
Like most who
have set Everesting
speed records,
Alice Thomson
completed her ride
on a painfully steep
climb.

Breaking records

# THE EARLIEST

Until 2020, George Mallory was credited as the first to climb the height of Mt Everest in one ride, but we now know he wasn't. The first-known Everesting appears to have occurred a full decade earlier than George's 10-lap ride in November 1994, on the other side of the planet.

In 1981, French physicist François Siohan was working at CERN – the European Organisation for Nuclear Research in Switzerland. He'd long been interested in cycling and had raced at a high level in the years prior. But when he started at CERN, with high mountains all around him, his interest in riding uphill intensified. 'It's around those years that I started thinking of "Everesting" as you call it, and doing it by daylight only,' he says. 'I didn't find anywhere (cycling magazines, etc.) anything on the subject, [and] had no idea if it was feasible.'

In June 1983, he took a big step towards his goal, riding eight laps of the Col de la Faucille, an 11.3-kilometre (7-mile) climb in the Jura Mountains of eastern France that rises 710 metres (2330 feet) over its length. All went to plan – François climbed more than 5600 metres (18,370 feet) and started to believe that the 13 laps required for the height of Everest would be feasible. 'According to my rule of thumb … if 60 per cent is no problem, then you can go for 100 per cent,' he says.

For his big day François borrowed an 8.2-kilogram (18-pound) Peugeot road bike from his local bike shop – very light for the time. The bike featured massive gears compared to what an Everester would use today. François's 42/52-tooth chainset was paired with a six-speed cassette (13-23 tooth) on the rear.

On 1 July 1984, François tackled Mt Everest on the Col de la Faucille. With his wife and daughter cheering him on from the roadside, the then 42-year-old completed his goal of 13 laps, racking up more than 9200 metres (30,180 feet) of climbing. 'Overall I really didn't have to push myself,' François recalls. 'It felt a bit harder at the 11th climb, but I had an ally on the 12th and 13th: a welcome updraft of wind that probably saved me one to 1.5 minutes on those climbs.'

All told, the ride took François 13.5 hours – a respectable time, indeed – ensuring he finished the ride before sundown as planned.

François's 1984 ride – what we'd now call an Everesting – is the earliest documented ride of its kind. Of course, it's possible the concept goes further back than that.

'Back in 1994 I had absolutely no way of knowing if anybody else had done this or not,' George Mallory tells me. 'I always thought it was a logical thing to do. I mean, how hard is it to come up with the concept of riding laps on a hill until you've got 8848 [metres] and thinking metaphorically, "This is the Mt Everest Day in Melbourne"?

'It would not have surprised me at all if somebody reliable had told me, "You're not the first – a bunch of guys have done this." I was delighted to hear that somebody did it before me. I just think "Great, less pressure on me!"' ▲

**Above**
François Siohan's
ride is the earliest-
known Everesting,
but it's possible
others climbed the
height of Everest
in a single ride
before him.

Everesting

Left
As a professional
racer, Emma Pooley
was one of the
best climbers of
her generation.
She hasn't lost
much in retirement.

The women's Everesting record fell four times between May and July 2020. The time of 8:53:36 set by Emma Pooley in July 2020 on the Haggenegg climb in Switzerland would emerge from that period as the fastest women's Everesting by roughly 15 minutes. In setting that new mark, Emma had become the first woman to go under 9 hours.

Such was the interest in fast Everestings in 2020 that the leaderboard looked entirely different at year's end than it had at the start of the year. The 18 fastest men's times and the 11 fastest women's times in the Hall of Fame were all set during 2020.

For the vast majority of riders, simply completing an Everesting is challenge enough. Completing such a ride at breakneck pace elevates the challenge to another level entirely. It's difficult to describe the strength of riders who are able to climb at such ferocious speeds. But let's try anyway.

Let's take Alberto Contador's ride, for example. Over the course of nearly 7.5 hours, the Tour de France winner's 'normalised power' was 287 watts. Normalised power is the average amount of power a rider is putting through their pedals throughout a given effort, adjusted to take into account the peaks and troughs in the power they're producing. It seeks to represent how hard a rider *could* have gone had their effort been completely consistent throughout the ride, rather than inconsistent (which every ride is).

At the time of his effort, we can estimate Alberto weighed somewhere around 65 kilograms (143 pounds) – a few kilograms more than the weight he raced at during his career. At that weight, his normalised power output per kilogram of body mass – his power-to-weight ratio – was around 4.4 watts/kilogram, for 7.5 hours.

The higher a rider's power-to-weight ratio, the faster they'll climb, and knowing Alberto's power-to-weight ratio allows us to objectively compare his effort between riders.

The comparison is a grim one for us mere mortals. Me personally? When fit, I could maintain 4.4 watts/kilogram for around half an hour, meaning I could probably manage to ride behind Alberto for around 30 minutes, at my absolute limit, before coming to a wheezing, sputtering halt. He would be able to continue at the same intensity for at least another 7 hours.

As for Emma Pooley's effort? Her normalised power for her roughly 9-hour effort was 207 watts. At around 50 kilograms (110 pounds) – she raced at 48 kilograms (106 pounds) – Emma's normalised power was around 4 watts/kilogram. On a very good day, I might be able to keep up with her for an hour before collapsing by the side of the road, completely spent. She could continue on at the same intensity for another 8 hours.

One thing the fastest Everesters have in common, besides superhuman strength, is their flavour of climb: they've all opted for painfully steep ascents. That's because the steeper the climb, the more efficiently you're able to accumulate elevation gain (to a point) and the quicker you're able to descend back to the bottom.

For most riders, anything above a 10 per cent gradient is likely to be unmanageable – the increased muscular fatigue from pushing a big gear outweighs any efficiencies of climbing such steep gradients. For professional riders with years of strength and conditioning in their legs though, such gradients don't take as much of a toll.

All of those at the pointy end of the Everesting leaderboard are tackling climbs well over 10 per cent – Emma Pooley and Alberto Contador, for example, tackled climbs that averaged 13 per cent. Remarkably though, these aren't the steepest climbs that have been Everested. Not even close.

The steeper the Everesting, the shorter the distance a rider will have to cover to complete an Everesting. The average Everesting

length is somewhere north of 200 kilometres (124 miles), but the shortest Everestings are well under 100 kilometres (62 miles), and at incredibly hard gradients.

Of the five sub-100-kilometre (62-mile) Everestings in the Hall of Fame, three belong to South Australian rider Dan Wallace.

You can get a sense of Dan's tenacity and love of a seemingly impossible challenge from the fact he completed his first Everesting in early 2016, just 69 days after breaking his femur in a nasty crash. It's also telling that he went on to complete his second less than a fortnight later, this one on the Lynton bike path in Belair, south of Adelaide, which ramps up at a distinctly un-bike-path-like gradient of 23 per cent. While the bike path is sealed, Dan rode it on his mountain bike, giving him access to smaller gears for the incredibly steep gradient.

Dan completed that Everesting in just 104 kilometres (65 miles). But he wasn't done there.

In August 2016, he headed out to Marino, also south of Adelaide, with the express purpose of breaking the record for the least distance covered for an Everesting. He'd found the perfect hill for it: a Strava segment named 'Bundarra Road Climb from Hell'. '[A] 23 per cent average gradient for almost 200 metres (656 feet) doesn't sound nearly as bad as it feels to ride up. The bottom of the road can't be seen from the top.'

Dan wasn't able to achieve his goal that Saturday morning – the screeching brakes on his mountain bike started waking local residents, so he decided it was best to come back another day after having his brakes tuned. But as he was getting ready to head home, he decided to ride a few laps of the nearby Mt Marino climb – another punishingly steep ramp. His few experimental laps ultimately turned into much more. 'Ironically the brakes had warmed up without such heavy use, and were making barely any noise at all an hour

Ride **79.6 km**   Elev Gain **8,930 m**   Time **12h 19m**

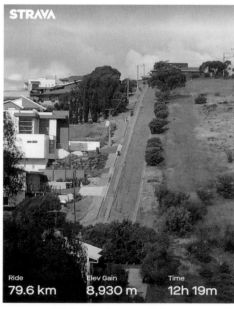

Ride **79.6 km**   Elev Gain **8,930 m**   Time **12h 19m**

**Left**
Even on a mountain bike with super-low gears, streets this steep are not fun to ride up.

or so later,' Dan says. He went on to finish an entire Everesting in 17.5 hours, covering just 109 kilometres (68 miles).

A month later, Dan had another tilt at Bundarra Road. This time he had even easier gears on his mountain bike – a 22-tooth front chainring and a 40-tooth cog at the back – meaning he was riding at walking pace. As they had a month earlier, his brakes let him down on the incredibly steep descent – after climbing and descending nearly 5000 metres (16,400 feet), his brakes were struggling to stop him.

Dan knew he was about to fail again, but before packing up he realised a nearby bike shop was open. He paused his GPS unit, rode the 5 kilometres (3.1 miles) to the bike shop, got his brake pads replaced and his hydraulic brake lines bled, and returned to tackle the rest of his ride.

At 7000 metres (22,965 feet), he started to suffer badly – worse than he had on any previous ride. 'Each lap requires such effort for only 42 metres (138 feet) gain,' he says. 'It seemed like an eternity to get from 7000 to 8000 metres (26,250 feet), but when I did a bit of energy kicked in. There was no way I was stopping now.'

Dan eventually got to the height of Everest having covered just 80 kilometres (50 miles) – easily the steepest and shortest Everesting anyone had ever completed.

Dan wasn't done with steep streets. In June 2017 he became the first rider to conquer a 10,000-metre (32,808-foot) Everesting in less than 100 kilometres (62 miles), with a total distance of just 98 kilometres (61 miles) on Tregenza Close east of Adelaide – a 200-metre (656-foot) climb at around 25 per cent. In December 2018 he completed the shortest-known gravel Everesting. On Gores Road in the Adelaide Hills – 300 metres (984 feet) at 17 per cent – Dan climbed the height of Everest in just 99 kilometres (61.5 miles).

At the other end of the gradient spectrum are those tackling very different hills indeed. Where the shortest Everestings are under 100 kilometres (62 miles), the longest are well in excess of 500 kilometres (310 miles). Or in the case of Austin Horse, more than 600 kilometres (373 miles).

Austin isn't just any cyclist – he's a bike courier by trade and a three-time winner of the North American Cycle Courier Championship, a test of both speed and bike messenger skills. In August 2017, in New York City, he set out to complete an Everesting in the hope of drawing attention to an issue close to his heart.

Austin was campaigning for 14th Street in Manhattan to be converted into a cycling-friendly thoroughfare, a campaign that coincided with the upcoming reconstruction of the New York City Subway's 14th Street Tunnel, used by the city's L train. Austin attempted his Everesting on the nearby Williamsburg Bridge, which links Brooklyn and Manhattan.

Though the rules of Everesting stipulate that a rider must climb and descend the same, single hill wherever it's possible to do so (to stop riders doing a loop and using a descent to gain 'free' climbing metres as they drop into the bottom of the next ascent), Austin wanted to cross the entire Williamsburg Bridge, meaning he would climb it from both sides rather than just one.

He approached Andy and asked for an exemption to the rule. 'I was actually at a disadvantage having to slam on the brakes and turn around at the bottom of the bridge,' Austin tells me. 'So as I received no advantage from this exception, Andy was comfortable in granting it. Both sides of climbing were aggregated into one Everest.'

The gentle gradient of the bridge – just a couple of per cent on each side – meant accumulating elevation was a laborious process. All up, it took Austin 34 hours to reach the magical mark, a full day of which he spent in the saddle. He'd ridden a torturous 601 kilometres (373 miles).

Most people who complete an Everesting are aged somewhere between 20 and 40 years of age, but there are some who fall well outside those bounds. Several riders have completed an Everesting in their 60s – a truly commendable effort – but so far the oldest-known rider to complete the challenge is American Don Zwiebel.

When Don first heard about Everesting in January 2020, his first reaction was disbelief at the enormity of the task. Two days later, he was studying logistics and doing as much research on Everesting as he could.

While Don was new to Everesting, he was an old hand at endurance rides. In July 2017, for instance, he rode 2250 kilometres (1400 miles) in 10 days from Seattle to Santa Barbara. By the time March 2020 arrived, he was prepared physically and mentally for the ride. 'When doing something difficult I always have a thought that arises: "If anyone can do this, I can do it,"' Don tells me. 'My mental aspect is always strong.'

Don started his Everesting at 4 am and settled into the first of 39 laps of a 3.3-kilometre (2-mile) climb just south of Palm Desert, California. All went well during the day and evening, but when night fell, the temperature dropped sharply. 'I had not brought a warm coat for the night and became so cold coming down that I could not turn back up,' he recalls. 'I would spend 30 to 45 minutes in my car with the heater on high. The cold really added to my time, which I was not happy about.'

Despite that setback, and despite tackling the entire thing on his own, Don got through his Everesting with few hassles. Over the course of 39 hours, he spent 28 on the bike, covering an eye-watering 470 kilometres (292 miles). In doing so he became the oldest-known rider to complete an Everesting, at 75 years of age.

Despite his impressive achievement, Don doesn't see his ride as anything special. 'I was aware of the fact that if I could complete an Everesting I would be 10 years older than the oldest to accomplish an Everesting, but I am sure there are many 75-year-olds that could do this,' he says. 'Currently I am only 5 years older now [than the next oldest] and I expect soon someone will beat my record. If that happens, I have thoughts of doing it again when I am 80 …'

There are remarkable stories at the other end of the age spectrum as well – stories that will make you wonder what you've done with your life.

For most 12-year-olds, cycling is a way of exploring the local neighbourhood, spending time with friends, getting to school, or maybe heading out for some weekend exercise with the family. For Tom Seipp, cycling is a slightly more serious affair.

In September 2017, Tom became the youngest rider yet to complete an Everesting. Riding alongside his dad Richard, Tom spent 18 hours and 40 minutes in the saddle to reach the height of Everest on the stunningly switchbacked road to Stwlan Dam in Wales.

This remarkable ride is documented in the book *22,000 Miles*, a chronicle of the father-and-son duo's cycling exploits, written by Richard. 'Tom first attempted one [an Everesting] on Holme Moss in England when he was 10 years old,' Richard writes. 'He climbed just over 5000 metres (16,400 feet) before his knees started to complain on his under-geared bike. Undeterred and determined to return and finish the challenge, Tom fancied giving it another go. One Friday evening in September 2017, Richard and Tom drove from England's Peak District to north-west Wales. They arrived

just after 10 pm with rain coming down, reclined their seats and tried to get some sleep. After a restless night Richard woke at 6 am to find conditions had deteriorated – rain had become hail. When Tom roused at 7 am, it was still raining, but the hail had passed. 'Tom wakes up and doesn't question the weather,' Richard writes. 'Instead he starts putting his cycling gear on, so I do likewise.'

The duo started riding at 7.30 am. By the time darkness fell, they'd done 20 ascents of the steep 2.8-kilometre (1.7-mile) climb, and had 14 to go. 'We were well over halfway, though it certainly wasn't a done deal,' Richard writes. 'We were both slowing down a little. Needless to say, as the night

progressed, we both felt more and more tired, though our spirits were high. We talked all the time on the way up the hill.' Just before 7 am the next morning, Tom and Richard were done. At just 12 years of age, Tom had become the youngest-known Everester – a truly remarkable achievement.

It will probably come as little surprise to learn that Tom didn't stop there. After completing a Half Everesting at 10, and an Everesting at 12, he pushed the envelope again in August 2018, aged 13. Again with Richard by his side, Tom spent 31 hours on the steep, cobblestoned climb of the Kemmelberg in north-west Belgium – a climb best known for its appearance in professional

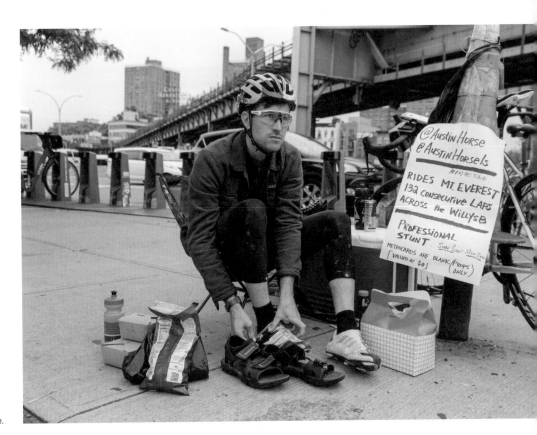

**Right**
Austin Horse at his
'Base Camp' on the
Williamsburg Bridge.

races like Gent–Wevelgem. By reaching 10,000 metres (32,808 feet) of climbing on the Kemmelberg, Tom became the youngest rider to complete a 10k Everesting.

But Tom isn't the only young rider breaking records. In June 2020, American 11-year-old Cian Connolly became the youngest rider to complete an Everesting of any kind when he tackled a vEveresting on Zwift. It took the Baltimore Youth Cycling rider just under 16 hours to complete the necessary eight and a half laps of Alpe du Zwift. 'I went through some dark places where I thought I was going to quit but I just kept on motoring on,' he wrote on Strava. 'This was an endurance ride that really showed my (sic) who I am in the sport. It was really hard and I thought at points I was not going to make it, but when some of my fellow riders joined it lifted my spirts beyond what I thought I could get back. PS: it was tough. Really, really tough.'

You'd certainly hope so.

## THE TALLEST MOUNTAIN ON EARTH

On the Big Island of Hawaii the slopes of Mauna Kea don't just exist above sea level – they extend deep below the Pacific Ocean, too. In fact, from its base on the ocean floor to its lofty summit, Mauna Kea rises a total of 10,210 metres (33,500 feet), making it the 'tallest' mountain on Earth from base to peak.

In choosing a climb for their Everesting, most riders opt for an ascent of between a few hundred metres and 20 kilometres (12.4 miles) in length. For this majority of riders, an Everesting will require anything from eight to a couple of hundred laps. But at either end of that spectrum are some remarkable outliers.

Alto de Letras is a name that inspires fear in road cyclists the world over. This Colombian ascent is one of the longest and most intimidating on the planet: a mind-boggling 73.9 kilometres (46 miles) of climbing from the town of Mariquita, at 500 metres (1640 feet) above sea level, to Letras at nearly 3700 metres (12,140 feet). In March 2017 Miguel Olarte and Sebastian Gil became the first riders to Everest this monster, covering 330 kilometres (205 miles) in a touch under 18 hours. Completing that Everesting took just two full laps, plus an additional 8 kilometres (5 miles) of climbing.

Remarkably though, there's an Everesting that's been completed with fewer laps.

On the Big Island of Hawaii, there's a road that runs from sea level at Waikoloa Beach to the top of the dormant volcano, Mauna Kea – a towering 89-kilometre (55-mile) climb that is perhaps the longest on the planet. With an average gradient of 5 per cent, a steep gravel section at the top, and a summit that pokes into the clouds at 4200 metres (13,780 feet) above sea level, it's perhaps the hardest cycling climb on Earth.

In March 2017 Scottish cyclist Charlie Rentoul set out to become the first rider to Everest this monstrous climb.

Bad weather greeted Charlie when he arrived on the island. He spent 3 days waiting for skies to clear. When conditions finally started to improve, Charlie realised it was now or never – he had to give it a shot, even if high winds and heavy snow were forecast near the top.

He set off at 2.45 am with the final 15 kilometres (9.3 miles) of the ascent still closed due to the inclement weather. Writing on Strava afterwards, Charlie described the first 65 kilometres (40 miles) of climbing as 'your run of the mill 4 per cent' – a laughably long climb in its own right.

The final 24 kilometres (14.9 miles) aren't just steep – with an average grade of 9 per cent – they're also home to a 7.5-kilometre (4.7-mile) gravel section, part of it deeply rutted, where Charlie found himself falling off several times, despite switching to wheels with 45-millimetre-wide (1.8-inch) tyres that would be more appropriate on gravel. And the challenge didn't end when the gravel did.

'I stopped again to switch back to the 28-millimetre (1.1-inch) road tyres for the final torture chamber, which is 6 kilometres (3.7 miles) averaging 10 per cent,' Charlie wrote. 'This is truly the worst part of the whole climb. There are 17 per cent sections (I think I saw 22 per cent at one point) at some serious altitude.

'I summitted in 7 hours 46 minutes, thinking, "How the hell am I going to get up here a second time!" I pulled on some warm gear for the descent and ended up back at the beach 2.5 hours later.'

After a litre of coconut water and some sushi for lunch, Charlie headed up for a second and final time – only two ascents of this monstrous climb would be required for an Everesting.

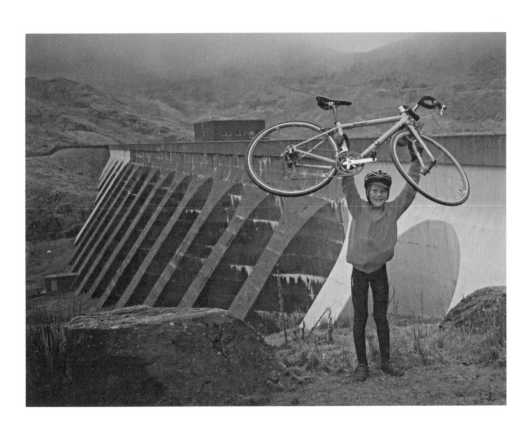

**Right**
Tom Seipp completed an Everesting at just 12 years of age.

In the opening kilometres of that second ascent, temperatures nudged 40°C (104°F). By 1500 metres (4920 feet) above sea level, it was down to 15°C (59°F). When the sun set and rain started to fall, temperatures dropped below freezing. 'I can handle most weather but rain and temps near freezing just isn't for me especially when there is about 5 hours of hell left,' Charlie wrote. 'One thing was for sure: it wasn't going to get any bloody warmer the higher I went.'

As conditions deteriorated and temperatures dropped even further, Charlie's progress slowed to a crawl. 'Although I had the support [of] car headlights and the almost full moon again, trying to decipher the best line in the gravel was alarmingly difficult,' he wrote. 'The final 6 kilometres (3.7 miles) I achieved at an eye-wateringly slow pace – 6 kilometres in 1 hour 35 minutes! Those 95 minutes were just head down and don't look up, while trying not to think about why I couldn't feel my fingers (it was -7°C [19.4°F] with a head wind). I finally made it to the top 10 hours 24 minutes after leaving the beach the previous day at 3 pm.' Charlie's second ascent had taken 3 hours longer than the first.

In all Charlie spent 21 hours and 10 minutes riding up and down the volcano, covering 360 kilometres (224 miles) in the process. With two ascents of Mauna Kea, he'd set the record for the fewest ascents needed for an Everesting. It's hard to see that record being broken any time soon.

At the other end of the spectrum are riders doing a phenomenal number of laps of super-short climbs. In August 2014, Jeff Morris completed an Everesting on Holly Hock Court, a suburban street in Craigburn Farm, south of Adelaide, South Australia. This 100-metre-long (328-foot) street is steep, at 12 per cent average, but with just 13 metres (43 feet) of elevation gain per lap, Morris needed to complete a beastly 836 laps for his

Everesting, a feat he achieved in just over 20 hours.

In August 2016, Pete Arnott upped the ante on the 140-metre-long (459-foot) Atkins Drive in Darwin, Northern Territory, Australia. The 12 metres (39 feet) of elevation gain per lap meant Pete had to complete 850 laps to reach his Everesting in just under 17 hours of riding.

But the record for the greatest number of laps for an Everesting was set in July 2017 on a 170-metre-long (558-foot) street just north of the Slovakian capital of Bratislava. That day Matej Mydla rode 'Slávičie údolie' ('Nightingale Valley') a staggering 911 times, over more than 31 hours. That's a hell of a lot of braking and turning around.

Most people who complete an Everesting are content with just one. They've set themselves an audacious target, trained hard for it, and ultimately achieved their goal. Some riders go on to do a couple or a few extra, often trying to collect more badges in the Everesting Hall of Fame. For a select few though, Everesting becomes something they revisit again wand again.

Guy Townsend falls into that camp with seven full Everestings to his name. He has a good way of explaining the obsession. 'I've noticed over the years that the anticipation involved in an event like this is a much longer-lived sensation than the post-completion euphoria,' he wrote on his website in 2017. 'For a week or so [afterwards], I felt really relaxed and content, but that soon faded, as it always does. So predictably, I started planning again.'

George Mallory has eight Everestings beside his name. Andy has led by example with 10 full Everestings. A small handful have managed between 10 and 20, and a select few have done between 20 and 30. But when it comes to serial Everesters, there's one man who stands head and shoulders above the rest.

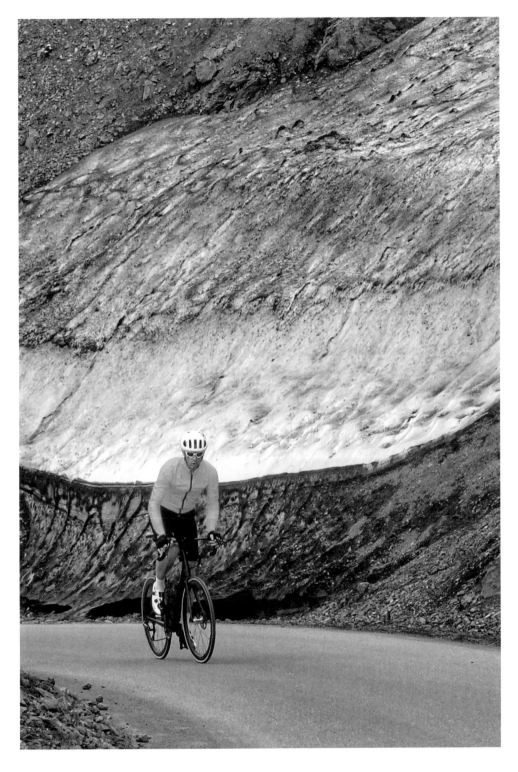

**Right**
Guy Townsend is
one of many riders
to have completed
multiple Everestings.

Sydney resident Jono Egan first heard about Everesting in 2014, after reading about the exploits of early Everesters George Mallory and Sarah Hammond. As an experienced ultra-endurance rider, Jono liked the sound of the challenge and in May 2014 he went out and completed his first Everesting on the 3.8-kilometre (2.4-mile) climb near Brooklyn, north of Sydney.

At that point he thought he was done with Everesting, but he soon realised the challenge had its hooks in him. 'It took me a few days to sort of feel OK and think maybe I'll do another one,' the 50-year-old tells me. 'I just started looking at how many laps I would have to do of various hills that were quite close to where I lived. And I thought, "Well, it could actually be more efficient to do lots of reps of a shorter hill …"'

Jono soon found himself completing Everestings with some regularity. He didn't just enjoy them – they were the sort of rides that fit in well between his shifts as a paediatric intensive care specialist.

'Because of work – mainly shift work – I wasn't able to do a lot of rides, but I could do one long ride every week or two,' he says. 'So I'd just do one big ride and that was usually 200 or 300 kilometres (124 or 186 miles). I found it a very satisfying thing to do. It's an enjoyable way to spend time on the bike really.'

In January 2021, Jono completed his 100th Everesting – a staggering achievement and easily the most of any rider in the Hall of Fame. Of those rides, 88 were completed outdoors and 12 were vEverestings. Incredibly, of Jono's 88 outdoor Everestings, 24 were completed on the same street: Florence Avenue in Denistone, northern Sydney, roughly a kilometre (0.6 miles) from Jono's house. Those local Everestings, despite not breaking any new ground, are some of Jono's most memorable.

'It's always nice when you talk to people,' he tells me. 'You see how people's days unfold while you're riding up and down the hill. There might be a gardener who comes at seven o'clock in the morning and goes at three and you sort of see what they do all day.'

Chatting to Jono, it's hard not to be impressed, not just by his phenomenal achievements on the bike, but by his humility. He doesn't see what he's achieved as anything particularly special. In his mind, he's just out doing long bike rides.

So do those long rides get easier? Or is Everesting always hard? 'It's still a big challenge,' Jono says. 'I find it a big challenge still to get up early, particularly when it's cold, and drive to the middle of nowhere and get out of the car when it's cold and wet and raining. But once you've done the first lap you get into the zone. I'm not getting any younger but physically if I feel OK after 2 hours or so, then at that point I think, "Well, it's going to be something wrong with the bike or the body or an animal or something like that [that will stop me] … I should get there." It's just a matter of time.' ᕦ

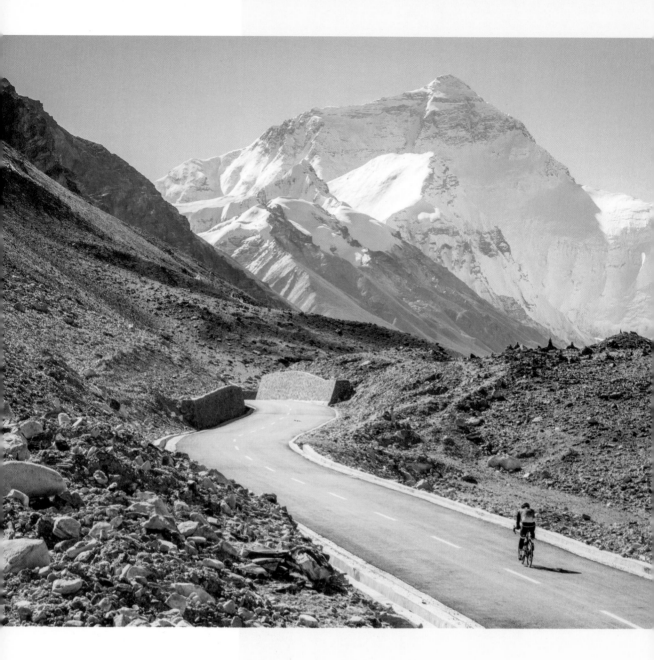

**Above**
Is there a more
evocative place
to attempt an
Everesting than
in the shadow of
Mt Everest itself?

Everesting

# EVERESTING ON THE ROAD TO EVEREST

It would be hard to find a more audacious Everesting attempt than that of Andy and his companions on the road to Mt Everest itself in 2017.

In June that year, Andy received an email from his friend Shannon Bufton, the founder of China-based bike brand and tour company Serk. The road to Base Camp on the Tibetan side of Mt Everest had recently been sealed and Shannon wanted to know if Andy would be keen to join him in attempting an Everesting in the shadow of Mt Everest itself.

Andy was understandably keen, even if the magnitude of the challenge wasn't quite clear to him at that point. He'd completed four Everestings to that stage, but in his words, 'doing it on the approach to Everest itself would take things to the next level. The temperature would range between 8°C and -5°C (46°F and 23°F), the cold air rolling down the North Face would all but ensure we faced a block headwind as we climbed, and the effect of high altitude would be an unknown factor we would struggle to simulate and prepare for,' he wrote for CyclingTips. 'There was no precedent for endurance cycling at high altitude that we could find. In short, it was clear that we had found ourselves an adventure.'

Shannon and Andy would be joined by a third rider: Australian semi-pro domestic racer Matilda Raynolds. Three times a week in the lead-up to departure, Andy and Matilda attended early morning altitude training sessions, in the hope of adapting to conditions at nearly 5000 metres (16,400 feet) above sea level.

It was on one of those early morning training sessions that the owner of the altitude training centre pulled Andy aside and told him he might be predisposed to altitude sickness. Andy was shattered – his Dutch lowlander blood had let him down. He wasn't about to share that prognosis with the team, though.

The expedition ran into trouble as soon as it began. After flying into the Tibetan capital of Lhasa, at 3650 metres (11,975 feet) above sea level, the team's videographer Mal Bloedel was bedridden with altitude sickness for 3 days. Just as arrangements were being made to replace him, Mal recovered enough to continue and the expedition set out towards Everest.

Unsurprisingly, Mal wasn't the last of the crew to feel the effects of altitude – after all, they'd allowed little more than a week to acclimatise once in Tibet, rather than the many weeks most will take when venturing into the Himalayas.

On a long climb on one of the acclimation days, Andy came face to face with altitude sickness. 'I wasn't in a good way,' he wrote. 'I checked my blood [saturation] – 99 per cent oxygen [is the saturation] at sea level, 80 per cent is your body under stress at altitude. I tried to hide the reading from the others as I inefficiently gasped in breaths of air, but it was too late. 51 per cent. With my head spinning and shoulders aching from the effort of breathing, a mild panic started to build.' Then Matilda got sick too, with headaches and crushing nausea 'that soon led to violent vomiting'.

Breaking records

Despite the earlier setbacks, on 12 October 2017, Andy, Shannon and Matilda began their Everesting on the road to Everest Base Camp. The 1-kilometre (0.6-mile) section they'd be riding included four stunning switchbacks and rose at a relatively mild average gradient of 5 per cent. But with the top of the climb reaching nearly 5000 metres (16,400 feet) above sea level, 5 per cent felt like much more.

It was freezing to begin with, and the three intrepid riders faced a roaring headwind for much of the climb. It wasn't long before Andy was in trouble. 'Focusing on keeping a straight line on the climbs was getting more difficult, and a general feeling of dizziness eventually gave way to an unnerving sensation of floating above myself,' he wrote. 'I felt drunk, and the occasional snapping myself back to reality had become a full-time chore. I was conscious of the decline but hoped it would pass.' It didn't.

As his cognitive ability continued to fade, Andy very nearly overshot a corner. It was then that he admitted to himself that things were getting serious. 'The text came through to Shannon from our doctor up the road at Everest Base Camp – "Blood oxygen sats below 75 per cent are cause for concern. 55–65 per cent means that the patient will be experiencing severe lack of cognitive function, and judgement will be severely impaired,"' Andy wrote. 'I groggily clipped the oximeter back in place on my finger. Once again the ominous alarm tolled. "Shit," I whispered under my laboured breath. I was sitting at 49 per cent saturation. As a GP buddy would later tell me, "If we had seen that on a patient in Melbourne, they would be on every machine."'

Andy called it quits after a few hours of riding. He'd hoped his stubbornness and Everesting experience would carry him through, but it wasn't to be. 'I had gone into the ride fully prepared to turn myself physically and mentally inside out, and yet something in my genes was preventing me from putting up a good fight.'

Shannon stopped sometime after midnight, with temperatures at -8°C (17.6°F), having climbed around 3200 metres (10,500 feet). Matilda battled on alone, fighting loneliness, freezing cold and driving winds.

After 15 hours on the bike, and nearly 21 hours after starting her ride, Matilda hadn't reached halfway. The altitude, the headwind and the cold conspired to see her accumulate elevation gain at roughly a quarter of the pace she would at sea level. Carrying on would have meant another 24 hours on the mountain.

At 5.15 am, with 4139 metres (13,580 feet) of climbing in the bank, she stepped off her bike for the final time, her ride over.

It seemed as if Everesting at such high altitudes was impossible – that the road to Base Camp was a climb just too hard to Everest. Until someone actually managed it.

Nine months after Andy, Shannon and Matilda's ambitious attempt, Shannon organised another expedition to the area, this time with a different group of riders. Again the goal was to complete an Everesting on the road to Everest. By tackling the ride in August, the warmest month of the year, Shannon and co. hoped to stave off the wretched cold that contributed to the demise of the first expedition.

At 4 am on 7 August 2018, a small group of riders began their laps of the same segment Andy and co. had tackled in late 2017. Some 12 hours into the ride, with 70 of the necessary 177 laps complete, a hailstorm forced the riders into their bus for shelter. With conditions not abating, and with a rider ill due to the effects of altitude, the party was forced to lower ground. They spent

hours in the Rombuk Monastery guesthouse, taking shelter from the weather.

It took many hours for the rain to clear and as night turned into early morning the crew was close to quitting. Those who wanted to continue were forced to stay awake, lest they break the Everesting rules.

Eventually, in the early hours of the morning, the riders returned to their segment and continued to ride. Temperatures fluctuated from freezing to 33°C (91.4°F) and as the ride went on, all but one of the riders pulled out. All but Zhuangchen 'JJ' Zhou.

Forty hours after beginning his ride, and after 26.5 hours in the saddle, the Hong Kong–based rider rounded the final bend and saw the top of the designated segment for the final time.

'I think the Everest has been taking care of us for the entire time that we're here,' he said, through tears, his breathing heavily laboured. 'Truly the mountain has spirits and I'm just very glad that we're part of this.'

At the insistence of his riding companions (who had joined JJ in support after abandoning their own attempts), JJ launched into a quick sprint to finish his monumental ride. 'I have never teared up in my entire adulthood,' he wrote on Strava. 'Yet, I cried three times on this ride – first when seeing the Everest for the first time on lap 101 and then lap 150 and lastly upon finishing lap 177.'

With that, JJ Zhou became the first rider to complete an Everesting – easily the highest-known Everesting – on the road to Everest Base Camp. ▲▲

Everesting

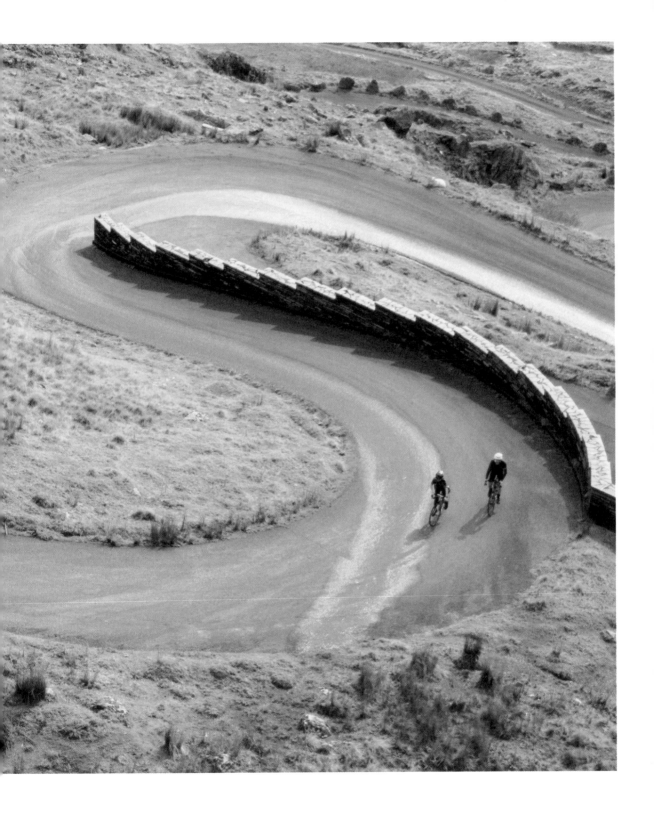

Breaking records

# PART FOUR
# THE TRAILBLAZERS

**13**

# GOING HIGHER

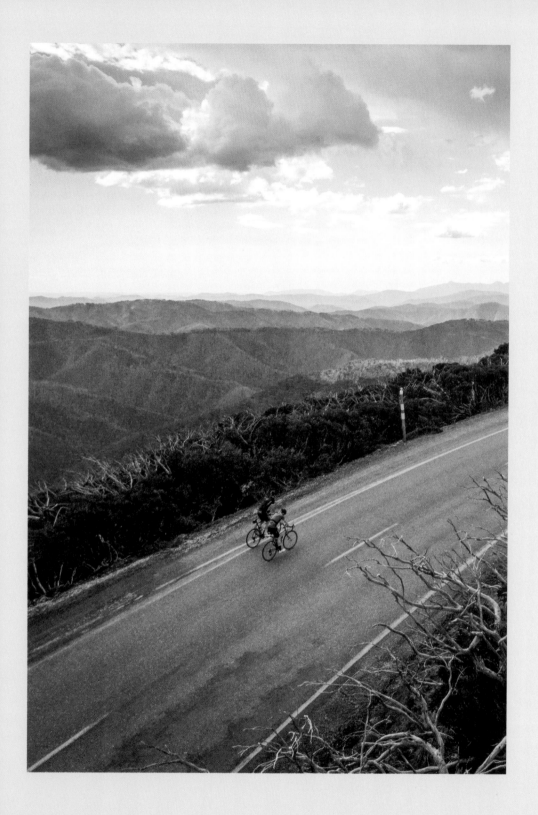

Everesting

**or most people** brave (or foolish) enough to attempt an Everesting, climbing 8848.86 metres (29,032 feet) is challenging enough. Having dug deeper than they ever thought possible, the majority limp over the imaginary finish line, grateful they can finally stop.

But what about those who reach the height of Everest and *don't* feel like they've reached their limit? What about those who feel they've still got more in reserve? Well, in a surprisingly high number of cases, they keep going.

Some decide to continue on there and then, pushing into the rarefied air above Everest. Others come back another time with an even loftier goal, trying again to find where their limits lie.

For those who do opt to climb higher, there are a couple of tantalising waypoints that can offer the motivation needed to extend Everesting beyond its intended ceiling.

For those who like their measurements in feet and inches, there's a satisfying target just beyond the summit of Mt Everest: 30,000 feet (9144 metres). Those who subscribe to the metric system have to push a little further for the satisfaction of a nice round number: 10,000 metres (32,808 feet).

If pushing into five figures isn't motivation enough alone, Hells 500 officially recognises '10k' rides as a subtype of Everesting, offering a special badge in the Hall of Fame for those who reach that mark. Hundreds of riders have stepped up to the challenge and pushed an agonising 1152 metres (3780 feet) beyond an already monumental height.

But it should come as little surprise that many riders aren't satisfied with reaching 10,000 metres. Some are keen to push on even further. Much further.

At its heart, Everesting is a tribute to the geological extremes of our great planet – a reverential nod to its highest point above sea level. So why not take inspiration from other planetary maximums? Those in the opposite direction, say.

Mariana Trench is believed to house the deepest point in the Earth's oceans, reaching more than 11,000 metres (36,090 feet) beneath the waves. In June 2020 James 'Hank' Lowsley-Williams, a presenter for the Global Cycling Network YouTube channel, tackled what he called a 'Trenching'.

'Trenching is descending the same accumulative elevation of the Mariana Trench, which according to current marine surveys is at 11,034 metres (37,086 feet) below sea level,' he said in a video from his ride. 'Now descending that far, well, it doesn't sound that hard, however you've got to be able to climb up to achieve this.'

In a challenge designed to raise funds for World Bicycle Relief, a charity that 'mobilises people through the power of bicycles', James pitted himself against the painfully steep Porlock Hill in Somerset, England. With an average gradient of 12 per cent and a maximum slope of 25 per cent, the hill was

much too hard for the 34 × 28 gear set-up James was running. Over the course of the 14-hour ride, the Briton had a mechanic install easier gears on two occasions.

He finished the day with a 34 × 34 setup, having covered 172 kilometres (107 miles) and descended (and therefore climbed) more than 11,000 metres (36,090 feet) – more than 2000 metres (6560 feet) beyond an Everesting. But why stop at 'only' 11,034 metres (37,086 feet)? Why not push on even further again?

I remember when I heard the phrase 'Double Everesting' for the first time. It was December 2015 and at that point, nearly 2 years after the launch of Everesting, I was still getting my head around the idea that 8848 metres (29,029 feet) of climbing was possible in a single ride. And here was George Mihailides completing a Double Everesting – a staggering 17,696 metres (58,058 feet) of climbing in a single ride.

The 55-year-old Melburnian had taken what was already a ludicrous challenge and straight-up doubled it.

In all, George spent just over 40 hours riding 248 laps of Booyan Crescent in Melbourne's north-east, covering just shy of 500 kilometres (310 miles). Truly remarkable.

I'd later learn that George wasn't the first to climb to such staggering heights – we'll meet the man who was, Craig Cannon, in a moment – but to me and many others, George's effort showed that pushing beyond the height of Everest was possible for those with incredible stamina and a seemingly endless supply of motivation.

Belgian ultra-endurance racer Kristof Allegaert has both of those things and more. He's a three-time winner of the Transcontinental, a 3000- to 4000-kilometre (1860- to 2490-mile) race across Europe (the route changes each year) that each time took him less than 9 days (he averaged 440 kilometres [273 miles] per day for his *slowest* victory). Kristof also won the Red Bull

Trans-Siberian Extreme, a 9200-kilometre (5720-mile) race that he covered in just over 13 days of riding.

In the context of these achievements, it's not surprising that Kristof was enticed by an endurance challenge like Everesting. But even for him, the idea of an 'accidental' Double Everesting raises eyebrows.

'Nothing was really planned,' he tells me. One morning in September 2017 he set out from home to ride the 30 kilometres (18.6 miles) to his target hill in Mont-Saint-Aubert in western Belgium, a backpack with drinks and bread on his back. When he started his Everesting, he was feeling great. As he pedalled away the kilometres, Kristof found himself dreaming about pushing the ride beyond the Everesting he'd planned.

His endurance wasn't a problem – clearly – and he could ask nearby residents to fill up water bottles for him. But what about food? Thankfully, there was a restaurant in the tiny town at the top of the hill. He stopped, ordered a meal of pasta, then did another lap as he waited for his dinner. Then, just as the restaurant was about to close, he asked them to prepare another pasta dish, and to let him know when it was done – he was passing by every 12 minutes.

As the evening turned into night, a bunch of 'young people' at a next-door party gave him plenty of encouragement. The ride got tougher as the night wore on. 'Early morning was getting cold and my extra light jacket wasn't [enough] for getting warm,' Kristof says. 'On the other hand it was perfect to stay awake.'

It was noon by the time Kristof finished. He'd spent a total of 31 hours on the hill, 27 of those in the saddle, covering 558 kilometres (347 miles). '[My] last job was cycling back home,' he says. 'Those 30 kilometres (18.6 miles) took me longer than usual, grabbing some food, drinks and straight to bed.'

Well-deserved rest, I reckon.

# THE WATERMELON EVERESTING

Most cyclists will come up with a plan for a tough ride, then work out their eating strategy around that. Charlie Martin, from Sunnyvale, California, wanted to flip that idea on its head – he had 'an epic eating goal begging for a complementary ride'.

'Last week I learned I was quite capable of consuming an entire watermelon during a ride,' he wrote on Strava – a great start to a story if ever there was one. 'It was a novel accomplishment for me, but I was haunted by lingering questions. How far could I push that? What is my watermelon limit? Two watermelons? It would take dedication, but I could probably do it. Three watermelons? Now we're talking! I had a worthy challenge in my sights. I immediately recognised that this was a challenge I must see to fruition.'

In May 2020, 2 years after completing his first Everesting, Charlie had a rare block of free time – the perfect opportunity for his watermelon challenge, which he'd complete virtually via Zwift. 'I decided I would attempt an Everesting whose lower bound for hill repeats was based on how long it took me to eat all three watermelons,' he wrote.

He was expecting it to be 'as much as a Double Everesting, which I'd been wanting to attempt for some time anyway'.

Cut up, with rinds removed, Charlie's melons gave him 10.5 kilograms (23.1 pounds) of fruit to get through. 'Finding refrigerator space and adequate containers was a challenge,' he wrote. 'At the conclusion of lap 9 (an Everesting and change) I had completed all the containers except for the Boss Container, which was about one watermelon's worth. It took another seven laps to defeat the Boss Container, which meant I may as well spend one more lap to get the Double Everesting, and then one final victory lap to breach the 60,000[-foot] (18,288-metre) territory.'

Charlie completed his Double vEveresting having ridden 440 kilometres (273 miles) over 34.5 hours. 'I normally lose weight during an Everesting, but at the end of this effort I was heavier by 1.1 pounds (500 grams),' he wrote. 'Based on some of the aftermath which I won't describe, I've decided I will not reproduce this watermelon challenge in the future.' ▲▲

More than 40 outdoor Double Everestings are in the Hall of Fame. And as more people have achieved this incredible feat, so the Everesting rules have evolved specifically to accommodate such rides.

Unlike in a regular Everesting, a rider attempting a Double Everesting is allowed some sleep between efforts. 'The first Everesting must still be completed with no sleep,' says the official Everesting guide, 'however an allowance for up to 2 hours for each "subsequent" Everesting exists. This 2-hour allowance is a total, so it can be taken as 1 × 2-hour sleep, 2 × one-hour sleeps, 4 × 30-minute sleeps etc. This allowance is to reduce the impact of sleep deprivation and ensure that you get back down off the mountain safely.'

## DOUBLE RUN EVERESTINGS

It should come as little surprise that several individuals have pushed the limits when it comes to Everesting on foot. At the time of writing there are six Double Run Everestings in the Hall of Fame, including efforts from the Belgian duo of Alexander De Wulf and Rik Goris, who claim to be the first to complete an unshuttled Double Everesting on foot.

The two spent an incredible 51 hours and 40 minutes walking up and down a set of stairs in Liège, Belgium called the 'Montagne De Bueren'. They covered 155 kilometres (96 miles), with 17,696 metres (58,060 feet) of elevation gain – just over twice the height of Mt Everest.

One rider who was more than grateful for the sleep allowance was another Belgian, Fien Lammertyn. For Fien, attempting a Double Everesting was little more than a natural progression; it was a case of pushing her personal envelope further and further.

She'd started her Everesting journey in April 2020 with a 10k vEveresting on Zwift, her 10,737 metres (35,225 feet) of climbing a then record for the most by a woman on Zwift in one ride. That same month she completed another vEveresting and two Half Everestings, before heading outdoors in June to tackle a 10k.

With that complete, she thought she was done with Everesting. 'I thought the circle was round, virtual and outdoor,' she tells me, 'until I realised there's this "Soil" badge [in the Hall of Fame, for off-road Everestings] and since I'm a mountain biker, I really need that badge right?'

After 7 weeks spent working with a physiotherapist to treat an Achilles tendon issue, Fien was ready to tackle her next big challenge. But with this ride she wasn't just going off-road – already more difficult – she was going much bigger, too. 'Since I'm a sucker for numbers and too competitive, I decided to do a Double,' she says. 'A Double off-road.'

In August 2020, Fien spent nearly 3 whole days in the be-MINE mountain-bike park just north of Beringen, north-east Belgium, with nearly 2 of those days – 46.5 hours – on the bike. In that time she endured crippling knee pain and temperatures that peaked at 40ºC (104ºF). In the end, it took her 24 hours more than expected to complete her 437-kilometre (272-mile) Everesting. She was the first woman to have achieved that feat.

Think Double Everestings outdoors is tough enough? Riding an indoor trainer for long enough to do a single Everesting sounds more than unpleasant. Doing it twice in a row? No thanks.

**Right**
Fien Lammertynn
en route to
becoming the first
woman to complete
an off-road Double
Everesting.

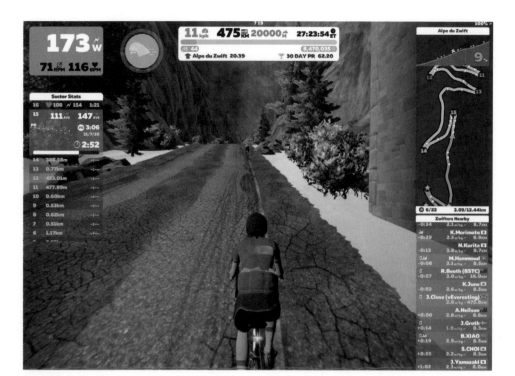

**Left**
The moment Jenny
Close reached
20,000 metres
of elevation gain
during her Double
vEveresting.

Canadian Mat Wilson was the first to complete a Double vEveresting. In August 2019 he set himself the challenge of completing 17 ascents of the virtual Alpe du Zwift climb. This virtual climb mimics the ascent of Alpe d'Huez in the French Alps, one of road cycling's most famous ascents and a regular battleground for the Tour de France.

Mat's ride took him a touch over 20 hours, in which time he covered just over 400 virtual kilometres (249 miles). In the comments section on Mat's Strava file, Andy praised Mat's effort, and made a prediction: 'This is proudly at the top of the virtual table in the [Everesting] Hall of Fame, and I also expect you've kickstarted something here …'

Andy was right.

For South African Jenny Close, a Double vEveresting didn't happen on her first attempt, but when it did, she went big. Jenny had ridden a vEveresting in April 2020

and, as so many others have done, she immediately set her sights on something bigger. 'The following week I decided to vEverest again with the hope of doing the Double,' she wrote on her website. 'I got to 10,000 metres (32,800 feet) and decided that was enough. I was mentally tired from the previous week and lacked motivation and my "why". So doing the Double vEverest has been on the back of my mind since then. I don't like to be defeated and knew I could do it.'

Three months later, Jenny returned to the virtual slopes of Alpe du Zwift and spent no fewer than 27 hours slogging up and down the mountain. And once she'd accumulated twice the height of Mt Everest, she decided to push on … to 20,000 metres (65,620 feet) of climbing – the most of any woman on Zwift at the time.

Jenny described the ride as 'the toughest thing I've ever done,' calling it 'a brutal mental and physical challenge.'

'The last few climbs seemed to go quite quickly although I did start to feel a bit delusional,' she wrote. 'Seeing my avatar on the screen slowly cycling up the climb, I kind of felt like I was there. I climbed the real Alpe d'Huez 2 years ago so my mind was playing tricks with my memories!'

Jenny wasn't alone in wanting to push beyond a Double Everesting. It turns out that, for some riders, the limits of their physical and psychological strength lie well beyond a single Everesting, and even beyond a Double Everesting.

For those with the ability to do so, why stop at a Double? When you've gone to the trouble of climbing nearly 18,000 metres (59,055 feet), why not push on?

I could tell you that a Triple Everesting involves 26,544 metres (87,086 feet) of climbing but, really, that number does little to convey the scale of the achievement.

Suffice to say, if a single Everesting is a huge challenge, then a Triple Everesting is an almighty, almost superhuman undertaking.

At the time of writing, just four people have put themselves through the abject misery of a Triple vEveresting – all on the same stretch of virtual roadway with, as per Everesting rules, just 4 hours sleep for the entirety of the effort.

The first rider to scale such virtual heights was Scotsman Ross Duncan who, in November 2019, spent more than 3 days climbing Box Hill in Zwift's virtual rendering of London. The ultra-endurance rider spent nearly 60 hours on his stationary bike in Dunfermline, Scotland, accumulating more than 27,000 metres (88,580 feet) of climbing over roughly 1220 virtual kilometres (758 miles).

## ROSS'S REMARKABLE RIDES

After his world-first Triple vEveresting in November 2019, Ross Duncan set his sights even higher. A little over a month later, he climbed an astonishing 50,000 metres (164,040 feet) on Zwift in one activity, raising money for World Bicycle Relief in the process. The effort took him most of 5 days, during which he spent 96 hours – 4 full days – in the saddle and just 14 hours sleeping. Along the way he covered 2160 virtual kilometres (1342 miles) on a combination of climbs on the Zwift island of Watopia. *Extraordinary.*

Ross wasn't done yet, though. In November 2020, he completed a vEveresting on Zwift every day for 14 days in a row. That's easily the most consecutive Everestings completed by one person, and a truly remarkable achievement.

**Going higher**

To date, 13 Triple Everestings have been completed outdoors. Strangely enough, the first-known Triple Everesting happened before the first Double – a little over a year after Everesting was first launched.

In late June 2015 US rider Craig Cannon completed an Everesting with relative ease on South Park Drive east of Berkeley, California. 'I climbed the 29k [feet] and ended the ride feeling great in spite of the fact that my "nutrition" consisted of a pizza I left in my car at the bottom of the hill,' he wrote on his website. 'Immediately I started looking for something bigger. I came across the 48-hour record, 94,452 feet (28,789 metres), and felt pretty confident that I could top it.'

In mid-July 2015, Craig went out and spent 24 hours climbing up and down the 12 per cent grade of South Park Drive. It might have been a training ride for the 48-hour record, but it was a monster ride in itself, with 13,508 metres (44,320 feet) of elevation gain.

A little less than a month later, in early August 2015, Craig ventured back out to South Park Drive and tackled the 48-hour record. Over the course of 2 days, he spent 42 hours and 46 minutes on the bike. Remarkably, he only slept once in that time: a 20-minute nap, at 3 am, after 34 hours of riding.

Writing later, he described that moment wonderfully: 'I rotate my left foot and unclip from the pedal. My cleat clumsily finds level ground among the gravel on the road's shoulder. Hunched over, forearms on the bars, I know what's happened. Sleep deprivation is sinking its teeth in and the longer I'm at a standstill, the harder it'll be to restart. I have to make a choice. Rest or push through? Up to this point sugar and caffeine have kept me going but as I lift myself off the bars and put my right foot on the pavement, the choice is clear – my legs are wobbling and my head is heavy, so heavy – I have to take a break. We open the hatchback's rear door, throw the bags out of the way, and I crawl in, barely finding the energy to swallow a couple painkillers and drink water before I curl up between a track pump and what looks to be a refrigerated tote bag. Instantly I'm asleep.'

Over those 2 days, Craig went on to amass a staggering 29,146 metres (95,623 feet) of climbing – more than three times the height of Everest. In doing so he achieved his goal of setting a new Guinness World Record for the 'greatest vertical ascent by bicycle in 48 hours (male).'

Craig's 48-hour climbing record stood for more than 5 years. It wasn't until September 2020, on the other side of the Atlantic Ocean, that someone was able to better it.

Irishman Alan Colville had already done multiple Everestings, a vEveresting, and two Double vEverestings by the time his mate Matt Jones suggested a tilt at Craig Cannon's 48-hour climbing record. Alan agreed. After searching for the perfect ascent, he settled on the B4519 climb near Llangammarch Wells in Wales – 2.6 kilometres (1.6 miles) at a painful 9.2 per cent.

His first attempt started well, but after 8 hours of struggling in temperatures nudging 30°C (86°F) Alan called it a day and decided to recalibrate. A month and a half later, on 19 September, he headed back out to Llangammarch for his second tilt. That started poorly, too – he blew out a tyre on his first ascent, forcing him back to the start to reset the clock.

As you'd expect for a ride that spans 2 whole days, Alan experienced plenty of challenging moments. None more so than after roughly 40 hours of riding, at 2.30 am.

'Parked on the side of Cwm Graig Ddu, I peeled myself off my bike and informed my friends Matt and Budge that I was hallucinating,' Alan wrote on the website of his cycling group, Team JMC. 'Descending [at] 70 km/h (43.5 mph) in the dark, I was worried for my safety as I was desperately tired, but didn't want to stop. The Guinness World Record was tantalisingly close and as the minutes slipped by, I knew something had to change.'

Alan found himself thinking he was in an animated world, and he had long periods of déjà vu. With some encouragement, he decided it was best if he took a 5-minute micronap in his campervan. 'As soon as I closed my eyes, I was hit with a barrage of flashing colours,' he wrote. 'But as I lay there, the lights faded and my breath slowed – if there was one transformational moment in this endeavour, that was it.'

**Right**
Alan Colville rode near continuously for 2 straight days to set a new Guinness World Record.

**Going higher**

## SAULIUS'S 40TH BIRTHDAY

In September 2017, Lithuanian rider Saulius Speičys decided to celebrate his 40th birthday with a 48-hour bike ride – a perfectly normal birthday celebration. His climb of choice was the road to Trijų Kryžių (the 'Three Crosses'), a prominent monument that has loomed over the Lithuanian capital of Vilnius since the 1600s.

The rain started on the first afternoon of Saulius's ride. Around 24 hours later he stopped for 20 minutes to enjoy a small birthday party with those who had come to support him. As he continued, rain became a constant and decidedly unwelcome companion; lightning and thunder only made things worse. At one point, Saulius was forced to stop for 5.5 hours to let the rain clear.

Ultimately, he fell short of his ambitious goal of 100,000 feet (30,480 metres) in 48 hours, thanks in no small part to the horrific autumn weather. But he'd still achieved something remarkable: more than 480 laps of the 55-metre-high (180-foot) climb, for a total of 26,593 metres (87,247 feet) of elevation gain – a very soggy Triple Everesting.

Alan described the next 3 hours as 'the toughest I've ever experienced on a bike'. But he battled on, and as the sun rose, so did his spirits. His pace increased and by mid-morning the job was done.

In 48 hours, he had ridden 617 kilometres (383 miles) and climbed 30,321 metres (99,479 feet) – 3.4 times the height of Everest – eclipsing Craig Cannon's record by more than 1000 metres (3281 feet). 'I fell off my bike, Matt leapt on me and the celebrations began,' Alan wrote. 'I'd realised a childhood dream by breaking not just any world record, but an athletic – and bloody difficult – one at that. I'd also finally proved something to myself since being hit by a truck while cycling to work in 2011, suffering a double back break, lacerated kidney and liver, and losing my right glute max (the cyclist's muscle). When I crossed that line in Wales, celebrations and congratulations ringing in my ears, I was finally able to put to rest what had happened. I now understand – it's my ambition that defines me, not a disability or an injury. Sitting there with my friends, on the side of that hill, I was on top of the world.'

While no one has yet managed to climb 100,000 feet (30,480 metres) in 48 hours – Alan Colville was just 521 feet (159 metres) short! – a select few Everesters have managed to push through that barrier in longer efforts.

A couple of months before Alan's record ride, 19-year-old international cyclocross racer Lane Maher was putting in his own mind-bending ride.

In June 2020, in northern Connecticut, USA, Lane started climbing Morrison Hill Road in West Hartland with a clear target in mind: reach 100,000 feet (30,480 metres) to raise money for the Black Lives Matter campaign. 'I have always been disgusted by the racism and general hate I see in the news, but I have never done anything about it because I never knew where to even start or what I could do to help,' Lane

**Right**
A Triple Everesting
is certainly one
way to spend your
birthday, as Saulius
Speičys found.

wrote on his crowdfunding page. 'This is where I start. I am embarking on a personal cycling challenge to raise awareness of and funding for the Black Lives Matter Foundation.'

The young American's monumental ride took him 72 hours to complete, 60 hours of which he spent on the bike. That's 3 whole days on the same 2-kilometre (1.2-mile) stretch of road, staring at the same sights as fatigue accumulated and his mental resolve faded. But Lane held firm and eventually, after covering 942 kilometres (585 miles), he reached 100,000 feet (30,480 metres) –

the equivalent height of Mt Everest nearly four times over.

'If someone told me 3 weeks ago that I could raise thousands of dollars to make the world a better place for others, just by packing up my car with food and a bike and going for a sick ride, I wouldn't have believed it,' Lane wrote on Instagram. Through one of the most remarkable Everesting rides yet recorded, he raised just shy of US$10,000.

Incredibly, Lane's 100,000 feet of climbing isn't the biggest Triple Everesting on record.

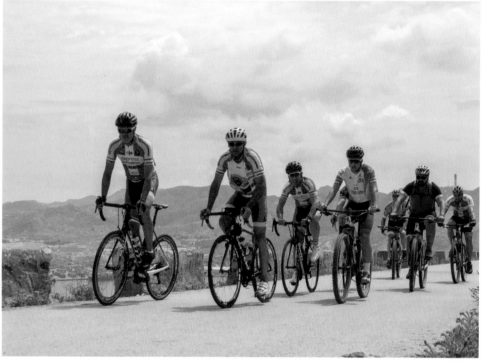

Everesting

**Left**
Pepe Uribe has
made a name
for himself by
pushing the limits
of the Everesting
experience.

A little over a year earlier, Spaniard Pepe Uribe spent 5 days getting intimately acquainted with the serpentine 2.7-kilometre (1.7-mile) climb to the Castillo de Galeras, an 18th-century castle in the city of Cartagena, south-east Spain. '[The Everesting] was made on a mountain that is owned by the Spanish Army,' Pepe tells me. 'I had to ask for a special permit to be there.' Over the course of his marathon effort, Pepe spent some 70 hours in the saddle, riding up and down, up and down.

Pepe didn't sleep after his first Everesting; during the second he slept just under 2 hours. He did likewise during the third. Ultimately, it was sleep that prevented Pepe from reaching the goal with which he'd started the ride.

Pepe wasn't just aiming for 100,000 feet (30,480 metres) – he was looking to become the first person to complete a Quadruple Everesting.

In the end, sleep deprivation took its toll and brought Pepe's attempt to a premature end. 'This activity ended because I fell asleep without realising it on one of the climbs – thank goodness that I got off the bike before,' Pepe tells me. 'As I sat down … I fell asleep without realising it and was awakened by a call on the phone from a friend who was waiting for me.'

Pepe knew the rules – more than the allowable amount of sleep meant his attempt was over. Interestingly, it wouldn't be the last time an unplanned sleep would derail Pepe's Everesting plans.

Despite the disappointment, Pepe had plenty to be proud of – he'd broken the record for the most climbing and greatest distance covered for a Triple Everesting. He'd summitted the Castillo de Galeras climb 186 times, covered 997 kilometres (620 miles), and climbed a total of 31,340 metres (102,822 feet) – more than three and a half times the height of Everest. A truly incredible effort.

## PEPE'S SLEEP

A few months after his Triple Everesting, Pepe Uribe was attempting an Everesting on the concrete road to Monte Calvario, just near Cartagena, south-east Spain. In temperatures that nudged 40°C (104°F), on a climb that averages 15 per cent, Pepe suffered through what he thought was enough laps to reach the height of Everest. He headed home and started uploading his ride to Strava, at which point he realised that he was 500 metres (1640 feet) short of the requisite elevation.

Pepe decided to take a break before heading back out. 'I thought I would watch the Tour de France stage on television and complete those 500 meters (1640 feet) that were missing,' he tells me. 'But during the Tour I fell asleep for a few minutes and it was no longer legal to continue.' Again, unintended sleep had thwarted Pepe's plans.

When you consider how hard a single Everesting is, the idea of doing four in a row defies comprehension. And yet, where Pepe Uribe fell short of his goal of a Quadruple Everesting, Giacomo 'Zico' Pieri succeeded.

Like so many who thrive in the world of Everesting, Zico had been riding long distances for many years. The career carpenter had ridden gran fondos, completed Ironman triathlons and run marathons and ultramarathons. So when he heard about Everesting, it was a natural fit.

Zico's Everesting journey began in May 2017 with 13 laps of the Monte Nerone da Pianello climb, a 13-kilometre (8-mile) ascent not far from his hometown of Cagli in central Italy. It took him just over 17 hours to complete the necessary amount of climbing in 241 kilometres (150 miles). The following month, Zico upped the ante with a Double Everesting on the Monte Petrano, just above Cagli.

The ride was a tribute to pro cyclist Michele Scarponi from the nearby town of Jesi, who died after being hit by a car in training in April 2017. In collaboration with the Scarponi family, Zico helped organise a monument to the fallen rider at the top of Monte Petrano. On the day the monument was unveiled, Zico spent 52 hours – 34 of it on the bike – riding 23 laps of the 10.2-kilometre (6.3-mile) ascent. He covered a grand total of 474 kilometres (295 miles).

But Zico wasn't done there. Not by a long shot.

He called his big project 'Everesting Unlimited' – he didn't want to impose any limits on himself. His plan was to return to Monte Petrano and to complete at least a Triple Everesting. 'This is the minimum objective, but I do not cloud mental balance with records, results and successes,' he told *Flaminia & Dintorni*, a local newspaper. 'The self-esteem I have acquired over time allows me to go further and experience everything as a further knowledge – the eventual failure would give me further knowledge, experience and stimuli.'

On 15 June 2017 Zico started his first of many ascents of Monte Petrano. As you'd expect, there were plenty of ups and downs along the way. He says that after 2 days of riding he started to feel 'crazy', that a lack of sleep was beginning to take its toll. But he never felt like stopping – he knew that 'after you feel bad, you can feel good'.

Zico was also energised by the growing number of people who were coming out to watch and support. 'Day by day in Cagli, my town, a lot of people [came out] every evening,' he tells me. Families with kids, young folks and old folks, riders and non-riders – all came out to support the 46-year-old in his mind-boggling endeavour.

After 4 days and 17 hours on the mountain – with 65 hours spent in the saddle – and with 45 laps, 904.8 kilometres (562 miles) and 35,395 metres (116,125 feet) of climbing in the bank, Zico finally brought his groundbreaking ride to an end. It was the most elevation gain ever achieved in an Everesting ride.

Remarkably, Zico had wanted to keep going – it was only at the insistence of others that he decided to stop when he did. 'He was stopped by the concerns made by people, doctors, the media and public opinion in general, all anxious that he was going "further,"' *Agorà Urbino* reported.

Reflecting on the ride, Zico says he could have gone further, but that 'to push my health was not the perfect message'.

As I listened to Zico tell his story, it got me wondering how hard a Quadruple Everesting is. Is it simply four times harder than a regular Everesting? Or does the difficulty plateau out at some point and it's just a case of pushing on (and on and on)?

Zico tells me that while the ride was very hard, he's done tougher rides in his time. 'For me, much harder was in the preparation, the training for Everesting. I did one single

On the chalkboard:
EVERESTINGUNLIMITED
SAB. 15 GIUGNO '19 PARTENZA ORE 4:40
1 2 3 4 5 6 7 8 9 10 11 1° EVERESTING
DOM. 16 GIUGNO '19
12 13 14 15 16 17 18 19 20
LUN 17 GIUGNO '19
21 22 23 24 25 26 27 28 29
3° EVERESTING
MART. 18 GIUGNO '19

**Above**
Zico Pieri was the first person to complete a Quadruple Everesting – a scarcely fathomable achievement. After more than 4 days spent riding the same climb, Zico wanted to continue on.

Everesting

Everesting in a short climb, but super steep – 20 per cent,' he says. 'My feeling was not good, my health was not good, but I wanted to try and it was very hard. It was harder in my head than Double, than Four Everestings.'

Amazingly though, Zico doesn't hold the record for the most vertical metres in an Everesting ride. That record belongs to plucky Basque rider Aitor 'Berritxu' Antxustegi, the only other person to have completed a Quadruple Everesting.

After completing 23 rides of Everesting height or greater – including a Triple Everesting in May 2018 – Berritxu decided it was time to aim even higher. As August 2020 turned into September, the 48-year-old slogged his way through 137 ascents of the 3.1-kilometre (1.9-mile) Lekoitz climb out of Markina-Xemein, a small town in the Bizkaia province of the Basque Country, northern Spain.

Where Zico Pieri had spent nearly 5 days out on his mountain, Berritxu spent less than three. In a total of 68 hours and 50 minutes, he spent 59 hours on the move – less than 10 hours of rest in almost 3 days – covering 980 kilometres (609 miles) and accumulating 35,422 metres (116,214 feet). He'd eclipsed Zico's mark by less than 30 vertical metres (98 feet) but taken 44 hours less to do it.

Fellow cyclist 'B Getxo' summed up Berritxu's mammoth effort with a comment on the ride's Strava page: 'There are astronauts who have climbed fewer meters. Congratulations champion!!'

A single Everesting is a phenomenal achievement on its own; something that, really, is beyond the vast majority of the population. Doing multiple Everestings in a single ride? It's almost impossible to imagine the strength and motivation required.

But as we learned back in Chapter 3, pushing limits is a big motivator for so many who have been enchanted by Everesting. And for a certain percentage of the athletic population, those personal limits can't be found with a single Everesting. Years of ultra-endurance riding has conditioned these individuals to be able to push well beyond what seems possible to the mere mortal, or even to the average Everester.

To those of us watching on in awe, it's hard to understand the magnitude of these achievements. At some point numbers start to slide into the abstract – 20,000 metres (65,620 feet) of climbing sounds like a lot, as does a Triple Everesting, but these descriptions are divorced from the reality and incredible effort required.

Make no mistake: these are truly extraordinary achievements, at the very upper limit of what the human body and mind are capable of. 🚲

Everesting

# EPILOGUE

**On paper,** Everesting shouldn't have taken off like it did. A challenge so hard and so audacious should never have gained any meaningful traction. Indeed, when the story of George Mallory's 'Mt Everest in a Day' made it out into the world in 2012, it was a source of considerable incredulity.

Here was a ride so extreme, so far beyond the imagination of even the most masochistic cyclists, that the chances of it ever being replicated seemed slim at best. So when Andy van Bergen launched Everesting to the world in 2014, few expected it to live beyond its opening weekend.

The fact 60 people were willing to give it a try that weekend was staggering; the fact roughly half were able to finish it beggared belief.

And yet, that opening weekend planted a seed. It confirmed that Everesting could indeed be done by the average amateur; that with a lot of training, motivation and more than a little mental toughness, this seemingly impossible challenge could in fact be conquered.

Since then, the challenge has been completed more than 11,000 times. What was once just a single rider's baffling passion project back in the 1990s has become so much more. In 2014 Everesting was a tiny community event; by 2021 it's an internationally recognised challenge completed all over the world.

Through Everesting, the world's highest mountain has been turned into a verb. Through Everesting, thousands have been able to tackle our planet's tallest peak, all without the significant expense and environmental impact of travelling to Mt Everest itself.

Everestings have been completed on mountain passes and on suburban streets; on silky smooth tarmac and gnarly rock-strewn tracks; on stairs, in pits and even inside homes. They've been completed by riders young and old, fast and slow, pro and amateur. They've been completed by cyclists on bikes of all kinds, by runners and other athletes besides.

And while the challenge started outdoors, thousands of Everestings have now been completed indoors, virtually. Everesting has attracted the attention of the world's best media outlets, and has been read about by millions.

As compelling as the story of Everesting's growth is, it's at an individual level that the tale gets most interesting. Each Everester has a story. For most, that's a story of significant, self-imposed suffering; for a great many, that story involves pushing through the pain to reach their lofty goal. Each that reaches the height of Everest has achieved something truly remarkable.

For so many, Everesting has proven a vehicle for self-discovery, a way to better understand the self – to poke and prod at one's physical and psychological limits. For some, those limits exist well beyond a single Everesting, as unbelievable as that may seem. For these incredible athletes, Everesting has provided a framework to test and understand the very limits of human endurance.

But Everesting has brought more than the pursuit of individual excellence – it's also provided a platform for those intent on helping others. By now, perhaps a million dollars has been raised for a great range of causes, turning personal journeys into something of greater value to those in need, and to the wider community.

And speaking of community, it is perhaps Everesting's ability to bring people together that is the phenomenon's crowning achievement. An ultimately solitary pursuit, one that forces riders to battle their own physical limits and psychological demons, has spawned a sprawling global fraternity. Riders that attempt the challenge invariably have the support of others, whether it be fellow cyclists out on the road, family and friends by the roadside, or the wider Everesting community via the internet. Likely it's some combination of all three, as I found during my own Everesting.

In one of our many conversations about Everesting, I ask Andy whether he's proud of what he's helped create. He says he is, but the feeling is somewhat amorphous. Day to day, he's so focused on the micro details of managing and overseeing Everesting that he finds it hard to step back and see the bigger achievement. 'I'm aware of the fact that it's this big challenge that's been created, but I can't connect with it because I'm still literally approving every single [ride] that's coming in the door,' he says. 'I can't see the forest for the trees, and that's fine. I know one day in years to come, I will, but I don't need that right now. Hopefully it keeps me a little bit humble too. I wouldn't want to get a big head about it.'

Over the past seven and a bit years, I've had the privilege of watching, from close by, as Andy and Tammy have built Everesting into a phenomenon. In some ways, it's odd to think that a concept like Everesting could ever be owned or managed by one organisation. After all, how can anyone own the idea of climbing up and down a hill to reach the height of Mt Everest?

But Everesting is much more than the completion of those hill repeats – it's a vehicle for self-discovery, a platform for supporting those less fortunate and, ultimately, a focal point for human connection.

None of that would exist without the vision, the dedication, and the tireless toil of Andy and Tammy. Since late 2013, the pair have spent nearly every day tending to Everesting, approving rides for the Hall of Fame, answering questions from would-be Everesters, creating and supporting events, fostering the community through a raft of online channels, and mailing out kit to successful riders. As Everesting has grown, so too has the van Bergens' workload.

They've truly created a monster but one that's brought great joy and satisfaction to so many around the world.

On 15 September 2013, Andy sent an email to 17 members of the Hells 500 inner circle with the intriguing subject line, 'The new Hells 500 epic awaits …' It was the first time he'd mentioned Everesting to anyone outside his immediate family.

In his email, Andy laid out the concept of Everesting, pointing readers to the story of George Mallory's now-legendary ride on Mt Donna Buang back in 1994. He explained the rules of the challenge and talked through the logistics of Everesting's opening weekend in early 2014.

In one particularly evocative paragraph about the ideals of Hells 500, Andy wrote optimistically about his vision for Everesting. 'We are not imitators – and rather than following trends, we set to create them,' he wrote. 'With the next Hells 500 challenge you are going to be the catalyst for a flurry of activity – not only here in Australia, but potentially around the world.'

The final line of his email: 'Everesting. We're building something new here.'

Little did he know. 🚲

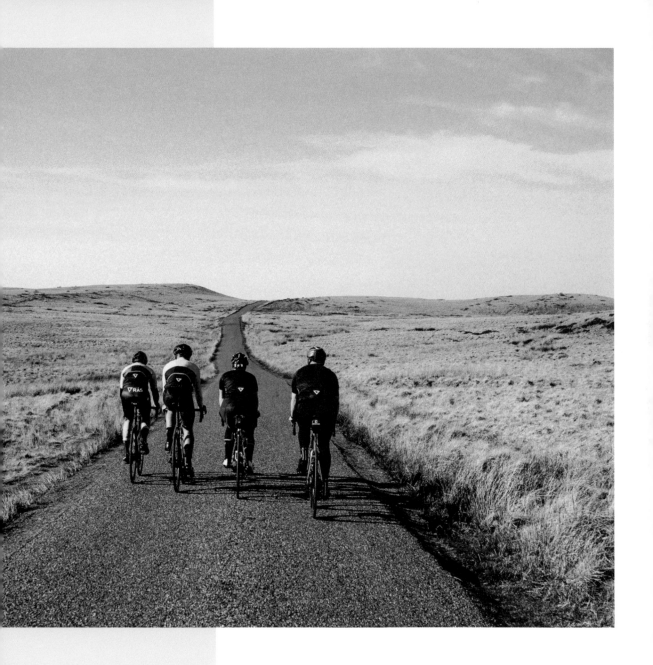

Epilogue

# ACKNOWLEDGEMENTS

This book would not exist without the time and energy of a wonderful supporting cast. Paul Dalgarno was instrumental in setting me on the right path initially, and his invaluable guidance helped me stay on that path throughout. In fact, Paul's influence on this project stretches back most of a decade – his mentorship at *The Conversation* shaped me into the writer and editor I am today, and for that I'll always be grateful.

I simply could not have told the story of Everesting without the enthusiastic support and energy of Andy van Bergen. Andy spent many an hour chatting with me about the phenomenon and ensured I got the details right. I remain in awe of his positivity and the joy he's brought to so many cyclists around the world.

Thanks to Rupert Guinness for connecting me with the fine folks at Hardie Grant Books. I count myself very fortunate to have landed in the care of editor Joanna Wong and publisher Pam Brewster, both of whom have been a true delight to work with.

Andrew Bain's impressive, razor-sharp edit didn't just make my manuscript better; he also inspired me to be a better editor and writer. Thanks too to Steven Amsterdam and Jane Rawson whose thoughtful advice and wisdom helped ensure my efforts were well-directed.

To my CyclingTips colleagues: you've all been wonderfully supportive at every turn. It's a privilege to work beside you all. Special thanks to Wade Wallace who gave me the time and space I needed to see this project through, and to Iain Treloar and Caley Fretz who continually inspire me to be a better writer.

Thanks to Dr Stephen Lane, Dr Alan McCubbin, Michael Inglis and Dr Chiara Gattoni who were all invaluable in sharing their considerable expertise. This book is all the stronger for their intelligent and generous contributions and I'm very grateful for their time. The same is true for every single Everester I spoke to who trusted me with their story. This book would not have been possible without you. Thank you.

Thanks to physiotherapists Andrew Kantor, Gary Cairnduff and Gary Nicholls for keeping my ailing body from falling apart entirely as I trained up for an Everesting. To everyone that came out and supported me on the day of my Everesting – my family, friends and the residents of Walhalla Drive and Isabel Avenue – a massive, heartfelt thank you. You made it a day I'll never forget.

Thanks especially to my dad Ron, my grandfather Rob, my brothers Brendan and Ash, Jeff Servaas, Iain Treloar, Nick Harvey and finally, to my partner Imogen. Imogen wasn't just crucial in getting me through the Everesting, she was my biggest supporter throughout this entire project. Her careful read-through of my manuscript was greatly appreciated; even more valuable was her positive reinforcement from start to finish, and the time and space she gave me to write when I needed it. Thank you so much. 🚲

# AUTHOR BIO

Matt de Neef is a cycling journalist from Melbourne, Australia, and the managing editor of CyclingTips.com, one of the world's foremost road cycling websites. He has reported from a number of Tours de France and many other professional bike races. In 2009 he created theclimbingcyclist.com, an ode to the challenge of riding uphill, with a focus on the many great cycling climbs around his home state of Victoria, Australia. Matt is a keen recreational cyclist who loves exploring new roads and testing himself on any cycling climb he can find.

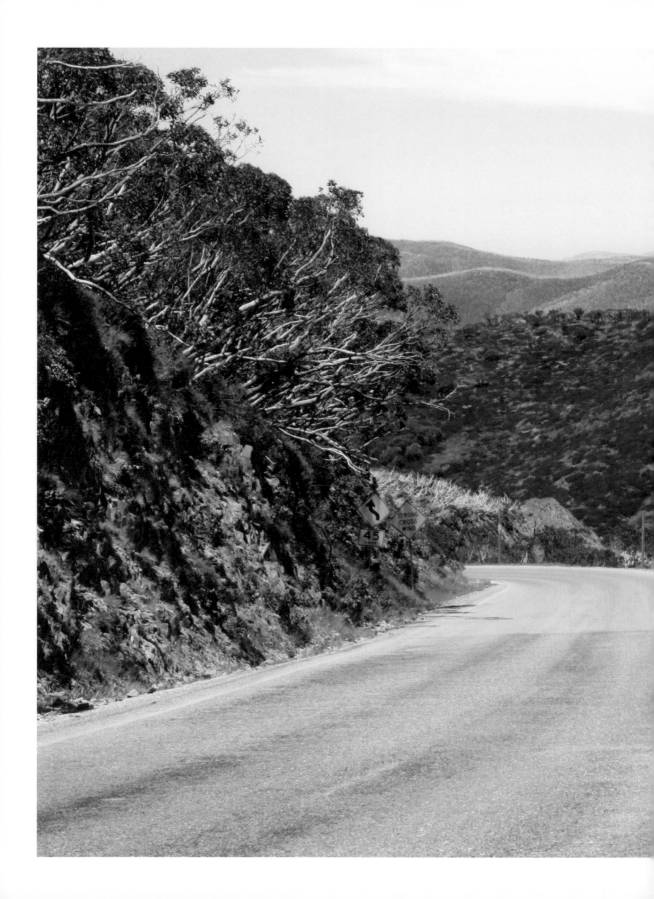

Published in 2021 by Hardie Grant Books,
an imprint of Hardie Grant Publishing

Hardie Grant Books (Melbourne)
Wurundjeri Country
Building 1, 658 Church Street
Richmond, Victoria 3121

Hardie Grant Books (London)
5th & 6th Floors
52–54 Southwark Street
London SE1 1UN

hardiegrantbooks.com

A catalogue record for this
book is available from the
National Library of Australia

Everesting
ISBN 978 1 74379 739 6

10 9 8 7 6 5 4 3 2 1

Publishing Director: Pam Brewster
Project Editor: Joanna Wong
Editor: Andrew Bain
Design Manager: Mietta Yans
Designer: Murray Batten
Production Manager: Todd Rechner

Colour reproduction by Splitting Image Colour Studio
Printed in China by Leo Paper Products LTD.